DESIGNING ASSESSMENT IN ART

Carmen L. Armstrong
Professor of Art
Northern Illinois University

National Art Education Association
1916 Association Drive
Reston, Virginia 22091-1590

1994

About NAEA . . .

Founded in 1947, the National Art Education Association is the largest professional art education association in the world. Membership includes elementary and secondary teachers, art administrators, museum educators, arts council staff, and university professor from throughout the United States and 66 foreign countries. NAEA's mission is to advance art education through professional development, service, advancement of knowledge, and leadership.

On the cover: Jasper Johns, *Numbers in Color*, 1959, encaustic and newspaper on canvas, 66–1/2 x 49–1/2", Albright–Knox Art Gallery, Buffalo, New York, Gift of Seymour H. Knox, 1959.

ISBN 0-937652-71-7

TABLE OF CONTENTS

Table of Contents (continued)

ACKNOWLEDGMENTS

Because evaluation or assessment of learning is not a new idea, the writings of many persons have helped to shape this book. I have credited many and apologize to those who may have inadvertently been omitted by name even though their influence is evident.

Guy Hubbard has been a continuing model and encourager. Mary Rouse's influence prods me still. Thank you both.

Various grant involvements have offered opportunities to field-test ideas with art teachers. In connection with these, I want to thank Stacy Schmidt, Robin Russell, Marilyn Schnake, Mike Harkins, the Illinois Art Education Association, and the Illinois State Board of Education.

Essential to writing the book have been art teachers enrolled in numerous sections of the Northern Illinois University (NIU) course "Evaluation and Art Education," which I taught. They served as critics, tested ideas out with their students, and provided inspiration and encouragement.

Both art teachers and university professors have given valuable suggestions as blind reviewers of early drafts. I extend particular thanks to colleagues who helpfully scrutinized drafts of chapters at various stages of development: Ginny Brouch, Blanche Rubin, Debbie Smith-Shank, and Tom Hatfield. Thanks also to Sandy McCollister for suggestions. Finally, I sincerely but inadequately thank my husband, Nolan Armstrong, retired Professor of Education at NIU, who steadfastly supported this endeavor by reading initial drafts and playing many roles to facilitate its completion. I am indebted to the NIU artists who so generously donated photographs of their art as plates in the book, namely, Renie Adams, Mary Glynn Boles, and Yih-Wen Kuo.

I am grateful to Richard Carp, chair of the School of Art at NIU, for releasing me from a class during the Spring 1993 semester to work on the book; to the Board of Directors of the National Art Education Association (NAEA) for their trust; and to the NAEA editorial staff for the fine tuning necessary to make the book available.

PREFACE

This book is written primarily for persons who teach or supervise art, assess student learning of art in formal education settings, or who are preparing for these roles. It is written for all teachers who care about teaching art and the effect of their teaching on students. In addition, it can provide guidance for administrators who look for valid ways to assess art in order to support claims for its critical role in formal education.

Assessment is viewed in this book as a component in an inseparable and cyclical educational triad—curriculum planning, instruction based on the curriculum planned, and assessment of student learning that results from instruction within art educational experiences. Assessment recommendations in this book recognize that in contemporary art education, students: Analyze visual qualities of their human-made and natural environments; Create art; Engage in philosophic thinking about art in general; Critically interpret and evaluate works of art; and Research the contexts out of which art has arisen throughout history and across cultures.

This book is designed to help teachers of art to responsibly assess what students learn in such activities through multiple means of observing and recording evidence of that learning. It illustrates how teachers can develop an overall plan and refine and expand assessment methods used in grading individuals and assessing group learning in art. It simplifies the process by showing how to use activities that are part of instruction as assessment, and how to be selective in assessing and reporting the most important student outcomes resulting from a comprehensive art program. The teacher assumes ownership of, and responsibility for, the assessment of learning in art.

In the United States alone, art education exists in a wide range of contexts. At the elementary school level, art may be taught by elementary classroom teachers with no post-high-school course work in art or by art specialists with many semester hours of graduate work in art and art education. Students may have art classes twice a week or every other semester or once every three weeks. Some art teachers have aides; some teach seven classes a day with five minutes between periods. Some high schools exist where the arts are central, while in others art teachers have five groups with varying experience and schedules within the same class period. Because communities support art education to such a varying degree, it is impossible for the recommendations of this book to be feasible for every art situation. They are offered as possible models to try or adapt.

Rather than dismiss the idea of assessment because of the many choices or possible unfamiliarity, the reader may want to select *some* of the recommendations appropriate to their and their students' situations. Certainly, art teachers will want to attempt what is manageable and can be done well. Using a few assessment methods at one or two grade levels may be a way to start. After initial successes, teachers will see the feasibility, and accept the challenge of, more comprehensive assessment procedures.

Recommendations for comprehensive assessment procedures unavoidably have curricular implications. While the examples are compatible with current directions supported by the literature in our profession, explanation of the curriculum planning process is beyond the scope of this book.

The book is organized to introduce general concepts before specific applications. However, the needs of individuals may be met by different segments of the book and in different order. After orientation to assessment in Chapters 1 through 3, Chapters 4 through 6 deal with comprehensive assessment and its relationship to a curriculum. Chapters 7 and 8 introduce types of assessment and model local applications in three encounters at three grade levels. Chapters 9 through 11 deal with construction of assessment instruments, particularly nontraditional ones. Chapters 12 and 13 make recommendations for implementation—administering, scoring, accumulating, summarizing, and interpreting evidence of learning. Chapter 14 deals with questions of ethics and assessment. Chapter 15 shows how reporting the results can restart the curriculum- instruction-assessment cycle.

For reasons of validity, the reader is frequently referred to previous chapters. In addition, this avoids redundancy inherent in demonstrating how the assessment process builds from its curriculum and instruction foundation.

Thus, the intent of this book is to enable teachers to become aware of, adapt, and create assessment instruments in art. The awareness enables choice of sound assessment practices that can inform students and teachers about students' progress and enlighten others about the nature of learning in art. This book encourages the teacher of art to take ownership of and responsibility for valid and reliable local art assessment, and it offers guidance in carrying out that task.

1

INTRODUCING ASSESSMENT IN ART

Chapter one describes several scenarios of art lessons and calls attention to the fact that teachers may already be observing and assessing in informal ways.

Assessment provides the basis for schools to be accountable to their communities for student learning in all subjects. As such, assessment is also an important part of a good art education. Assessment occurs during as well as after the art lesson. It provides some assurance that students are learning what teachers intend to teach.

Assessment of learning in art is not new, but more systematic approaches to getting feedback about certain kinds of art learning are new to some art teachers. Ideas about what we teach in art have expanded. That expanded content, and approaches to learning that characterize the disciplines from which the expanded content is derived, invite the use of new methods of assessment.

Much more could be assessed than any teacher has time to do. As a result, art teachers do not, indeed cannot, assess everything that is taught, but must consciously select representative content or behaviors as samples of what students have learned. Some great feelings about teaching art are likely *because* teachers have assessed—casually and informally, perhaps—but truly assessed none the less and, therefore, have evidence of students' successful performance.

Some Familiar Scenes

The following three scenarios are presented to suggest ways that assessment can naturally fit into art instructional situations.

Imagine that an art teacher's planned instruction includes questions to ask fourth-grade students as they observe the structure of trees on a winter walk around the school building. The students observe how the tree trunk narrows as limbs divide from it and how light affects the value of the color of the bark. The art teacher explains the problem of drawing trees to show the structure and the effect of light on its limbs. Back in the classroom, the students tackle the problem with confidence gained from their observations.

As students finish, some still have a rectangular trunk with unvaried straight lines radiating from its top. Others show tapering limbs that divide as they taper. Others show

lighter brown on parts of limbs to indicate a single source of light. Some pictures have tapered limbs on the tree that appropriately change value as if lighted by the sun. Clearly, some students show that they understood better than others and not all in the same way. This is a form of assessing the student's learning in terms of the concepts (tree structure and effect of light on the color of forms) for which instruction was planned. These are called "criteria."

This type of assessment also occurs during art criticism experiences. Imagine a close gathering of a second-grade class around a poster-size reproduction of Rousseau's *Pierre Loti*, with Renoir's *Woman with a Cat* and Steinlen's *Girl with Three Kittens* nearby for comparison. Without giving the names of the artworks, the art teacher poses the question of whether the Rousseau painting is about a cat or something else. Students are asked to name the objects in the picture, and nearly all students can contribute some new object or color observed to the group's list.

As the discussion continues, most students overcome their fascination with the cat and decide that the human face is the area on which the artist wanted the viewer to focus. Many see how the viewer's eye could be drawn around the picture by the placement of objects. Less than half observe (in their own words, of course) that the sober expression on the face was like the quiet, dulled colors the artist chose and those qualities give a quiet, serious mood to the picture. Even though some students think the man looks too stern (to be a father or cat lover), most mention that the painting is good because Rousseau made all parts of the painting seem to fit together well. Jamie even thinks the cat and Pierre Loti look alike because of the sober, straightforward looks on each! What art teacher would not be pleased at the amount of voluntary participation by the students and the respect they showed one another?

The students' answers indicate that they are looking carefully and thinking about how parts relate in the painting. Most answers to the art teacher's questions about what the painting means include reasons based on the painting or comparisons with the two reproductions nearby. Again, assessment of this experience is based on evidence. What the students observed and related verbally constitute the assessable criteria. The objectives were to have students observe art properties, respect opinions of others, provide reasons for opinions, and voluntarily participate in this art criticism experience.

The assessment also may be made while watching a videotape of the discussion. In either mode, the art teacher may also choose to make an anecdotal record of Jamie's association between the cat and Pierre Loti as an unanticipated learning, wondering if that might turn out to be something that occurs frequently. A teacher's log book (see Chapter 11) helps to record these events.

Let's move on to a hypothetical high school Art I unit on portraiture. Each student is asked to replicate a portrait by a favorite artist except for the face of the subject. Instead of the artist's subject, the student renders a likeness of a partner in the manner of the artist's style. The art teacher observes that this challenging assignment results in differing degrees of success. Some students grasp the idea of this artist's technical qualities and mimick them well. Some sense the color relationships and are able to duplicate that aspect. Some capture their partner's likeness amazingly well. The completed works are displayed, and everyone steps back for an overall look. As if not seen before, the grouping of the portraits makes their contrasts more evident. The art teacher is delighted to record that the unique character of each artist's work can be clearly seen in 90% of the portraits.

In addition, in reflective, short essays the students verbally describe the color relationships, likeness, and technical qualities that they replicated and reveal their empathy for the artist's way of working because of understanding the era and societal conditions of that time. Perceptual awareness and art historical understanding were goals, and the degree of achievement toward those goals is measured by what the student wrote and produced. A point system can denote the quality of the learning relative to each criterion—color relationships, likeness, technical qualities, and understanding the influences of the context on the artist's work.

Summary

These classroom examples describe some learning that art teachers might expect as the result of instruction. These expected outcomes are observable evidence of learning that a teacher can assess. Assessment can result in art grades for individual students and also be the basis for reporting to others (P.T.A.'s, school boards, community members, and fellow teachers) how groups of art students are learning in ways that meet the district and state goals.

2

WHY ASSESS LEARNING IN ART?

Chapter two provides three basic reasons to support the practice of assessing art learning. Art teachers can welcome the idea of assessment as they see the great variety of ways that teachers can accumulate information about what their students learn in art, within art lessons as well as after the lesson. Beyond state mandates for accountability, it is important to take assessment seriously because it is educationally sound to determine whether what was thought to be taught was indeed learned by the student. Also, reporting the results of careful assessment provides the opportunity to demonstrate the value of art in terms that the public understands.

Assessment of student learning contributes, among other elements, to the evaluation of the effectiveness of a school program, because it is focused on gathering evidence of what students know and are able to do (i.e., performance outcomes that have been stated as learner goals). Most teachers assign art grades to their students, but their reasons for assessing students may exceed compliance with district procedures. They may therefore want to ascertain the effectiveness of their instruction or art achievements that are not listed on grade cards.

There are three basic reasons for assessment of student learning:

• Assessment of learning in art is **educationally sound.**

• Assessment of learning in art is **required** by some states or school districts.

• Assessment of learning in art is **an opportunity to inform others** about art education.

Educational Soundness

Assessment serves four major educational purposes: (a) measuring attainment of curricular and instructional goals for student learning in art; (b) diagnosing student knowledge base and needs; (c) revising or justifying instruction; and (d) recognizing, describing, informing, and comparing student learning.

Measuring Attainment of Goals

Art goals reveal the comprehensive structure of an art program and should show how art uniquely contributes to the district goals for student learning. Stating goals is one thing.

Demonstrating that they are being accomplished requires focused instruction, observable evidence, and assessment.

Intentional, ongoing assessment linked clearly to art goals examines the curricular structure and contributes direction to improving art education. It provides a basis for refining goals and instruction. Teachers should be accountable to a school district and should provide evidence that students are meeting the district goals as they meet art goals.

Curriculum goals are meaningful when they are aligned with instruction and assessment. Any art lesson should identify some general art goal or goals to which the lesson contributes. If a student learns what the lesson is meant to teach, she or he will be meeting the general goal in some way.

Not only does assessment provide a basis for examining and modifying the curriculum and instruction, but such an examination of art education practices and student responses may reveal positive, unanticipated learnings. Depending on the nature and value attached to them, these unanticipated positive learnings may subsequently be addressed as intended goals and the objectives of instruction.

Teachers should identify goals important to art education and then seek ways to assess student learning of these goals rather than select goals or instruction to fit what is easily, or likely to be, tested. A teacher, who identifies new goals or teaches new art content or approaches related to it, also should prepare appropriate ways to observe whether students learned what they were taught. Art teachers need to investigate the feasibility of authentic methods of assessing the holistic act of responding to and creating art. This holistic act should include opportunities for students to ponder meanings, generate responses that relate and synthesize learning, and demonstrate art learning by their reflection and self-assessment or other appropriate formats

Diagnosis

Assessment helps art teachers determine existing levels at which students can achieve. If instruction is geared to knowledge or skills for which students do not have prerequisites, the educational efforts may be ineffective, and subsequent assessment is a misguided activity.

Another use of diagnostic assessment can be compared to "before" and "after" changes. Art teachers often comment on a student's "growth" in art. Diagnostic assessment before initiating learning of certain knowledge or skills provides baseline indicators for noting change after instruction. Any initial state-wide assessment of art probably should be considered as acquiring baseline data. Subsequent testings could look for improvement on that first assessment benchmark.

If students consistently have errors on certain types of items, levels of thinking, or areas of content, such an assessment suggests teaching the content or facilitating the thinking level again in another way, or assessing by other methods. Use of a variety of instruments could reveal that certain students are better able to give evidence of learning on one kind of instrument rather than another.

Instruction

Assessment is the culmination of instruction. It informs the student, teacher, district, and parents of the nature and degree of learning achieved in art education. Without periodic and continuous assessment, instruction can become directionless. Art education without assessment is much like a horse ridden without reins. There would be no cues to provide direction or reinforcement. The horse, unchecked, may go nowhere or wander everywhere in the process.

Furthermore, if not related to instruction, art assessment yields useless data (except for comparisons with other groups of students on comprehensive tests of art knowledge). Assessment results unrelated to a student's instruction would not indicate the level of achievement attainable with instruction in that content.

For young children, art teachers can include the disciplines of aesthetics, art history, and art criticism at an appropriate interest and ability level. Like any subject, the way children are introduced to and asked to think about the content varies for different age groups. Concomitantly, assessment of student learning in these art disciplines must be more innovative than traditional modes of assessment and must also be responsive to the developmental level of the students.

Assessment should be an accepted, ongoing part of the instructional process. It looks for a cause-effect relationship between goals, instruction and what students know and can do in art. In particular, *formative* evaluation (ongoing assessment) of worksheets, quizzes, checks on oral participation, or writing assignments allow for correction of temporary sources of errors in understanding—a lasting benefit for subsequent learning. At the same time, assessment reinforces conceptual accuracies through contiguous feedback.

Recognize, Describe, and Compare Learning

Assessment describes individual or group learning, summatively or over a period of time with multiple checks for the same type of learning. It provides a consistent basis for feedback about learning to teachers and to students who received the same instruction. Assessment of learning can serve as praise or reward for students, helping them to recognize their strengths and areas that need work.

Art teachers "think backwards" as they prepare to teach. They determine which concepts and behaviors students will need to experience in order to meet an outcome or goal successfully, and they plan instruction to facilitate those learning experiences. In the end, the teacher assesses student outcomes by evidence in the students' performances. This educationally sound triadic relationship allows the teacher to praise a student for specific goal-related successes when the whole task solution may or may not be superior.

Assessment can also have affective benefits, namely, rapport and trust. When teachers and students work together toward meeting goals, they develop some common values and expectations. When groups achieve their goals, that success reinforces the goals and group cohesiveness.

Honest teacher feedback enhances trust in the teacher as a critic and coach. If the assessment is based on specific evidence of growth rather than global praise, it contributes to students' positive self-concepts about learning. Accurate feedback also improves subsequent realistic goal setting and performance. If a display of student artwork includes descriptions of the concepts taught that are evident in the products, the display is a form of assessment. Then, any viewer, including the student whose work is displayed, can make a judgment as to how effectively students learned, based on what can be seen and read. Student, peer, and self-appraisals can contribute to group rapport, individual insight, and positive attitudes.

State or District Requirements

A number of states are recognizing the arts as vital curricular disciplines that must be taught in schools. With acceptance of the visual arts comes responsibility to report on what students are learning in art. Wise art teachers monitor the fulfillment of state goals for the visual arts even in the absence of a state assessment program. In partnership with those who argued for legislation

that mandated the arts education, art teachers must shoulder responsibility for demonstrating that valid learning does occur in each art classroom.

Some states have mandated the arts and are in various stages of implementing state assessment programs that include the arts. For example, when the 1985 Illinois State Assembly amended the School Code by Public Act 84-126, they legislated that the State Board of Education establish goals consistent with the purpose of schooling , which included the fine arts in its definition of areas necessary to children's continuing development. It charged local districts to meet or exceed the state goals developed for each area of learning and to establish local objectives, assessment plans, improvement plans, and public reporting procedures. In 1995-1996, the Illinois State Board of Education plans to assess art in a sample of schools at three grade levels.

There is logic in being accountable for learning in art considering the nature of contemporary society. Disciplines like mathematics and English, traditionally valued in schools, have been tested. Some even suggest that assessed subjects are seen to be important by the public. Comprehensive state tests also provide teachers with an outside measure of the adequacy of information covered in the district art curriculum.

Other institutions of society lend reinforcement to the idea of state-mandated instruction and assessment of the arts. In projecting plans for 1991-1995, the National Endowment of the Arts acknowledged the need for better methods to evaluate the quality of art education programs.

On the local level, assessment of art learning can contribute to school districts seeking state recognition of their art programs. Program recognition reflects the results of group assessment derived from records of individual student achievement. Through assessment, art teachers secure that evidence of achievement in art.

Opportunity to Inform our Communities

Persons who judge an art class may do so by very different criteria—quiet, orderliness, neatness, comfortably pretty pictures—than those used by the teacher. Consider how learning might be assessed in each of the following situations by the different individuals involved:

- The principal calls the art teacher over the public address system. Art class at that moment consists of a group of fourth graders enthusiastically planning a puppet show. Only their noisy enthusiasm is heard as a reply. By what standard might the principal judge learning in the art class?

- A parent walks into the art room and slips on a blob of papier mache. Is maintaining a clean environment part of the grade for a creative activity? By what criteria might parents assess the art education of their children?

- The district art teachers are preparing true-false questions for an art quiz for 500 fifth graders. One questions if the benefits of assessment outweigh the chance of penalizing divergent thinking of students who can think of remote exceptions to each question.

People evaluate situations based on what they think they know (e.g., art is busy work or a break from serious study). Art teachers can contribute to the reconceptualization and valuing of art education by responsible assessment. This involves reporting evidence from the variety of experiences through which students learn, such as:

1. perceptual sensitivity which builds specificity of concepts (beyond naming) and the value messages of images,

2. reflection in decision making and the intellectual connecting essential for higher order thinking,

3. responsibility for whole creations from conception to completion and verbal explanation of the historical roots and reasoning process involved.

What is worth teaching *is* worth assessing. The evidence of these claims can be assessed.

Assessment takes many forms and can be shared in many ways. Imagine an older couple, whose children are grown, wandering into a school for which they pay taxes. What do they see that suggests a good use of their money? There is a display of children's art work that attracts their attention. Is it just charming? How has the art teacher helped that display to give a picture of the authenticity of learning in art? What analytical experiences increased students' visual awareness and enabled them to know about those details that give such character to the drawing? What did students find out about how artists used their drawing tools to get certain effects? What kind of practice did they do? What did they find out by reading stories about an artist that they describe in a paragraph titled "Things I like that other artists like"? What stories did the students write about a work of art where the individual interpretations are clearly supported by characteristics observable in the art reproduction displayed ? What big ideas that the students came up with in their aesthetics discussion has the teacher audio taped and edited to have audible by the display or boldly written as posters or titles? Displays can inform viewers about the breadth of the art experiences and document the learning acquired by including evidence of the learning process in a display.

Art teachers need to use their creative imaginations to inform their communities about the richness and value of art education as a general, vital part of formal education. Documentation or assessment provides evidence that shapes the interpretations and judgments by which school programs are valued whether by official organizations or informally by the public.

Summary

Why assess art? Reasons emanate from three arenas: (a) professional education, (b) the government, and (c) the local community. *Professional education* maintains that a sound education links instruction and feedback about the effect of that instruction. The *government* maintains that a common, general education is in keeping with the democratic tradition, and evidence of progress toward that end is expected. The *local community* maintains that its interpretation and shaping of education for its children is a right; and education in a community will, within legal limits, take on the character expected. Each group expects that learning provided by its support should result in evidence of student growth in keeping with its goals.

Art educators cherish their uniqueness. At the same time, that uniqueness contributes to a precarious position in which art teachers too frequently find themselves. Few persons understand and value the uniqueness of art education as an important part of general education for all students. Art educators need to demonstrate that the learning unique to art contributes to the education of all students and that students do produce evidence of learning in art. Without assessing what students learn in art, art education will remain in a peripheral value position in formal education. Assessment provides an objective basis for the claims that arise from art teachers' hunches and chance, casual observations made daily at the scene of action in the art classroom.

3

WHO ASSESSES LEARNING IN ART?

Although many persons may be involved, the teacher of art is the primary person responsible for assessing art learning. This chapter explains some evaluation concepts relevant to assessment, identifies assessment personnel for varying situations and levels at which assessments are administered, and explains why it is primarily the teacher on whom the responsibility of assessment in art rests. It reveals some decisions teachers may face about art curriculum, instructional resources, and utilization of time in order to assess.

Students, their parents, classroom teachers, discipline specialists and administrators at multiple levels are involved in assessment procedures. Teachers of art look for evidence that students learned what was intended to be taught. School districts may want to check for across-district learning in art, and many state boards of education are implementing state-wide assessment plans. A major national effort at assessment of art learning—the National Assessment of Educational Progress in Art (NAEP, Art)—is being restructured to assess what students know about art.

Some Concepts Pertinent to Administration of Assessment in Art

External and internal

Assessment is external when the observer is not a normal part of the situation, and/or the assessment instrument (usually a test) was constructed by persons outside of the school district. Internal assessments use locally developed instruments and are usually administered by the teacher or teacher aide as part of instruction or subsequent to it.

Preordinate and responsive or naturalistic

Extending the descriptions of program evaluation (Stake, 1975) to types of assessment, preordinate assessments of student learning would be based on predetermined standards (e.g., state-mandated objectives) and typically assessed by traditional forms. Responsive assessments pick up on unanticipated outcomes or nonspecified learning. Authentic assessment is responsive and naturalistic in the sense that evidence of learning is part of a realistic task that can be observed

and documented. It is responsive to the nature of learning in art. Evidence of that learning, and means of gathering it, may differ from traditional assessment procedures and instruments. Both forms of assessments can contribute to the total valid portrayal of learning in art education.

Table 3.1 shows how combinations of external or internal and preordinate or responsive assessments can be expected for different levels at which assessment occurs. The ongoing term refers to the daily, in-process feedback that teachers obtain from students (i.e., formative assessment of learning).

Levels

Table 3.1 shows levels at which assessments are administered and the type of assessment that can be expected or may (x) occur at each level. Explanation of these relationships is given within the following discussion of each level.

National

The first National Assessment for Educational Progress in Art (NAEP, Art) is a model of external, preordinate art assessment. To develop the NAEP, Art scholars identified the comprehensive content and behaviors associated with art learning, formulated objectives that combined those two components, and identified questions that were designed to give evidence of student achievement relative to those objectives (Wilson, 1971). Assessment of knowledge about art, drawing skills, attitudes, and creativity demanded a variety of instruments. The instruments, administered throughout the United States, generated baseline information about what groups of students knew about art.

Mass administrations of external preordinate assessments allow such comparison . An advantage to external preordinate evaluation is that comparative data produced through such tests can help a district or teacher check out what art students have learned in the general content assessed. This is useful where the intent is to offer a comprehensive, common or general art education to all students.

State level

State legislatures can mandate that state boards of education conduct assessment across a state. If a state conducts testing in the arts, such mass testing is most efficiently carried out with traditional assessment instruments most commonly containing multiple choice items. The selection of content for test items is based on state goals addressing minimal achievement of what is generally expected to be taught in art programs by specified grade levels. Mass testing instruments are considered preordinate in that they are based on specified goals, and expected evidence of learning is decided prior to visiting a particular situation. The specific curriculum, circumstances, or unanticipated learnings of each school art program are not considered. Developers of such tests strive for comprehensiveness, but can only take small samples of the content categories selected. They may be administered by videotape, district personnel, or teachers (who serve as the arm of the external evaluator as they read given instructions exactly).

States that assess learning in the arts should develop an assessment instrument that is based on theoretically sound principles, but should also allow districts to shape their art curriculum and to develop local assessments to exceed the state recommendations. A comprehensive state test provides teachers with an outside measure of the information covered in the district art curriculum and is useful in determining the normative body of knowledge that the student has built.

An underlying concern about a state-wide test is that teachers may feel inclined to address information likely to be tested. Ebel and Frisbie (1986) write that, in addition to spoiling the test as a measure of learning achieved, teaching to the test is not educationally beneficial to the student. However, an important distinction is made between teaching to the test that is "attempting to fix in students' minds the answers to particular test questions..." (p. 4) and "...teaching material *covered* by the test (attempting to give students the capability to answer questions *like* those in the test on topics covered by the test)" (p. 4). Ebel and Frisbie declare that attempting to fix answers in students' minds is thoroughly reprehensible, but maintain that teaching material covered by the test and the capability of answering similar questions "reflects purposeful teaching" (p. 4). If district art objectives are modeled after state objectives—the basis for state assessment—and district art objectives are met through the art encounters, then students are taught what the state assessment covers. This is not the same as teaching students to correctly answer *the* questions on the test.

The prospect of state-wide assessment brings up the question of equity due to district or regional differences in available teaching resources such as equipment, films, reproductions of works of art, library books, videos, or art curriculum texts. Also, parental values and economic levels are sources of life experience differences in student learning for individuals and communities. A rich environment is conducive to learning as it develops a broader base of information for relating and synthesizing ideas. Higher order thinking cannot occur without a factual base (Gagne & Briggs, 1974), and creativity does not emerge out of a vacuum (McFee, 1970). Accommodating unavoidable regional differences would seem to make mass tests geared to a lower level of acceptability than many art teachers expect.

School District

Districts may include K-12 grade levels in one or multiple schools (unit districts) or include either elementary or secondary schools in a particular area. Depending on the size and nature of the district, planning an assessment program in art may be primarily the responsibility of the one art teacher, or there may be a fine arts (music, art, drama, dance) assessment program-planning committee chaired by an art(s) consultant, art(s) supervisor, or district curriculum coordinator. Districts may be mandated by their state board of education to have common district-wide assessments in addition to state or more individualized assessments. Some art assessment may be done entirely by individual art teachers.

It is a good idea to involve other educators or interested persons in assessment plans especially if such planning is left up to the art teacher or an art consultant working with elementary classroom teachers. Persons should be selected to serve on a district assessment program planning committee who represent school administration, parents, classroom teachers and resource persons. A two-tiered committee of members and advisory consultants could work well. The major responsibility would fall to the arts specialists as designers of the assessment instruments. The advisory consultants could attend meetings and be asked for input on specific points discussed at a designated meeting or on an impromptu basis. The arts supervisor/consultant, specialists, or a designated art teacher committee may choose to articulate the district art goals, content areas to be taught, and common content to assess by a variety of methods. In large districts where diverse populations and mobility of students or teachers are factors, this kind of communication in planning and tracking of instructional effectiveness is the basis for understanding, support, and good continuity in art education and the assessment program.

Building or department

A less common level of assessment can exist where departmental assessment procedures are instituted. This is particularly advisable where several teachers instruct multiple sections of a

course which is prerequisite to other courses. A principal and teachers in one building may choose to plan assessment of some common goals, such as behaviors or kinds of thinking that are valued by the teachers or community. Either of these cases suggest internal, preordinate assessment of learning, but they could also be responsive in nature if the planning group agrees to the concept and individual teachers plan to gather that kind of data.

Individual teacher

In a conversation with an art teacher, the prospect of assessment in art came up. " When we do get to assessing art, whoever is..." the art teacher started, but broke off, then continued "Well, I guess that will be my responsibility." How right she was, and how fortunate to perceive her role clearly! Art teachers everywhere have the opportunity, through assessment, to demonstrate the value and effectiveness of art education.

Art teachers must be accountable for students accomplishing the carefully considered objectives formulated in line with district and state goals for art education. Where small classes make it feasible, advanced students may plan art goals and criteria for assessing their achievement jointly with the teacher. Art teachers' assessment of art learning, in response to specified objectives, is internal and normally preordinate. In spite of efforts to provide a common equitable education for all students in a district, each art teacher, each class, each situation, and each student introduce variables that may modify recommendations for assessment of art learning. This freedom to teach and assess is cherished and vital to meaningful learning.

Art teachers are, continually, responsive evaluators of art learning. They are alert to on-the-spot signs for appropriate redirection of a lesson or introduction of a different art historical exemplar. They elicit feedback or informal verification that indicates success:

- The way a child persists in working out an idea,

- An extended explanation with reasons observable in the art work,

- Anticipation written all over the faces of the class,

- Incorporation of students' good ideas to come up with a comprehensive, true statement about the nature of art,

- Notes on "think sheets" or journal entries, or

- The originality of the surprise picture assigned.

Do these things happen just once? Do they happen for all students? Only the art teacher, sensitive to these nuances of the art class, can determine how to tap their potential for making a statement about learning in art. Only the art teacher can have a sense about how to set up situations where positive moments are encouraged for all students and all are given the "green light" to respond. Keeping tabs on those responses on a day-to-day basis can only be accomplished by the art teacher who knows the students, knows what is expected, is present to recognize a quality of response when it occurs, and, by practice, has learned how to record such moments.

Any teacher can reasonably expect a temporary disruption of one's comfort zone when accepting new challenges, but there is a revitalizing effect that accompanies the positive results of good planning and assessment, to say nothing of the respectability of having sound evidence of students' learning in art.

Table 3.1—Types of Assessment Occurring at Levels at which Assessments are Administered

	Type				
Level	External/ Preordinate	External/ Responsive	Internal/ Preordinate	Internal/ Responsive	Internal/ Responsive Ongoing
National	x				
State	x				
District	x	(x)	x	x	
Building/Department		(x)	x	x	
Classroom		(x)			x

Involving Others in the Assessment Process

Students and teachers who produce and collect evidence of learning in art are the primary players in assessment. Others—administrators, parents, and board members—are frequently involved in educational performance monitoring (Henry, Dickey, & Areson, 1991; Weiss, 1986). Persons who share ownership in the assessment process share commitment to its purposes. The composite of viewpoints of all persons involved in assessment contributes to (a) goals or standards, (b) authentic experiences by which to achieve outcomes, (c) multiple indicators of performance, and (d) the use of assessment to improve learning through curricular and instructional evolution.

Administrators

Art teachers can help administrators to keep art education a front-line priority by tactfully sharing updated conceptions and rationale for art in general. Art teachers should explain that current conceptions of assessment—performance-based, authentic, holistic, portfolio—are particularly suited for art education today.

Administrators, particularly principals, can support art programs if they understand the current objectives. Some theorists propose cooperative planning between teachers and administrators with each party bringing expertise of a kind to the encounter to facilitate better understanding. The informed principal realizes that certain factors work in favor of successful assessment programs. Weischadle (1978) recommends "bottoms-up" planning with the principal being the key player, but involving the teachers in decisions. The principal orchestrates change that often comes down from higher levels of influence and needs the confidence and trust of teachers who will contribute to the effectiveness of the school goals.

To succeed, there must be an institutionalized commitment to assessment as an ongoing part of education. As such, an assessment infrastructure compatible with the goals being assessed must be supported. Resources for instruction are necessary as well as resources and time to prepare for, conduct, and summarize the evidence of learning accumulated. Assessment of art education may mean requesting released or paid time for staff planning

and training. Administrators need to know that art teachers have these needs related to assessment.

Parents

Informing parents about art and contemporary art education, including assessment, can increase their support of it. Parents bring conceptions based on their recollections of art to the parent conferences, parent organizations, their volunteer work at school, or their child's art work. An art teacher, either through the child or directly, also educates the parents of each child, even though the parents are not gathered together in class as are their children. When a teacher takes the time to help students reflect and verbally formulate their ideas about art, the students are better prepared to convey the meaning of their art learning to others. This adjustment of priorities supports the motto "Teach less, better" because an in-depth approach necessitates reallocation of time and priorities. Thus, a teacher may elect to plan fewer "projects" but increase their meaningfulness.

Involving parents can contribute to their appreciation of a new conception of art education. Parents serving as what has been known as "picture ladies" can be invited to cooperatively agree on works of art that can be integrated with the art education lessons. Teachers can gently coach these parents into expanding their approach to works of art if necessary, and then let them assist in gathering data about student responses to works of art.

Parents serving as teacher aides can share in discerning and recording those subtle, but valuable evidences of learning to which the teacher has alerted them. The teacher involves the aide in recording frequency of types of statements made by students in a discussion of an art reproduction. The aide might work with a small group completing a worksheet on art history and report observations in a log book or conference with the teacher.

An aide, having witnessed the art teacher's guidance of an art criticism experience with a reproduction, could repeat that role for students who were absent or code students' video-taped participation. An aide could videotape an art history time-line activity for later content analysis with the teacher. This same activity, edited and combined with other videotaped classroom events, could be shown to a parent-teacher meeting.

A back-to-school night could feature students conducting discussions with their parents about works of art or reproductions around the classroom.

Videotaped art criticism experiences are effective means of helping people gain a new conception of what art education involves and the kind of real life assessment that such an activity provides. Parents are impressed by the insightful student responses to works of art, responses that are elicited by well planned teacher questioning. An explanation of the assessment criteria and recording process will convey the value as well as the personnel and time needs to conduct authentic assessment.

Students

Students' cooperation can be enlisted in assessment for teacher/student product evalua-tions, self-evaluations, individual logs or diaries, group project evaluations, sketchbook notes (visual and verbal), student-marked tallies for type of participation or completion on charts, and student helpers in other ways as art teachers imaginatively see fit. Students can

become accustomed to the fact that formative assessment serves learning and is a part of it. They can grow to regard assessment as a means to learning rather than a letter grade.

Students can be consulted in forming criteria that are appropriately used to assess their achievement. They can self-assess in narrative form or use rating scales if the criteria and ratings are clearly defined. Knowing the criteria while working on an activity contributes to student learning.

Summary

Whereas assessment in art has been conducted at the national level and is being conducted at state levels, it is the local school district level at which meaningful assessment is most feasible. The individual teacher assumes principal responsibility in this process. At the same time it is advisable to involve the other concerned individuals—administrators, parents and students—so that they understand the purpose and benefits of ongoing, broad-based assessment and to enlist their support and help. Educational accountability must work without alienation (Weischadle, 1978) and because of the concerted efforts of enlightened administrators, dedicated and informed teachers, concerned and open-minded parents, and curious and cooperative students.

4

WHAT CAN BE ASSESSED?

This chapter reviews some recognized categories of art content and behaviors and proposes cross–disciplinary art behaviors that can interact with the content of art education to guide comprehensive curriculum planning, instruction, and assessment. In addition to the accumulation of facts and production capabilities, teachers may assess other important learning, such as, classroom behaviors, attitudes, effective synthesis in art work, initiative, complex thinking skills, visual sensitivity, and understanding the "roots" of art.

What do art teachers want to happen as a result of students' formal education experience with art? Would they want to assert that their students

- Know about art and artists ?

- Show competency in use of art tools, equipment, processes, techniques?

- Effectively give visual form to ideas ?

- Differentiate visual qualities of the natural or human–made environment?

- Actively participate in all art activities ?

- State relevant reasons to support positions about art issues ?

- Are perceptive in analyzing works of art and interpreting their meanings?

- Show positive attitudes toward art and the relevance of art in life?

- Are curious, inventive, innovative, reflective, open to new ideas ?

- Clearly express ideas, orally and in writing, about art ?

- Relate and synthesize ideas in art discussions or creative art production?

Most art teachers say "yes" to all of these possibilities. While this list was not designed to be comprehensive, it does include art information and art behaviors that are commonly addressed in art teaching.

Content

Content in art is the subject matter or information about which students learn and think. Figure 4.1 suggests the content focus of each art discipline and inquiry–process behaviors that charac-

...ize persons primarily involved in each discipline. Persons associated with *each* discipline use concepts related to the elements and the principles of art to describe qualities of and interpretations of works of art; but these are enabling concepts.

Figure 4.1—Art Content and Behaviors Addressed in Art Education

ART HISTORY	ART CRITICISM	AESTHETICS	ART PRODUCTION
Content			
artists	journalistic	questions	media
art works	pedagogical/	issues	tools
eras, dates	academic	theories:	equipment
countries	scholarly	imitation	processes
styles	popular/	expression	techniques
art world	personal	formalism	concepts:art/
influences:		social institution	life/art forms
political		pragmatism/	
social		instrumentalism	
economic		non-western	
geographic		anti-theory	
philosophic			
Behaviors			
establish docu-	describe	reflect	set a direction
mentary facts:	analyze	compare	discover
attribute	interpret	contrast	visually analyze
describe	judge, evaluate	relate	classify
reconstruct	speculate	synthesize	personalize
interpret:		question	hypothesize
intrinsic/extrinsic			reorder
explain influences,traditions			synthesize
discover regularities			evaluate

Note: Art historians, critics, artists and aestheticians all make reference to the *sensory qualities of elements, formal principles, and art technical aspects.*

Disciplines of Art

Four major disciplines contribute to the content of art education—aesthetics, art criticism, art history, and creating art. Within each exist many content subdivisions which art teachers can introduce to students throughout the K–12th grades.

Aesthetics

Aesthetics is a philosophic discipline that addresses questions about the nature and value of art, and other art–related issues. Aestheticians seek to clarify concepts used in discussing art, the aesthetic experience, meanings, artist's intent, and circumstances that bear on claims that an

entity is "art." In simplified language forms, even young children can use their concrete visual experiences in art to identify major explanations about what art is. They can know that there are multiple answers to the questions "What is art?" and "Why is art important in all times— present and past?" Young children can also discuss in simplified ways the kinds of issues that aestheticians debate. Synthesizing from their concrete art experiences, they can verbally express big ideas or general truths about art at their conceptual level (Armstrong & Armstrong, 1977). Older students can associate theorists with points of view on aesthetics issues or themes. Depth of experience in art contributes to the ability of older students to begin to formulate personal philosophies about art.

Art Criticism

Art criticism is examination of works of art to perceive them fully, understand their meaning, and judge their merit. Careful description and analysis enable interpretation of the meaning and making judgments about a work of art. From the study of art criticism, students at secondary school levels can read and categorize types of art criticism differentiated by Feldman (1967) as personal, academic or pedagogical, journalistic, and scholarly. Older students can study certain contemporary critics and works of criticism. Students of all ages can know basic questions to ask themselves to aid in looking at art critically, resulting in intrinsically supportable interpretations and judgments .

Art History

Art history focuses on contextual information about works of art across time and cultures— who made it, where, why, under what conditions or influences, and so forth. Contextual information helps students relate art to geographic conditions and the influences of political, economic, social and philosophical institutions that are common to all evolving cultures. The contextual information, although extrinsic to the work of art, can enhance one's interpretation of its meaning. Recognition of contextual influences can extrinsically inform and enhance interpretations of works of art. Art history helps students organize knowledge of their art heritage and contemporary art world by periods, styles, countries, regions, artists, and time. With art history content, students can recall important names and dates, and, as Gagne and Briggs (1974) point out, knowing these kinds of factual information is a necessary prerequisite for higher order thinking. At the other extreme, valid generalizations about art can be facilitated by attention to across–time and cross–cultural comparisons of common themes in art.

Creating Art

Through experiences in creating art, students learn information about the characteristics of visual art forms—such as sculpture, painting, drawing, photography, printmaking, fiber arts, ceramics, jewelry, architecture, design, and the media, tools, equipment, processes, methods, techniques and facts associated with each art form. Students also learn about artists and their ways of working. This repertoire of information related to the content area of creative art production facilitates choice in the student's art production and his or her response to works of art by others.

Other Content Areas

Art Vocations and Avocations

Besides the four content areas of art education, information about art careers is frequently learned by children in connection with their study of community helpers and other art–related

work that people do. Students learn about full–time artists and others for whom art is an avocation. They learn about persons untrained in formal art schools, whose art making arises out of cultural, religious, ethnic, folk, or family traditions. Older students learn the nature and educational needs of various art careers in an industrial and information society.

Art Institutions

Students learn that people study for careers in art. Older students recognize the institutions that are included in the "art world" and that help support it. They recognize that art museums preserve art and artifacts for their aesthetic qualities; that foundations, endowments, museum memberships, and taxes support public art institutions; that galleries promote contemporary, folk, thematic, ethnic, or historical showings of art; and that alliances or other advocacy groups lobby for governmental support of the arts.

The Contributing Role of Elements and Principles of Art

Generating, or understanding, encompassing ideas or meanings of art—the ultimate end of art education—involves knowledge and facilitating behaviors. Elements of art (e.g., line, shape or form, texture) and principles (e.g., unity, balance, movement) by which the elements are manipulated in organizing works of art, are part of the language of art. There are specific concepts—simple to complex—related to each element and principle that may be taught as enabling concepts as they contribute to meaningful employment in problem solutions. Taught in isolation, they are purposeless. Nor should they be the *focus* of goals, instruction, nor "authentic" experiences in art education. Furthermore, since the Western principles of design, composition, or organization of works of art are not an issue in many cultures, one cannot automatically expect to observe them in all artwork.

Behaviors

Intellectual Skills or Levels of Thinking

In each discipline, content can be addressed at different levels from memorization of simple facts to comprehension of complex concepts and higher order thinking such as hypothesizing relationships or forming principles or generalizations. Hierarchies of thought such as the cognitive domain (Bloom, 1956) and information and intellectual skills outcomes of education (Gagne & Briggs, 1974) affect assessment. Chapter 5 explores hierarchies within categories of behaviors that can be developed by an art education.

Inquiry as Cognitive Behavior

Students can be taught approaches to dealing with content that contribute to creative thinking. How many art teachers are dismayed by scenes like this:

> Ev (showing a careless, very incomplete picture) : "I'm done, teacher!"
>
> Teacher (wanting to encourage a more complete visual statement): "This is a good start, Ev, but you have twenty minutes yet to put many more ideas in all this space in your picture!"

This art teacher has some idea of the benefits possible by spending thoughtful time in pursuing the problem given. Students need to learn that slower, more thoughtful procedures can benefit art work (Packard, 1973).

Inquiry approaches refer to the way art education role models approach creative work, rather than what they produce. Artists, aestheticians, art historians and art critics write about the way they go about looking at works or thinking and preparing ideas for works of art.

Artist

Taking cues from the artist role model, art teachers encourage many preliminary sketches to forestall premature closure on an idea. An apprentice is apt to mimic the behavioral characteristics and approach of the master artist—looking closely at everything visual; experimenting with strokes, colors, and shape variations; reordering a whole visual statement; and evaluating the success of the work of art that results.

Research on inquiry in art production (Armstrong, 1986) identified behaviors that are involved in creating art based on writings by artists about their process. Artists have a set or inclination to act (an attitude). Their visual awareness—discovering, analyzing, and classifying visual qualities of phenomena and objects—built concepts or ideas throughout their lives as well as when they want to examine something particularly. Artists reflect on their personal natures, viewpoints or preferences. They find problems to address, and use both convergent and divergent thinking as they hypothesize ways to address the problem uniquely or give form to their individual ideas. Artists change and reorder their work as a result of reflection and evaluation during its development. They synthesize all of their relevant experience in a visual statement—the work of art.

Subsequent to the decision of completeness, artists continue to evaluate, and from that evaluation, may change the work, destroy it, move on to another idea related to the first, or change the direction of their work. The Inquiry in Art Production behaviors that an art teacher encourages are:

• Setting a direction,

• Looking generally, then analytically,

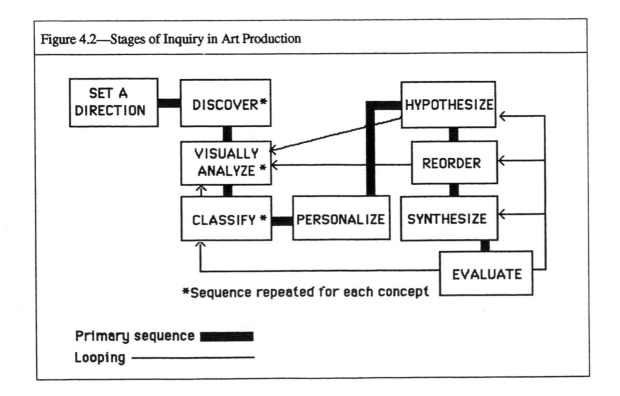

Figure 4.2—Stages of Inquiry in Art Production

• Classifying by visual attributes to form concepts,

• Personally reflecting,

• Risking action on an educated hunch or hypothesis,

• Reordering and changing,

• Modifying and synthesizing, and

• Evaluating.

Figure 4.2 pictures the general progression through these behavioral stages, with recognition that looping occurs within the sequence.

Work by Gardner (1989) suggests that art teachers encourage reflection on preliminary ideas. Reflection is an approach to handling information in any of the content areas of art, but in reference to the student's creative process on making works of art, it can mean figuratively stepping back from the work to ask "What?" "Why?" "How?" and "Where?".

Art Critic

Art teachers encourage the inquiry approach of the art critic as they engage students in discussions of particular works of art. Young art critics must discern the subtle as well as the obvious details, symbolism, and organization; interpret the meaning; judge the merit of works of art (Feldman, 1967); and possibly, speculate beyond that work (Hamblen, 1986). Obviously, young children do not have the cognitive maps nor capacity for synthesizing abstract principles of art criticism. But they can organize their perceptions in order to read the meaning of art works. Teachers encourage students to look closely at or analyze a work of art to see important details and relationships that could influence the interpretation. They encourage critical thinking, that is, substantiating interpretations or opinions with reasons that are observable.

In creating a painting of a stormy day, for example, two students may make a stormy sky different basic colors, one having observed a Turner or an El Greco and the other personally observed a yellowish pretornado sky. Wilson (1988) could be describing the inquiry process skills of the student art critic or creator when he writes:

> Works of art do not become works until they are worked—until they are understood. It is this process of unpacking, reworking, recreating, performing, interpreting and understanding that is the essence of arts education in general education. (p. 28)

Art Historian

Students can engage in age–appropriate research behaviors of an art historian. Art teachers encourage students to be curious as art historians are when persistently seeking information about where, when, and why works of art or periods of art occurred. They explain the contexts that gave rise to art and provide a broader understanding of how the art related to the world at the time it was made. They classify works of art by style, media, period, location, time, and so forth. Older students can learn how to ferret out illusive information from documents, contextual data, artifacts, personal accounts, and works of art themselves (Erickson, 1983). For young students who do not conceptualize time abstractly, time–lines and art reproductions might be color–coded so they could, by concrete spatial differences, demonstrate "time" by placement of objects in color spaces from the present. They could formulate general statements about influences on art at different times from observations of like characteristics of works that are placed in close proximity to each other.

Aesthetician

Philosophers of art combine taking intellectual risks with caution and reflection about art. They risk dead ends as they hypothesize answers to questions about the nature and value of art and analyze their tentative answers for coherence and completeness. They look for differences and relationships between theories that seek to explain and define art. They seek answers to challenging questions about other art–related issues. Aestheticians synthesize ideas. They check out tangents for possible logical flaws or inconsistencies, and attempt to produce general, true, and satisfying answers.

In aesthetics dialogues or seminars, students reflectively consider issues, and relate and synthesize ideas into tentative comprehensive generalizations or big ideas (Adler, 1982; Armstrong, 1990a; Stewart, 1988). They can respect opinions of others in talking about art issues or puzzles (Battin, Fisher, Moore, & Silvers, 1989). They can be reflective about and explore reasons for the variety of things called art. They can learn to support their opinions with reasons that are observable in art (Stewart, 1988).

Art teachers encourage other inquiry approach behaviors of originating, innovating, relating, analytical looking, reflecting, elaborating, risking, experimenting, rearranging, persisting, and being openminded. They encourage students to express perceptions or conceptions visually, orally and in writing, and to synthesize. Concern for development of inquiry behaviors is shared by art education models (Armstrong, 1986, 1990b; D. J. Davis, 1971; Greer, 1987). *Inquiry* behaviors are basically cognitive strategies (Gagne & Briggs, 1974) or approaches to handling information. Others describe similar ideas as thinking skills, creative process behaviors, higher order processes, inquiry skills ... each with its own specific definition. Cognitive strategies refer not to thinking at some low or high level, but to the approaches to thinking of, or inquiry about, visual information. Higher levels of thinking are, however, facilitated by valid inquiry approaches.

Manipulative, Motor Skill Behaviors

Muscular activity enables students to produce evidence of learning whether it is control of a drawing tool or formulating the words, sounds, or gestures that communicate an interpretation of a work of art. To be appreciated, students must give form to creative ideas. A student's well–developed motor skills enable others to see through the eyes of the artist, whether that art form is graphic, three dimensional, oral or written, sound, gestural, or kinetic. Students learn techniques in order to choose the most appropriate by which to give explicit form to an idea. Students use art tools and equipment in ways consistent with their engineering. Good control in the use of media, tools and equipment contributes to good craftsmanship both in the forming and finishing of the work of art.

Social Responsibility Behaviors: Interact/cooperate

As a rule, art education occurs in group situations; this is an important difference from most adult artists. It means that students need to learn a balance between cooperation and independence. They become responsible for sharing and care of tools, equipment, facilities, and space. They are taught to be respectful of differing views or capabilities and tactfully express opinions or observations. Stufflebeam (Brandt, 1978) maintains that evaluators should look at, social, physical, vocational, affective, and aesthetic development areas in addition to cognitive development.

Affective Behaviors

Art attitudes are internal states that effect choices students make. These attitudes are positively influenced by success experiences.

Art Appreciation

Art appreciation involves both knowledge (information) and attitudes (values) outcomes. Appreciation starts with a willingness to attend to works of art or participate in art experiences. Works of art present viewers with morals and values shared across time and cultures through visual imagery as well as starkly contrasting values. Art students should demonstrate openness to uses and conceptions of art different from their own The students should show acceptance of a variety of portrayals of themes and events. Students value the role of art in society: its functions, institutions, careers, communication, and public enlightenment.

Aesthetic Growth

Art students reflect the values of their homes and the degree of exposure to art that exists there. With opportunities for open discussions about art, students' perceptions and demeanor should be characterized increasingly by a love of art. Enthusiasm in art classes should extend to self–initiated, outside–of–class participation in arts events.

Certain situations allow teachers to observe positive aspects of students' aesthetic growth. In a society of planned obsolescence and convenience packaging, evidence of persisting, maintaining, restoring, and cherishing suggests student aesthetic attitudes. In an increasingly multicultural/multiethnic society, expanding interest in and the ability to relate to art of other cultures indicates aesthetic growth.

Consolidation of Basic Art Behaviors

Art education is more than absorbing content. It is also important that students experience real–life art behaviors and recognize their value. Many educators and art educators have identified similar categories of behaviors that should be considered when planning art experiences and instruction (Armstrong & Armstrong, 1977; Armstrong, 1986; Bloom, 1956; Davis, D. J. 1971; Gagne & Driscoll, 1988; Kibler, Barker & Miles, 1970; Krathwohl, Bloom, & Masia, 1964; Wilson, 1971,1988). The commonalties between these hierarchies of behaviors, plus the behaviors associated with the art disciplines, are the basis for a consolidation into seven visual art–related behaviors (See Figure 4.3). These behaviors are: Know, Perceive, Organize, Inquire, Value, Manipulate, and Cooperate/Interact.

Know, Perceive, Organize and Inquire are predominately cognitive in nature. Value and Cooperate/Interact involve inclinations, attitudes, and feelings that are affective. Manipulate encompasses the motor skill development that enables students to give concrete form to their ideas.

Identifying art–related behaviors helps the teacher teach for different ways in which students learn the content of art (elements and principles; tools, media, processes; artists, historical periods of art, and theories of art) through the behavioral approaches employed by art historians, art critics, artists, and aestheticians as they inquire in their fields.

Know

Because knowledge is covert, a teacher can assess such knowledge only when students overtly say, point, match, draw, or otherwise show what they know. Examples include:

Figure 4.3—**Comparison of Basic Art Behaviors with Other Classifications**

Basic Art Behavior	BLOOM (1956) Behavior Domains	D. J. DAVIS (1971) Art Behaviors	GAGNE/BRIGGS (1974) Outcomes of Learning	WILSON (1970) Behaviors for Art Education
KNOW	Cognitive knowledge	Knowing language	Information facts, names artists principles	Knowledge facts, terms, conventions sequences, methods, classifications theories generalizations
PERCEIVE		Perception	Intellectual skills discriminations, differentiate	Perception within/between artworks
ORGANIZE	comprehension application analysis synthesis evaluation	Analytic classify, describe, explain, interpret Execute produce art forms Judgment or Evaluation	conceptualization rules or principles higher-order rules or generalizations	Comprehension Analysis relationships Evaluation
INQUIRE		Execute flexibility, fluency, originality, elaboration	Cognitive Strategies innovative thinking	Production creativity
VALUE	Affective receiving responding valuing organization of a value complex	Reacting Valuing-attitudes characterization by a value complex	Attitudes personal preferences social interaction societal responsibility	Appreciation empathizing, feeling valuing
MANIPULATE	Psychomotor	Execute	Motor Skills use tools, materials	Production skill
INTERACT/ COOPERATE	Social development is included in categories that could be evaluated besides cognitive behavior by Stufflebeam in an interview with Brandt (1978).			

- Students list the steps of the coil method of hand–building pottery.

- Students recall and verbally define facts, concepts, processes, and rules.

- Students name the media for which a tool is designed.

- Students select Impressionist artists' names.

Perceive

Developing visual perceptual awareness is basic in art education. Assessment is possible when students describe differences they see or draw details observed. Perception is an enabling behavior, providing a source of visual data that contributes to higher levels of creation, interpretation, and decision making. Teachers do not assess every small perceptual ability unless subsequent learning is dependent upon it, and then it would appear as part of the instruction. Examples of perception include:

• Students notice how things look.

• Students recognize and name what they observe visually in nature and art.

• Students look closely to analyze differences, qualities, or attributes in nature, artworks, and the effects of media and tools.

• Students describe the visual qualities that contribute to certain effects.

Organize

The generic category "organize" refers to the hierarchical mental processing of visual information. It encompasses coding or classifying information to comprehend ideas (concepts); forming concepts; applying what is learned; relating concepts; synthesizing and generalizing from information, concepts, and principles; and evaluating results. It includes such activity as hypothesizing what to incorporate in creating works of art; analyzing the composition of, interpreting, and judging works of art; formulating rules that help one to classify art into certain periods; or coming up with a big idea about art in life that is true in many cases. A teacher recognizes organization when

• Students comprehend art ideas at different levels from simple to complex.

• Students understand or form concepts, that is, ideas, by separating one item, process, thought, or rule or by summarizing an idea from another item, process, thought, rule, or summarizing idea. For example, students would classify all the "perceived" visual attributes of a Dalmatian to separate that breed from a Doberman and use the verbal label for the concept "Dalmatian" correctly.

• Students explain or form rules or principles (incorporating information or knowledge into rules that exist in nature or art, such as, the principles for creating an illusion of depth on a flat paper).

• Students relate concepts learned to form general, big truths about the nature or characteristics of the visual arts and artists. Generalizations must connect several concepts or principles meaningfully and, for young children, must be based on concrete experiences.

• Students compose works of art that effectively demonstrate solutions to a given problem or a student–defined problem.

• Students self–assess the quality of work produced based on criteria.

Inquire

The cognitive inquiry behaviors are critical to art. They lead to self–learning and independent thinking. The approach to handling information determines innovations. Certainly an education in art demands behaviors such as experimenting, being curious, flexibility, thinking divergently, withholding premature judgment, reflective thinking, and critical thinking.

Instruction can encourage a variety of approaches to creative thinking and assessment can measure their success. Also, the type of mental process students *expect* to be tested on will

influence their method of study and preparation. If students are to develop and demonstrate creative problem–solving abilities, they need practice in encounters that encourage those approaches to handling visual information and experience in assessment techniques that show their accomplishment. Teachers may observe that

- Students are flexible in their thinking and willing to change to more promising directions.

- Students reflect before answering questions.

- Students experiment and resist the urge for premature closure on ideas or problem solutions.

- Students elaborate on ideas and images.

- Students are curious and probe for more information or other approaches.

- Students seek original solutions and ideas, but may combine familiar ideas or images in new ways.

- Students support opinions with relevant reasons.

- Students are open–minded and entertain multiple possibilities.

- Students think divergently, coming up with many "right answers."

Value

Traditionally art education has encouraged students to be sensitive to the visual beauty that surrounds them in the natural and humanmade environment as well as in artworks or artifacts created by humans. Artists are also students of human nature, capturing the human moods and nature in the artworks. Teachers observe and assess evidence that their students emulate the affective nature of persons involved in the disciplines of art by noting when

- Students describe out of school experiences with art.

- Students choose to participate in art beyond the requirements.

- Students respectfully regard their own and others' artworks.

- Students show interest in discussing ideas about art.

- Students initiate ideas about artworks being discussed.

Manipulate

"Manipulate" refers predominately to the forming or constructing aspects of art production (as opposed to the mental organization of ideas and ways to present them). A line can only be expressive if the student effectively controls the media and tool in producing that line. Here, it is not the idea that is being assessed, but the student's coordination and dexterity. It is the way that the students follow procedures for handling media to accomplish a variety of ends. Generally, students demonstrate skill in the control of media and tools as they experiment with and use those tools and media in creating art. For example,

- Students build the clay wall of a piece of pottery with consistent thickness.

- Students make fine parallel strokes having equal spacing with pen and ink.

- Students crayon sufficiently heavy and with consistency for a resist.

- Students cut their linoleum block accurately according to their design.

Cooperate/Interact

Whereas art education has long stressed individualism as an appropriate artist characteristic, many art careers and visual arts ventures depend heavily on the cooperative efforts of artists and between artists and people in other walks of life. Furthermore, groups of art students must each individually assume such responsibilities as sharing and caring for tools, materials, and common work spaces. Group critiques or aesthetics dialogues demand a semblance of order, and profit from respectful interaction between students. Encouraging student–to–student interaction and cooperation between students contributes to meeting art goals. Examples of desirable "cooperate/interact" behaviors include:

- Students follow the clean up procedures posted in shared areas of the classroom.

- Students make constructive comments about each other's work and opinions expressed.

- Students build ideas together when appropriate.

- Students properly care for tools and materials shared by other students.

Summary

The content of art and art–related behaviors are both involved in forming outcome statements or goals, guiding instruction, and assessing evidence of learning. Comparison of art behaviors associated with art disciplines as well as behavior domains, outcomes, and art behaviors identified by educators in the past led to a consolidation of seven basic art behaviors—know, perceive, organize, inquire, value, manipulate and interact/cooperate. These art behaviors can be observed and assessed.

5

WRITING ASSESSABLE GOALS FOR STUDENT LEARNING IN ART

The previous chapter identified the content and behaviors to teach in art education. Chapter Five compares these expectations with the context of mandates from state legislatures and boards of education, the profession of art education, teacher preparation and resources. The levels within each behavior category at which students can perform are also described as well as the necessity of expressing outcomes or goal statements operationally, that is, in words that convey what students will do that can be observed by others to demonstrate their learning in art.

Contextual Considerations

Standards that directly or indirectly influence art goals originate from several sources:

- The content and behaviors of art.

- National, state, or district educational aims.

- Professional organizations.

- Other persons or organizations associated with the world of art education.

General Education Goals

Goals or standards may be mandated as minimal expectations for student learning and backed by state legislation. Mandates from state boards of education vary from general objectives for all subjects to sample student objectives in each subject area. Some are aimed at instruction or programs, and some focus on observable behaviors or outcomes of learning.

Art teachers can systematically evaluate the compatibility between their existing art goals and state and/or district general education goals by means of a chart or grid as shown in Figure 5.1. One criterion for evaluation of art goals proposed by Efland (1974) is that they contribute positively to the community's concerns for how students should benefit from their schooling. Support of the aims of the school or state can be demonstrated if general educational goals for student learning have been specified, and art goals (state, district, or personal) are also entered

on the chart. In seeking the relationship between general and art goals, ask: To which general education goals for student learning does this art goal (or one that could exist) contribute?

It is not necessary to have art goals contribute to every general education goal, but there should be coherence, that is, the art goals should generally fit well with the school goals. It should be clear that art makes an important contribution to meeting school goals and, therefore, it has a rightful place in the school. Teachers can phrase art goal statements with integrity that also conform to criteria expected for district approval.

Professional art education standards and recommended goals

The National Art Education Association (1984) formulated goals for art education programs. They specified that an art education consists of the study of four content areas—art production, art history, art criticism, and aesthetics. The Getty Center for Education in the Arts (1985), promoting Discipline-Based Art Education (DBAE), has emphasized a balanced attention to these four disciplines. The final document, The National Visual Art Standards, contains standards that use the above 4 components. State art goals, outcome statements, or objectives could also be the art goals model.

Even if an art teacher chose to use a set of professional goals as is, the goals grid comparison (Figure 5.1) can lead to writing subgoals, combining or adding goals, or specifying goals more clearly because of this process. When goals focus on a category of content and observable behavior, evidence of learning can be expected and assessed.

Efland also recommends that art goals should emphasize the uniqueness of how an art education meets district goals. The wording of art goals makes it possible to demonstrate that uniqueness. In Figure 5.1, the sample local art goals are modeled after the professional goals and worded so that it is clear that students meet the general education goal through art experiences. Words like "visual," "imagery," "works of art," "art," "art production," "value of art," and "in art" focus attention on the specific content introduced and on the unique experiences leading to the outcomes indicated through art education. The placement of the local art goals in Figure 5.1 also indicates their compatibility with general educational goals and professional standards.

Context of School, Teacher Preparation, and Resources

Art learning occurs in a number of contexts within formal schooling. Although art should be taught as a special subject by certified art teachers, it may sometimes be integrated with other subjects by a classroom teacher, or by an art teacher in consultation with a classroom teacher, where learning in each subject enhances the meaningfulness of the other. Art learning may also occur in the community, such as class visits to art-related businesses, museums, or historic restoration sites, or through community guest artists invited into the classroom as adjuncts to the art curriculum. Art learning may occur in consort with study of another fine art form. Where art teachers are not available, art may be taught as a regular subject by elementary classroom teachers, and possibly, by lay persons who are interested in art. In each situation, the teacher should strive, as much as possible, for the ideal recommendations in curriculum and assessment.

Art teachers are employed by school districts to provide a quality education in art. They are trained in some common ways and certified as having met basic standards of preparation. These standards are recommended by professional associations based on a comprehensive view of art, art education, and schools. It is generally accepted that art education minimally consists of introducing students to possible ways of making art. Most art teachers introduce students to examples of art or reproductions of art created by artists as an introduction to the idea of an art

Figure 5.1—Comparison of Local Art Goals with Professional Standards and Typical General Education Goals for Students

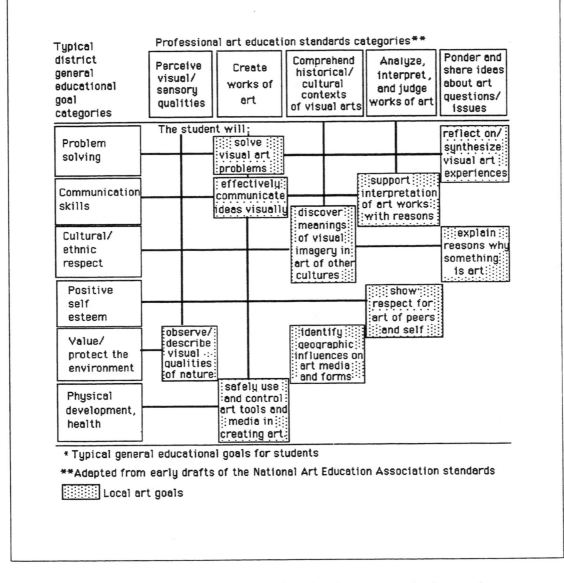

heritage. Some involve students in critiques of works of art or reproductions and some engage the students in more general, probing discussions about the purposes of art in our lives.

Considering the variations in the delivery of art education, initial plans for assessment should be somewhat lenient. Most art teachers have unequal experience with the four disciplines as content areas of art education, and it will take time to develop knowledge and confidence in those areas. On the cutting edge of this curricular direction are those art teachers who have professionally updated themselves by reading, attending conferences, and pursuing additional education in (a) aesthetics, art criticism, art history, and art education applications of those disciplines, and (b) ways to meaningfully integrate them in art-curriculum planning and instruction.

Two additional criteria for evaluating art goals relate closer to the context of the classroom. The definition of certain terms, which are open to more than one interpretation due to the general nature of goals, must be clarified by subordinate goals specifying how the term is used

in art. Efland (1974) gives the example of how subordinate goals referring to expression of artists and response of art historians and critics help to define the term "art heritage." Subordinate goals may also break down a goal for use at one grade level with varying content, complex behaviors for different grade levels, or a combination of these.

Finally, the goal must have prescriptive power. This means that the wording of the goal would call to mind possible art activities through which the goal could be met. Many activities could cluster under a single goal and contribute to a student's ability to meet that goal. Assessment, which provides evidence of student learning relative to that goal, can occur in each of the activities of such a cluster.

Specifying Levels of Thinking and Behaving in Writing Goals

The basic art-related behaviors identified in Chapter 4 are useful in writing assessable goals for student learning or outcome statements in observable terms. Goals written as general, observable student behaviors bridge the frequent gap between instructional goals (what the teacher intends to teach) and assessment of student learning.

There are simple and complex thought processes within each of the basic art-behavior categories identified in Chapter 4. With available information, students think at different levels of complexity. It is important to specify the achievement levels expected of students. If students have achieved lower levels within a category, goals addressing higher levels of that category can be formulated to plan future instruction and to assess student learning. Within group differ-

Figure 5.2—Levels of complexity within some basic art behaviors

Behaviors	Hierarchical levels within each art-related behavior Low................................Middle................................High		
Know	label, identify.............................. state facts...........................have bodies of knowledge		
Perceive	discriminate....................................differentiate..visually analyze		
Organize	conceptualize..............................relate, generalize..evaluate		
Inquire	elaborate...experiment, reflect...innovate		
Value	prefer (personally).......................choose...............................maintain consistent attitude		
Manipulate	do part skills................................perform routines..........demonstrate a complex of skills		
Interact/ Cooperate	comply..be responsible........................show interpersonal skill		

ences may recommend assessing the same goal but specifying levels of attainment that accommodate the differences of students with special needs. The following paragraphs elaborate on the complexity levels within each of the basic art behaviors (as shown in Figure 5.2) and the different teaching and assessment approaches necessitated by their complexity.

Know

At the lowest level (for our purposes), knowledge consists of knowing the verbal labels for things. Simple items of information—facts and basic concepts—are necessary for learning and involve memory and recall. More complex rules or bodies of knowledge represent a mid-level of knowledge since the may be committed to memory without comprehension of that knowledge. A mid-level example is "Red, yellow and blue are primaries." At a later point, students learn to organize information from their art experiences and comprehend principles or rules such as "Primary colors are mixed to make secondary colors—green, violet, and orange," or "Parallels seem to converge to a vanishing point."

Perceive: Discriminate to Analyze

Visual awareness or sensitivity has a long tradition of acceptance as an enabling goal of an art education. Visual awareness is an intellectual skill or capability developed by perceptual experiences that involve making visual discriminations. This lowest level of perception requires students to detect or recognize (not describe) differences in visual stimuli of the natural or human-made environment or in works of art. Students may decide whether two objects are alike or not.

Art educators intently strive to develop students' skills of visual differentiation where students *are* expected to describe the visual qualities of what they observe using their acquired store of facts and simple concepts (jagged, yellowish, thick, outside). Even at young ages, students can describe the visual differences between the fruit "orange" and an orange gourd. Art students visually analyze their environment, objects, and works of art; "read" and think about visual symbols; see connections; and describe similar or shared visual attributes. Art teachers assist this visual perceptual development by providing objects for analysis, contrast and comparison.

Organize

Organization of visual information enables its retrieval and use in art. Art students sort and classify observations based on their common visual attributes. When items with certain attributes in common are identified (maple leaves), then the student has formed a concept. The student has identified an object as a member of a class of objects. As classes of objects become large and more complex, advanced students mentally organize subordinate concepts within the larger class of objects. Thus, the complex class, "dogs," divided into specific subordinate concepts of working dogs and pets, can be further divided into Australian sheep dogs and Saint Bernards, and setters, dalmatians, greyhounds, terriers, and so forth.

As a student uses words to describe complex classes of images, the concept moves from being "concrete," that is, able to be pointed to, to the type called "defined" (Gagne & Briggs, 1974) where sentences must define them, such as composition, historic preservation, or Op Art. Advanced students must grasp the meaning of subordinate concepts as a prerequisite to a total comprehension of a complex concept. Assessment tasks parallel the complexity taught.

Retention of concepts is enhanced (a) by the students' organization of their observations and (b) by application and correct use of the concepts learned in producing artworks and/or talking about art. These capabilities can be assessed. Whereas there may be many right answers to providing evidence of correct conceptualizations, a misconception is a wrong answer, even in art!

Principles are a more complex level of organization. In art, principles are rules that students comprehend and apply, or derive inductively and apply, as they make decisions, for example, "Primary colors are mixed to create secondary colors." Principles are composed of concepts

used in a meaningful and related way; so students must understand the concepts used in a principle to understand and apply the principle. For example, to understand the principle that "Good design should have movement and balance," a student must understand the concepts of both balance and movement.

The highest level of intellectual skills identified by Gagne' and Briggs (1974) is higher order principles, or generalizations. Generalizations organize several complex, abstract concepts or principles into a meaningful, true, and general statement that has possible applicability to many situations. The student forms a generalization in response to a teacher's request to formulate a big art idea as a statement, for example, an idea that explains art's major role in people's lives. A generalization may be a verbal statement or one made through a work of art. Connections between students' art activities and previous art experiences prepare them for making generalizations, but generalizations are more encompassing than any one lesson. For example, "Art is visual communication of shared ideas or values" or "Art draws the attention of people to important details that are often overlooked" or "Realities of life can be depicted with abstract visual symbols."

Finally, art students learn to verify, confirm or evaluate by perceiving the success of all the activities associated with their art learning experience. Thus, they learn to

- Weigh their own responses to teacher questioning about visual stimuli,

- Consider answers on work sheets,

- Observe their own progress as they create and complete a work of art,

- Engage in class critiques of tasks,

- Judge the value of artworks in art criticism experiences (within the confines of their conceptual levels and exposure to art), and

- Judge the reasoning of their own statements and those of their peers in aesthetics dialogues or journal entries.

In each situation, the student is organizing observations, concepts, and principles to evaluate. Generalizations held by students would influence their evaluations.

Inquire

The name of this behavior is a concise reference to the behaviors associated with inquiry processes (see Figure 4.1) that have been described in relation to each art discipline (Armstrong, 1986; Erickson, 1983; Feldman, 1967; Hamblen , 1986; Langford, 1992; Stewart, 1988; and others). The approaches to handling information or cognitive strategies are subtly developed over many years (Gagne & Driscoll, 1988). At a naive level students may merely elaborate. With greater encouragement they can become more independent and divergent in thinking. They may move from seeking given answers to reflecting and questioning or experimenting. Ultimately, students become innovative thinkers and identifiers of problems to solve.

Value

The value behavior stems from Krathwohl, Bloom, and Masia's (1964) affective domain, Gagne and Brigg's (1974) "Attitudes" outcome, and the field of art education (the value component of art appreciation). Valuing can have degrees of complexity which move from a willingness to attend to something to making informed choices, to operating on a consistent set of values. Gagne and Briggs' examples suggest a kind of value continuum moving from an egocentric, personal preference to making informed choices to a concern for society.

Interact, Cooperate

Unlike the artist who works alone, students more often work in groups. They interact as they share ideas, tools, equipment and space. Gardner's (1989) interpersonal intelligence construct supports less frequently mentioned behaviors which may influence art education goals. These may range from simple compliance to assuming responsibility to exemplifying leadership skills based on interpersonal intelligence.

Manipulate

Art goals may describe a continuum of sophistication of manipulative skills. Students may evidence learning of partial skills such as pasting adequately but not over abundantly. They may cut, score, twist and adhere paper to make an additive paper sculpture mask—a routine of

Figure 5.3—Relationship of art goals to behaviors and level of attainment inferred

ART GOALS — The student will:	KNOW (bodies of knowledge / facts / labels)	PERCEIVE (analyze / differentiate / discriminate)	ORGANIZE (evaluate / relate-generalize / conceptualize)	INQUIRE (innovate / reflect / elaborate)	VALUE (consistent concern / choose / prefer)	INTERACT, COOPERATE (interpersonal skill / be responsible / comply)	MANIPULATE (complex of skills / routines / part skills)
1 solve visual art problems innovatively			X	X			X
2 show respect for art of peers and self				X	X	X	
3 observe, describe visual qualitites		X		X			
4 effectively communicate ideas visually		X	X				X
5 discover meanings of visual imagery in art of other cultures	X	X	X	X			
6 support interpretation of artworks with reasons		X	X	X			
7 control art tools and media in creating art	X					X	X
8 reflect on/synthesize visual art experiences			X	X	X		
9 identify geographic influences on art media and forms	X		X				
10 explain reasons why something is art	X		X	X			

manipulations. They may create a work of art that involves fine motor skills, engineering manipulative skill, and control of lighting effects.

Planning what and how to teach considering an appropriate sophistication level of behavior for each grade level or special student is a curriculum task. Developmental psychology principles give general guidance about when to expect students to be able to think at different intellectual levels, but there are variations within any group. In art, students store visualizations for the abstract labels given to concrete concepts. If a teacher reminds students of the experiences that developed the concepts, students may be able to synthesize those concepts and generalize at a much younger age than may be inferred from cognitive development theory. Like identification of the content, levels of behaviors are also considered in assessment.

A model for a systematic check of art learning by content and process behaviors was created for the development of the first National Assessment of Educational Progress in Art instrument (Wilson, 1971). Each item in the assessment instrument related back to this chart by a numbering system. Adapting that procedure to a structure of art content goals and behaviors introduced in the previous chapter results in the partial accountability chart shown in Figure 5.3.

An "x" is placed where a local art content goal would seem to address a particular level of an art behavior (a cell). Each cell contains a possible hierarchy of that behavior (shown in Figure 5.2) related to levels of content complexity. Low levels of a behavior are low in the cell and to the left side. Higher levels are higher in the cell and to the right side. The placement of an "x" indicates how the goal can be met at a level of behavior, for example, a goal meeting a higher intellectual level of organizing with art history content would be marked in the upper right portion of the cell where that goal and the "organize" behavior intersect.

As Gagne' and Briggs (1974) note, information is used by students as they perform in a variety of ways, so it is not unusual that more than one category is marked for a goal. Also, as students think at higher levels, it is likely that their cognitive strategies such as analysis, flexibility, and/or reflection, enable that more complex level of thinking. As their art products begin to successfully emerge, students are thinking and synthesizing at the level of generalizations, utilizing many motor skills in consort with their idea, and likely having positive attitudes toward the achievement they are realizing.

Appendix A contains a blank Figure 5.3 worksheet for teachers' practice in analyzing their goals. It would make sense to have such a planning chart for each grade level being assessed because the levels of thinking expected would be influenced by the maturity of the student. In turn, expected levels of thinking would determine expected levels of attainment and the design of assessment tools appropriate for the student and compatible with instruction.

Refining Goals

Stating Observable Outcomes

The movement begun in the late 1960's involving behavioral objectives emphasized that teachers should not assume students had learned what could not be observed. Like any movement in education, there were extreme applications and opinions on both sides of the issue. Whether one refers to student objectives or outcomes, a commitment to, or mandate for, assessment necessitates being explicit about what is observable and can be accepted as evidence of art learning. If the arts are to be considered an indispensable part of the curriculum, art educators need to be accountable for substantiating claims made and goals set.

If a teacher told a parent, "Pat is drawing just beautifully," the comment may be flattering but not very informative. If the teacher said, "All the details in Pat's drawing vary each object in similar ways. This creates an expression of the same feeling ... a technique similar to the

Benton painting we studied ," the parent has a much clearer idea of what the child has learned. The verb is the key word in writing goals that suggest assessable learning. The verb should be an action verb, such as "vary," "compare," "list," or "illustrate."

Goals designating an observable student behavior or outcome are crucial for assessment of learning. Avoid instructional goals—what the teacher plans to provide. Also, avoid ambiguous goals. For example, "The student will respond to art" is not observable. However, it is possible to observe—and assess—a student's ability to "describe, analyze, interpret, and judge works of art that vary in form, media, subject." A goal of "exposure to many media" could be better expressed as "The student will appropriately control, care for, and use tools, media, and techniques of art production." Even in writing goals met through many art experiences, teachers can write them in terms of what the student will be capable of doing—an observable behavior.

Clarity of goals is enhanced by the key word—the verb. The verb should indicate the level at which the student is expected to behave. Discrimination ability may be indicated by verbs like "point out" or "pick (the different)." Differentiation verbs would ask for use of concepts, for

Figure 5.4—Key words for focusing goals and objectives on art behaviors

KNOW

recognize	match	identify	state	designate	recall	choose the...
point	label	name	list	select	spell	state the rule

PERCEIVE

discriminate	group	trace	distinguish	pick pairs	describe differences
observe		contrast	compare	differentiate	visually analyze

ORGANIZE

follow steps	group	define	apply	design	contrast	systematize
show	classify	formulate	diagram	generate	discuss	synthesize
locate	relate	explain	demonstrate	construct	solve	interpret
acknowledge	sort	exemplify	illustrate	arrange	form rules	evaluate
		produce	communicate		express	

INQUIRE

find	elaborate	hypothesize	question	change	experiment	innovate
modify	recombine	analyze	reflect	persist	imagine	speculate
be curious	recreate	search	reason	risk	think divergently	originate

VALUE

listen	react	prefer	volunteer	elect to participate	identify with
attend to	have opinion	be open	choose	sympathize advocate	champion

MANIPULATE

hold	cut, blend	carve	trim	center	execute	construct

INTERACT/COOPERATE

share	comment	care for	discuss	contribute	consider	build on
comply		be responsible			effectively lead	

example, "describe the visual differences between the leaf in the sun and in shade." Other verbs that call for differentiation are "compare" or "illustrate and explain the difference." Conceptualization capability would expect students to "categorize," "order," or "cluster by similarity." The capability of forming principles or rules would be invited by "hypothesize," "predict," or "compose." The higher order of thinking called for in forming generalizations is expected by verbs such as " synthesize," "summarize," or "determine the pervasive forces to account for." When planning assessment of learning, plan to assess the highest level in a hierarchy for which students have been prepared. Unchallenging assessments limit the claims the art teacher can make for student learning.

An inquiry approach can also be indicated by the verb of a goal or by adjectives and adverbs. For example, goals might specify that "The student will produce divergent solutions" or "The student will reflectively discuss works of art."

Figure 5.4 summarizes verbs that relate to each basic art behavior category for use in writing goals in terms of student observable behaviors.

Summary

Assessment should relate to art education goals and the instructional experiences that address those goals. Making goals assessable warrants consideration of goals that state how art education uniquely meets the goals of the school and the profession. Goals should also suggest explanatory subordinate goals and imply the kinds of art activities through which the goals would be met by students.

Goals should be expressed in terms of what students can be observed to do, write, or say and suggest the level of sophistication at which they are expected to be met. The verb is the key word in conveying this suggestion.

6

IDENTIFYING EXPERIENCES FOR ASSESSING THE CONTENT AND BEHAVIORS OF ART GOALS

Previous chapters have identified the content and behaviors of an art education and addressed variables that influence the wording of art goals. Chapter 6 focuses on the content and behaviors inferred by art goals and assessable instructional experiences designed to help students meet those goals. This process contributes to content validity of an assessment program or individual instrument, (i.e., assessment which representatively samples the goals and learning experiences).

Relating Goals to the Behaviors and Content of Art Education

Art goals for student outcomes, and their more specific objectives, involve both art–related behaviors (know, perceive, organize, inquire, value, manipulate and interact/cooperate) and the content of art education (derived from art criticism, art history, art production and aesthetics). Education behaviors must be related to the art content in order to choose appropriate means for assessing learning in art. For example, to interpret a Leon Golub visual statement, students must mentally organize and synthesize visual information of scale, expressive facial and body images, current events of people's inhumanity to people, and sensory qualities and technical application of color. Figure 6.1 shows an example of how a goal statement implies art–related behaviors acting on art content.

Across-content Behaviors

The same art–related behavior may act on a variety of content. Synthesizing, an intellectual skill, is such a behavior. It is an organizing behavior which could be developed by students in relationship to the content of any field of study. If teachers want to know how well students learned to synthesize the relevant concepts in making interpretations, they might look for that evidence in an oral art criticism activity, a written short essay, or a multiple–choice item offering only one plausible interpretation based on relationships between all the visual characteristics of the artwork.

Figure 6.1—Sample goal implying an art–related behavior acting on art content

Art Content	Know	Perceive	Art Related Behaviors Organize	Inquire	etc.
Art criticism			6. Students synthesize evidence from within art work to support interpretations		
Art history etc.					

The same type of instrument for assessing learning may be used across content areas. Several rating scales may assess visual differentiation. Visual awareness critical to the development of specific concepts related to creating art may also be an important component of art criticism and art history experiences. Oral description, sorting exercises, or observation of meaningful symbols may be assessed by a rating scale instrument, which has visual differentiation as a criterion in each case.

Figures 5.2 and 5.3 outlined the assessable levels of art–related behaviors. Because higher levels of operation are not possible without mastery of lower levels of behavior, the highest level appropriate for a grade level is generally the one assessed. To adequately perform Bloom's (1956) highest cognitive behavior of "evaluation," the student would need to develop capability in all lower levels of intellectual skills. Thus, in assessing the highest level to be attained by students, the number of specific bits of information or behaviors to be assessed is greatly reduced. In view of the immensity of a thorough assessment task, it is enough to assess specifics about the elements and principles **only** in the context of their meaningful employment in achieving more holistic outcomes (i.e., in solving art problems or interpreting artworks). Thus, experimentation with line qualities could be viewed as preliminary exploration within a portfolio of related activities, not as an item to be individually assessed.

At the same time, preadolescents are capable of higher order thinking with less complex concepts and principles that are within their frame of reference or concrete experiences (Armstrong & Armstrong, 1977). Therefore it is possible to ask young students to generate an appropriate "big idea" of an encounter by relating the experiences that have been a part of their art encounter experiences (e.g., an art history enactment of *Snap the Whip* emphasizing its contextual values, a paragraph supporting its intrinsic meaning, or a clay relief contemporary play scene). The generalization thus formed may lack adult sophistication and completeness, but the same holds true for the paintings, art history comprehension, and adequacy of judgments about art of young students. Learning in art, as any discipline, is a process of revisiting common concerns of a discipline (Bruner, 1960) and gradually building the completeness and sophistication of the mature art scholar or artist (Clark & Zimmerman, 1978). The same principles apply to other areas such as motor skill development, which varies along a continuum of refinement regarding both muscle development and experience.

While the conceptual levels at which students can organize visual information vary for the different age groups, planning for within group variations is also a good idea. Creative art teachers find many approaches to teaching at one level to maintain a high student interest or to respond to the individual differences within a group whether those differences be in intellectual capacity or learning style. This planning for differences applies to assessment instruments as well, which can be adjusted to account for the differences.

Multiple Assessments

Just as one can assess the same behavior in several content areas (e.g., "supports statements with reasons" both in art criticism activities and in making decisions in art production activities) a variety of assessment procedures may be used in each content area of art. For example, in reference to the creation of art, Day (1985) wrote:

> Many evaluation problems in the productive domain are alleviated when teachers realize that they have different instructional purposes at different times and that different evaluation procedures are appropriate according to the specific instructional purpose. (p.235)

If there are multiple outcomes associated with the production, history, criticism, or aesthetics components of an art encounter, then one can expect to use several means of gathering evidence of learning for any one of them.

Analyzing the Relationship

Art goal statements blend content and behaviors, but it is helpful to separate them to identify types of assessment tools that will observe the same behavior inferred by several goals (e.g., visual awareness). Repeatedly, writers of test questions advise charting the content and behaviors of a subject when planning a comprehensive assessment program. Four reasons summarize why this charting is an appropriate pre-assessment procedure:

1. If teachers outline behavior categories (outcomes) to be assessed, assessment items or instruments can focus on those behaviors and the results of assessment are interpretable in term of the behaviors specified. Figure 6.2 allows teachers to identify students' behaviors relative to each content category. If students know the content, what behavior can be observed (what they do or say) to confirm that knowledge or give evidence of learning?

2. Customized content of teacher-constructed assessment instruments can result in content-valid measures. If assessment instruments measure observable behaviors that refer directly to the content of goals or objectives, they will be measuring content and behaviors that they claim to measure. If assessment instruments are designed to measure representative aspects of art education that are specified as goals, then the assessment has validity for that program. If the art program goals are comprehensive in terms of observable content and outcomes, the claim to a comprehensive program will mean a comprehensive assessment program if the assessment parallels the goals. Outlining behaviors and content categories is the place to start.

3. Charting the behaviors and content of art education can bring to light desirable, though unintended, outcomes. Teachers may not have specified certain potential learning situations as goals, nor assessed student learning in some worthy directions. A comprehensive look at the potential learning of art education may suggest how to teach for, observe, and assess heretofore unemphasized, but educationally sound, art learning.

In addition, charting the content and outcomes allows teachers to be responsive to community values or current concerns. Usually, specific concerns can be addressed by an existing category of the comprehensive chart, and the teacher can assure the community of the

legitimacy of their concern and make the emphasis on that concern visible. If the concern for learning behaviors or for content is unique and not encompassed by the comprehensive chart, then another category can be added. Likewise, if an issue has immediacy—that is, it is currently commanding the attention of a community—such as, interrelating art and other disciplines, a major upcoming election, or multiculturalism, and sufficient visibility cannot be achieved under other content areas, the concern, again, could be added to the comprehensive chart. Figure 6.2 includes a content category added because of community concerns.

Other Category Variations

Figure 6.2 depicts the content areas identified in Chapter 4 in another way. Vocational and avocational art is included in the aesthetics content category under the subcategory "Theory/Issues" pertaining to the nature of art. "Art institutions"—art museums, educational institutions, galleries, arts foundations, federal arts endowments or grants, and alliances or support groups—also are encompassed by the "contextual value" content subcategory of the aesthetics discipline.

Comparison of Art Goals to Content–Behaviors Chart

Each art goal can be analyzed to discover the inferred or stated behavior expected in regard to content. For example, in the goal "The student will identify works of art by major artists or periods and how the works reflect influences of the values of the time," *knowledge of information* (identify works of art by major artists and values of the time) is expected. In addition, use of principles (rules that explain why values influence artists' works in a period) engage a student's *mental organization* of the visual information in the artwork and comprehension of how the visual organization relates to the values of the time. The number of such a goal would be entered where the behavior "organize" intersects with the "contextual influence" (art history) category, as the highest level of thinking to which identification of facts are to be used. The outcome expected is the employment and relating of facts to gain new insights into the contextual influences on art.

Ten art goals have been used as examples of this process in Figure 6.2.

A blank copy of Figure 6.2 is available in Appendix A for the reader to use. Art teachers can number each of their art goals and temporarily place the number of the goal in a box of Figure 6.2, where the behavior expected by the wording of a goal intersects with the content with which that behavior should operate. This process would continue for all art goals. As the classification of the goals on the chart nears completion, art teachers may become aware of the need to add goals that can be met by observable student behavior or delete redundancy or overemphasis.

Assessable Situations for Observing Content and Behaviors of Goals

At this point, it is assumed that teachers are planning to observe evidence of student learning in art by structuring ongoing learning activities that can provide such evidence. They may plan to construct ongoing and/or culminating assessment instruments that are primarily objective- or criterion–referenced. (Essentially, these are the same except that "objective–referenced" suggests greater generality. A criterion–referenced instrument may measure students' grasp of specific concepts or other aspects related to an objective.)

Evidence of learning in art takes on so many forms that it must be assessed by a variety of means. Art teachers need to be innovative in discovering ways to assess behaviors that are less

Figure 6.2—Analysis of goals* in regard to content and behavior components

ART CONTENT	Know	Perceive	Organize	Inquire	Value	Manipulate	Interact/Cooperate	Community Concern e.g. self-discipline assertiveness
Aesthetics								
Contextual value: Art world/social world					10			
Theory/Issues categories			8,10	8				
Characteristics: Aesthetician				10			8,10	
Art Criticism								
Criticisms written by critics								
Types of criticism					2		2	
Stages of the critical process		3,5	6	6			6	
Art History								
Research methods	9							
Contextual influence: attitudes/institutions	5		5	5				
Facts, attribution: time, location				5,9				
Assoc. w/style, artist, period, culture			9	5,9				
Art Production								
Synthesis: Creative problem solution			1,4	1		1	1	
Strategy, technique				1,4		4,7		
Tools, materials, equipment	7		1			7	7	
Processes, areas	9					7		
General: Visual arts disciplines								
Elements of visual art		3		3				
Principles of organization			1,4					
Community concern for content								
e.g. Ethnicity, interdisciplinary study								

*Sample At Goals.
The student will
1 solve problems innovatively
2 show respect for art of peers and self
3 observe, describe visual qualities of the environment
4 effectively communicate ideas visually
5 discover meanings of visual imagery in art of various cultures
6 support interpretations of artworks with reasons
7 control art tools and media in creating art
8 reflect on/synthesize visual arty experiences
9 identify geographic influences on art media and forms
10 explain reasons why something is art

likely to be observed by traditional means. Rather than marking choices from those provided on a test, evidence of learning may be such student-generated behaviors as:

Figure 6.3—Situations* through which students evidence learning of content and behaviors of art goals**

ART CONTENT	Know	Perceive	Organize	Inquire	Value	Manipulate	Interact/Cooperate	Community Concern
Aesthetics								
Contextual value: Art world/social world					10D,J			
Theory/Issues categories			8,10 D,J	8D				
Characteristics: Aesthetician					10D			
Art Criticism								
Criticisms written by critics								
Types of criticism					2D,J		2D	
Stages of the critical process		3,5D	6D	6S			6B	
Art History								
Research methods	9W							
Contextual influence: attitudes/institutions	5W		5S	5J				
Facts, attribution: time, location				5,9W				
Assoc. w/style, artist, period, culture				5,9W				
Art Production								
Synthesis: Creative problem solution			1,4A	1A		1A	1D	
Strategy, technique				1,4B		4,7A,B		
Tools, materials, equipment	7T		1E			7A,E	7B	
Processes, areas	9T					7A,E		
General: Visual arts disciplines								
Elements of visual art		3D		3B				
Principles of organization			1,4A					
Community concern for content								
e.g. Ethnicity, interdisciplinary study								

ART-RELATED BEHAVIORS

****Refer to Figure 6.2 for list of goals**

Sample situations that can produce evidence of learning.

At work (A)
Guided discussions (D)
Essays (S)
Tests, quizzes (T)

In–process behavior (B)
Planning, media experiments, sketches (E)
Journal entries, think sheets (J)
Worksheets (W)

• Empathetic description of observations (e.g. natural objects, artworks).

• Accurate use of concepts taught in art production or in discussions.

• Precise manipulation of art instruments and media.

• Reasoning advanced for judgments.

• Independent thinking and innovative ideas.

• Responsibility for making decisions.

• Thoughtful questioning of, and respect for art and opinions of others.

• Thoughtful self–reports of out-of-school art activity.

• Analytical, reflective, or spontaneous approaches to visual problems.

Teacher–developed, nontraditional instruments could record and assess these art–related behaviors through many experiences, such as art products, discussions, classroom behaviors, and portfolios of art work. In addition, through assessment of written work, evidence may be acquired of a student's insight into his/her own direction, organization of ideas, individual expression in communication of information, selectivity and completeness of one's thinking, analytical and critical thinking, and synthesizing ability. Assessing every behavior and specific bit of content in art would be an enormous and unnecessary task. However, some time spent organizing ideas and structures will help teachers to recognize that comprehensive assessment is feasible.

For illustration purposes, Figure 6.3 suggests a systematic approach to identifying situations for gathering information about what students are learning for selected behavior and subcategories of art content. Descriptions of eight sample methods of assessment follow. (As seen in Figure 6.3, where content and behaviors are expanded for community or other concerns, situations for assessment are not recommended because these concerns are only locally relevant.)

Artwork (A). Artwork includes creative production in all forms of the visual arts. One expects that this category of experiences will provide considerable data for assessment.

In–process behavior (B). Daily approaches to solving visual problems and thinking strategies that students use can be noted. If care of art tools, intellectual curiosity, investigation, and willingness to take risks are behaviors important to artists' success, art goals may reflect this, and student behavior in this direction would be noted and recorded.

Guided discussions (D). Guided discussions are common when students engage in art criticism experiences, seek and share contextual information about works of art, critique other students' works, hold aesthetics dialogues or seminars, and participate in concept–developing visual analysis.

Planning, media experiments (E). Creating in art usually involves preliminary thought processes that may be observable in verbal or graphic forms—preliminary sketches, notes, historical or contemporary contextual information, media experiments, studies with or without specific intent . Here, the emphasis is not on the form, but rather on the logic and completeness of thinking through the process, needs, and consequences of decisions. These plans could be in sketchbooks, loose papers, notebooks, diaries, or portfolios.

Journal entries (J). Student journals or sketchbooks can permit insight into the student's reactions, inspirations, connections, and incubating ideas.

Essays (S). Essays include both short (paragraph) and longer versions (several pages). They may be part of a test or as a lesson–related assignment. They could be individually written or with a partner or group. In any case, the points that should be covered should be made clear to students, and the levels of achievement for each criterion clearly defined, with examples, before assessing the essay.

Tests (T). Tests designed by art teachers could include game formats (e.g. hangman); crossword puzzles; diagram–type drawing to illustrate concepts; traditional multiple choice

(e.g., matching or true–false items, word completions); and so forth. Typically objective tests may also include comment lines which allow students to explain answers or to react to questions. True–False items could ask students to correctly rewrite any false statement.

Work sheets (W). Evidence of learning occurs throughout the instructional experiences as teachers ask for student responses on work sheets, in–class tasks, or homework assignments.

These are just a sample of assessment opportunities that teachers can and do incorporate into teaching. They provide evidence of student learning in art for assessment purposes if teachers systematically record the results.

Having numbered and analyzed the implied content and behaviors of art goals of a district (as shown by Figure 6.2) and considered what kind of art activity could provide evidence of that learning, a teacher would identify some appropriate ways to observe and record it. A code for each way of observing evidence of learning could then be added (see the samples in Figure 6.3). Goals that have the same letter suggest activities facilitate learning that can be assessed by the same type of instrument (e.g., an observational code sheet, a teacher log, a traditional test, a criterion–referenced product rating scale, or content analysis of student journals).

In the example of Figure 6.3, evidence of meeting goal One would be obtained by averaging ratings on sketches and art products (A) in terms of application of the principles of organization, contribution of various aspects of the product to the solution, innovation of the solution, and students' manipulative skills in the use of tools and media. On a class list, the teacher would observe and note the degree of individual students' exploration before coming to closure on the solution (B). Review of portfolios would show experiments and art product plans (E), and a critique would reveal both the intellectual synthesis of students in regard to their own work and their respect for the work of their peers (D). Over the period of a year, like evidence can be clustered for summary statements or calculations.

Summary

This chapter has introduced a systematic way to help identify the kinds of experiences that can be assessed in art. The model for a comprehensive structure for assessment decisions includes both general outcomes or capabilities that should result from education and the content areas of art education with which those capabilities operate. When existing goals are plotted according to their implied content and behaviors, a visual picture of the comprehensiveness of the goals appears. The step of matching assessable situations to each goal helps plan for multiple sampling of particular behaviors. The final step in identifying for students what evidence of learning is expected in each learning situation was modeled in an early published curriculum series of art texts for children, *Art: Meaning, Method, and Media* (Hubbard & Rouse, 1972), followed by others (e.g., Hubbard, 1987; Chapman, 1987).

The blank Figure 6.2 worksheet in Appendix A, or variations of it, can be helpful in developing a comprehensive assessment program. The comprehensive view helps identify types of assessment instruments to use and clusters of similar assessable situations where evidence of learning can be accumulated and summarized. For example, successful use of concepts in art products across a semester can be averaged as a score or become a verbal or written statement about the *art concepts applied* or the conceptual growth observed over time. By contrast, teacher observations through multiple group discussions about art in general, where students are expected to reflectively express their substantiated ideas about the worth of art, lead to conclusions about the quality of *students' inquiry* behaviors from cumulative records kept.

7

TYPES OF ASSESSMENT INSTRUMENTS

Chapter seven explains some major differences between standardized tests, traditional, and nontraditional instruments, and the type of learning usually assessed by each in general education and art education. Advantages and disadvantages of traditional and nontraditional assessment instruments are offered including teacher involvement and obligations.

Unlike most other curricular areas, art education lacks a long history of experience with testing. Art tests used in research necessarily are focused on aspects pertinent to the studies, and only in a limited sense do they resemble the kinds of activities that occur in art classes. (See Note 1.)

Consistent with Eisner's (1974,1979) caution about incompatibility between tests and art classroom experience, many teachers of art recognize that testing is only a small part of assessment of learning in art. For years they have assessed portfolios of art work, a concept that has been adapted and expanded by other disciplines. However, contemporary art education curricula necessitates expanding assessment to include evidence of learning from many types of art experiences. This chapter, therefore, covers the various types of assessment instruments available, moving from the general to the specific, that is, from external, preordinate assessment to internal, responsive modes.

Standardized Achievement Tests

Description

Standardized achievement tests are general, comprehensive, and assess learning of a subject area or areas. Achievement tests do not reflect any specific curriculum, but are designed to sample possible learnings of a subject. "Standard" refers to a fixed set of items representing specific content that is the same for each administration. Procedures for administration and scoring of the test are also held constant.

Achievement tests are designed as norm-referenced tests. Student scores on an achievement test can be compared to large reference groups . A reference group may be alike in sex, grade

Note 1. Eisner (1974); Clark, G., Zimmerman, E., and Zurmuehlen, M. (1987);and Wilson, B. (1971) offer historical-critical reviews of research testing in art.

level, age, geographic area of the country, socioeconomic level, or combinations of these demographics. The typical scores of large reference groups are norms. Achievement tests should be recently normed as well as provide appropriate norms for a particular group of students being tested.

Advantages

Achievement tests allow one to ascertain pupils' relative position in a larger, clearly defined reference group. For example, a teacher can compare the score of an Indianapolis, Indiana, third grade student's art test with the test scores of many other third grade, large city students. Thus, it is possible to identify where individuals stand in a group larger than their own class. Achievement tests also show

- The range of ability in a group compared to a broader context.

- Areas of instruction that could be improved.

- Special needs or achievement unrecognized in the daily activity of the classroom.

- Learning errors so that remediation can be planned.

- Need for greater clarity of objectives or need to include additional objectives to provide a comprehensive program.

In addition, selected items or subtests may mesh with local art objectives and could be used to assess them. The achievement test may be a model for constructing local assessment measures; establishing validity, reliability, and item difficulty; and for scoring and reporting guides. Achievement tests can help meet local accountability needs in combination with other forms of assessment.

Limitations or Cautions

General cautions about the use of standardized achievement tests are:

- Check the fit of the achievement test with local objectives.

- Check on local district agreement with the publisher's interpretation. For example, if media and tools are introduced in the district in order to enable students to give form to ideas, but a large proportion of questions focus on the use of media and tools in art as ends in themselves, these test items would be inappropriate.

- Consider that students in some schools may not have had specific experiences referred to on the test. Because many possible means exist to meet the same objective in art (by varying media, techniques, processes, subject, historical exemplars, art forms), some items, considered generic by the test maker, may be outside the direct experience of a student. If a test doesn't fit, create a parallel one that fits the students' art experience. Compare the results and substitute the relevant test, if permissible. (Refer to Chapter 9 for how to check for reliability and validity on teacher-constructed instruments.)

- Consider that students' responses on any mass administered test will lack the frame of reference of a classroom art encounter. In a classroom encounter, visual analysis, media experimentation, study of historical models, the production experience, and discussions of the nature and importance of art of the sort addressed are meaningfully integrated in order to build the art capabilities planned. If necessary, vocabulary substitutes made by the teacher can link the standardized test to the classroom encounter.

- Check that the use of terms is consistent with local use. The English language offers a breadth of terms from which to choose, a special concern in art education. Some art teachers seem prone to use their artist's license when communicating verbally about art,

like discussing what makes a painting "work." A teacher may communicate this idea clearly to students, but when the test refers to "the interaction of elements as composed by the artist," the students may not recognize they are being asked for the same knowledge garnered during their discussion of what "works."

- Recognize that machine-scorable, forced-choice (multiple-choice or true-false) questions require that the student get into the mind set of the test writer not only in terms of labels for concepts and expressions, but also in wording of the choices offered. In standardized tests, students' thinking is directed; they do not generate answers, only select a response from those given.

- Recognize that inferences must be made from self-report attitude questions. Answers to forced-choice attitude questions can vary depending on the frame of reference of the student or lack of opportunity to engage in activities for a number of reasons.

NAEP, Art

The NAEP, Art is the best known achievement test in art. In work preceding it, its author Wilson (1971) structured items to assess seven domain behaviors pertaining to art content areas—perception, knowledge, comprehension, analysis, evaluation, appreciation, and production. He expanded on recognized domains theorized by Bloom (1956) to include behaviors traditionally accepted by art educators. NAEP, Art also recognized the variety of learning that exists in art and included content areas from the currently recommended disciplines of art—art history, criticism, production, and aesthetics. In the research that preceded NAEP, Art, individual test items were coded to identify the behavior and content areas addressed by that question. The NAEP, Art reports—*Knowledge About Art* (NAEP, 1978) and *Attitudes Toward Art* (NAEP, 1978)—show that a variety of traditional, forced-choiced, cued-type questions can be used to assess thinking at many levels.

A limitation of the NAEP, Art cited by its author (Wilson, 1970) was a curtailment of some important items due to costs, material needs, time available to evaluate written paragraphs or essays, and the need for individual rather than group administration. Also, these NAEP, Art items were not the machine-scorable, forced-choice type traditionally designed for mass achievement testing, but were responsive to the nature of art.

Textbook Tests

Description

Textbook tests are achievement tests based on the content and behaviors addressed in a given text.

Advantages

The greatest advantages of textbook tests are convenience and low cost. If an art teacher's objectives follow the content and activities of a text closely, and the test questions examine the students' achievement of the material covered by the text, chances are good that the test is valid. That is, it assesses what it claims to assess. As with any achievement test, teachers are free to assess objectives for which they have taught in addition to those met by the textbook.

Limitations or cautions

Textbook tests vary in the help given teachers in printing, scoring and reporting results of the test. The test manuals should provide reliability information, and no test should evidence gender or ethnic bias.

Art teachers should check for alignment of the test items to their local objectives. Where art teachers only supplement their instruction with a text, the textbook test would not suffice as valid assessment.

As with any test, art teachers will teach the categories of content covered by the test, but avoid teaching the test.

Locally Developed Instruments

Traditional teacher-made instruments

Description

For purposes of this book, traditional teacher-made instruments are objective, forced-choice, cued assessment tools that often are machine scorable. Objective types of items (e.g., matching, true-false, completion, multiple-choice, and unlimited multiple choice) are normally associated with tests. Completion items (see Chapter 10 for ways to convert these items to a machine-scorable format), short answer, and essay items can be teacher-made and are traditional, in the sense of being familiar to educators. Traditional assessment tools are typically used to ascertain recall, recognition, or identification ("know" behaviors) of specific factual aspects of the content areas, for example, listing the names of categories of aesthetic theories or selecting the correct contextual facts about the *Mona Lisa*.

Traditional tests are sometimes called pencil-and-paper tests, but that descriptor does not differentiate something like a multiple-choice item from a student's drawing or diagram which cannot meet the other criteria of forced choice or machine-scorable. "Machine- scorable" means that the format would allow that method, but not that machines are necessarily used for scoring purposes. Short answer and essay items require a different scoring procedure so will be considered "nontraditional" means of assessing learning.

Advantages

Teacher-made traditional assessment instruments have the advantage of credibility to the teacher and community. A teacher who feels ownership of the assessment of students will be able to confidently explain the function and benefits of assessment.

The state or a teacher's summative assessment can only check for a sample of performance. However, repeated forms of worksheets, aligned to local objectives, can provide formative assessments that occur throughout the school year. It is possible to establish uniform procedures for administering such tools in order to meet good assessment requirements. A summary of those achievement indicators can legitimately supplement any summative assessment.

Assessment on a smaller scale allows flexibility in form and frequent smaller administrations. It is adaptable to varying sizes of units and permits more opportunity for altering the items as appropriate to the instruction. If an item asked students to match activities of an encounter with concepts learned in them, and if the same concepts were learned through different activities in another year, the activities could be substituted in the encounter and in the item, as follows:

This example shows how a modeling clay animal product in 1993 was replaced by the papier mache animal product in 1994. Both activities emphasized that "form is 3-d."

1993 Grade Three Art Test		1994 Grade Three Art Test	

1. Draw a line to match the activity with the idea we learned through it

1. Draw a line to match the activity with the idea we learned through it

1.1 wash figure drawing	a. edges of forms	1.1 wash figure drawing	a. edges of forms
1.2 modeling clay animal	b. depth by value	1.2 papier mache animal	b. depth by value
1.3 contour face drawing	c. form is 3-d	1.3 contour face drawing	c. form is 3-d
	d. secondary colors		d. secondary colors

Limitations or Cautions

Constructing good assessment instruments is a difficult and time-consuming process. The quality of the assessment instrument remains an unknown unless a school district keeps a file of assessment tools used. Validity, reliability, and item difficulty need to be determined locally and that process is likely to be less stringently conducted than if professional test constructors were responsible for doing so. Designing, testing out the items, printing, administering , scoring and reporting tasks are left to the teacher or teachers. Finally, when all this is accomplished, scores can only be meaningfully compared within the local school district assuming full participation of all art teachers.

Nontraditional, teacher-designed methods of assessment

Description

Observation of evidence of student learning in art is possible by a great variety of nontraditional, teacher-designed, assessable instructional experiences. Included in the category of the teacher-designed assessment experiences are short-answer and essay questions, writing assignments, self-reports about preferences and attitudes, anecdotal records from student journals, and reflective analysis of art work of artists, their own and peers, and others.

Nontraditional assessment instruments are checklists (presence or absence of a criterion) or rating scales (numerical or other symbols used to indicate quality of learning achieved in terms of criteria) used to assess learning from oral discussions, art products, sketchbooks, art behaviors, and process behaviors. The content of student journals, peer appraisals, and anecdotal records can be analyzed for knowledge of content, insights, relationships, observations, levels of thinking, relevance to projects, innovative ideas, reflection, or other behaviors and recorded and given a quality rating. Trends can be observed, noted, and shared with the student.

Meaningful evidence of learning is sought. It isn't as important that all students named objects during their art criticism experience, but that they related observations and could say why an artist might have made a decision based on the title given to the work. In some cases, the students may be unaware that the experience is providing evidence of their learning in art. Figure 7.1 lists a variety of experiences that are for the most part nontraditional, and the primary person(s) knowingly involved as participants in the assessment.

Figure 7.1—Types, experiences, and primary person(s) involved in assessment

Type: Observation
Persons Involved: Teacher and/or Students
Sample Experiences:
- Taped aesthetics dialogues or group discussions on art criticism
- Art classroom behaviors' monthly chart
- Log books or other anecdotal recording of observations
- Narrative appraisals
- Videotaped classroom activities, photo documentation
- Annotated exhibits of student written work and art work
- Systematically rotated observation of students' characteristics, art-related behaviors
- Art work: cumulative, topical, encounter portfolio review
- Written or oral art criticism experience with reproductions or works of art by artists and peers
- Taped preplanned group discussions or debates

Type: Traditional Test Items—Forced Choice and Completion
Persons Involved: Teacher and/or Students
Sample Experiences:
- Matching words, pictures, statements, and/or names
- Multiple choice: verbal and visual content
- True-false items: verbal and visual content
- Completion items

Type: Nontraditional Test Items
Persons Involved: Teacher and/or Students
Sample Experiences:
- Short-answer or essay questions
- Unlimited multiple-choice: verbal and visual content
- Noncued, machine scorable adaptation of completion items
- Drawing or diagramming to illustrate concepts
- Correction statements on true-false items marked "false"
- Comment lines on tests for learning that was not tapped

Type: Ongoing Performance Samples (nontraditional)
Persons Involved: Teacher and Students
Sample Experiences:
- Tracing or diagramming compositional aspects of art works
- Peer-group process evaluation
- Student art experimentation and final products
- Crossword puzzles (e.g., for concept definitions)
- Visual perceptual detection tasks
- Manipulative tasks
- Progress checklists
- Survey of opinions or attitudes with comment lines
- Sorting tasks related to concept development or art history
- Q-sort adaptation for determining relative value placed on...
- Commercially available or teacher-constructed art history inquiry activities
- Study sheets (e.g., for museum or field trips)
- Journal: descriptions of projects, experiences, process observations, reflections
- Think sheets (with teacher prompts to encourage extension of ideas and observations)
- Self-evaluation of entire art encounters or art work

Type: Person to Person
Persons Involved: Parent/Guardian, Teacher, and/or Student
Sample Experiences:
- Questionnaire from art teacher or school
- Interview: parent/guardian-teacher conference, teacher-student
- Log of informal comments, questions

Advantages

Written, locally developed, nontraditional assessment allows the students to use terms with which they are familiar. The teacher, with broader experience, can understand and classify a student's ideas fairly. Thus, in locally administered and scored essays, a student may express ideas in language that, correctly interpreted, tells whether the student achieved the objective for which the item was designed. Students can demonstrate organization of ideas and verbal expression, as well as grasp of the concepts, principles, and generalizations used in answering the question.

The major advantage of nontraditional assessment measures is their ability to accommodate the nature of learning in art. They can document the qualitative nature of art—the incidents of (a) divergent thinking, (b) reflection, (c) perceptual awareness, (d) innovations, and (e) analytical and critical thinking. Influenced by ethnographic, naturalistic (Guba, 1978) research methods and responsive evaluation (Stake, (1975), nontraditional approaches to assessment are less obtrusive than traditional testing situations and are often imperceptible to the students. Nontraditional methods of assessment seek evidence of learning within the natural events of the classroom art experiences or results of those experiences.

Limitations or Cautions

Written nontraditional responses to assessment instructions check for more than the specific content. This becomes a limitation of the written task assignment if students have language difficulties. Audio-taping responses is one alternative for some situations. If a student has recently emigrated from a non-English speaking country, bilingual teachers may be needed to translate the instructions for the student and the student's response for the art teacher.

Nontraditional assessment of art learning is time consuming and requires preplanning. Teacher's aides, or coding sheets prepared with the criteria expected, allow the most efficient use of a teacher's time and contribute to the accuracy of a nontraditional instrument, especially when discussions serve as evidence of learning. These means of assessment can be worked into an instructional unit with little difficulty.

Art teachers know that it is difficult to predict what will be happening at any given moment in an art classroom. It seems that gathering evidence of learning in art might be like catching a butterfly. The very nature of art learning contributes to limitations of assessment, even nontraditional, but those limitations do not constitute an insurmountable barrier. Precautions are in order. For example, a single snatched observation is insufficient evidence of learning. Responsible nontraditional assessment necessitates repeated, systematic sampling of any behavior about which a claim may be made. A teacher would no more claim that the group of art students thought critically if on one occasion they gave good reasons for their opinions, than if one child out of thirty gave evidence of critical thinking.

Summary

Art education situations vary extremely across school districts, and art assessment will reflect that variation. The number of students served by an art teacher in a week will determine what is reasonable to assess and with what frequency. It may mean introducing fewer lessons with new discussion or writing components to make those few more meaningful. It may mean making a plan to gradually introduce authentic assessment.

Nevertheless, in almost any teaching situation, teachers can identify behaviors that would provide evidence of learning, structure classroom experiences conducive to observing that evidence, and be prepared to record that anticipated evidence or even unanticipated outcomes. Being literate about assessment is an ongoing challenge.

8

SAMPLES FOR PRACTICE: PRETESTING THE IDEA OF ASSESSING LEARNING IN ART

In this chapter, sample encounters at three grade levels show how student learning can be assessed through a variety of art activities. Teachers can replace the criteria of a model instrument with their own criteria to make an instrument meaningful and appropriate. Teachers are encouraged to select an appropriate instrument and practice assessment of current art activities. Assessment can increase as the teacher's comfort level rises.

If some ideas about assessment in art are new, teachers will need time to get a sense about how those assessments of students' performance can be informative. A hypothetical art encounter (Efland, 1977) is here adapted for grades three and seven and a general art course at the high school level. The aim is to exemplify activities that generate evidence of learning. Models for assessment items are given that can be used to assess learning of activities related to the disciplines of art education (art criticism, art history, aesthetics and art production) and art-related behaviors. The model items include nontraditional and traditional modes of assessment. Any model assessment item can be modified for other grade levels.

Teachers are encouraged to adapt a model to an art encounter that they plan to teach. Teachers need to teach for the objectives of their encounter and assess how well students met their objectives by using the assessment instruments they have appropriately adapted from the models. This practice allows teachers to pretest instruments in order to acquire a feel for how they can suggest improvement of instruction and help measure attainment of objectives. Subsequent chapters will benefit the teacher most who has a sense about how to utilize some assessment instruments in order to realistically plan a program of assessment in art. New kinds of art learning situations and possibilities for assessing them may occur as a result of pretesting adapted assessment models.

Art Encounter

An art encounter is a cluster of activities—that may be sequential or overlapping—where learning experiences related to the four disciplines of art education are meaningfully integrated.

Each activity is valued and given attention for its contribution to learning in art. In other words, a slide of a work of art is not displayed as an incidental aspect of an art production experience; rather, it is discussed for its meaning in its time and within its geographic and cultural context and for its meaning to us. Likewise, the art production experience is not merely an illustration of an art history lesson (Armstrong, 1990b).

The encounters for which the model assessment instruments in this chapter are planned all relate to the imitation aesthetic theory—roughly, that art is imitation of nature or an ideal. These hypothetical encounters are assumed to be part of a vertically sequenced curriculum where student comprehension of depicting depth has been built over the years. Concepts that contribute to understanding this truth about some art are expanded and made more complex at the higher grade levels. High school students are expected to correctly use the concepts developed at the junior high and elementary levels in addition to those specified for the secondary level.

Art Goals

The following general art goals are met by one or more of the encounter activities at each grade level:

- Students will recognize relationships between art and the contexts from which it arises.

- Students will openmindedly engage in criticism experiences with works of art or reproductions and their own art production.

- Students will show visual perceptual awareness.

- As students create visual images to meet a variety of aims of art education, they will apply art principles.

- Students will make decisions thoughtfully and independently about what art is and why it is important.

These general art goals encompass many more specific encounter objectives.

A Third Grade Encounter Called "When Eyes Tell Lies"

Our eyes tell lies when, for example, they see part of an object that is actually whole, a large object that is far away looks small, and distant objects do not appear to be on the same ground level as near objects. Yet such visual tricks create an illusion of depth on a two-dimensional surface.

Encounter Objectives

Encounter objectives are subordinate art goals that refer to the particular activities planned. The following objectives translate general art goals to specific ways planned to meet them:

- Pairs of students will read library material and complete worksheets about the background of landscape artists who worked realistically, including what people at the time expected art to be.

- Students as a group will describe, analyze , interpret, and judge the importance of *Constable's Salisbury Cathedral* by, closely studying for comparison and contrast, poster-size reproductions of Sisley's *Autumn Landscape* and Feininger's *Arch Tower I.*

- Students will make a construction paper landscape, separately cutting out at least 15 objects of varying shapes and reassembling them on a 9"x12" background so that the

illusion of deep space is created by overlapping, size variation, and position of objects relative to the horizon.

- After experiencing these first three activities, students will reflectively engage in a group discussion begun by the teacher's question "Why would an artist try to make art that looks real?" The students should support their opinions with logical reasons observable in the art works studied and respect and appropriately integrate other's responses into summarizing statements about how artists show depth on flat surfaces.

Activities

Activities engage the student in experiences planned to effect art learning that meets the art goals.

- The teacher guides students in an art criticism experience, comparing and contrasting the Sisley and Feininger works with the Constable reproduction as needed to help students perceive qualities of the Constable painting.

- Aided by the teacher's guiding questions students visually analyze the view out their classroom window by

 - Visually measuring sizes of similar objects near and far,

 - Comparing the position of objects within the area of cardboard frames is held to the window, and

 - Discussing how much of each object can be seen (in whole or part) and why.

- Students create the 15-object cut paper landscape picture to employ several means of showing depth.

- Students select artists represented by reproductions provided by the teacher and complete the art history worksheet the teacher designed. They use biographical sketches in simplified reference books or teacher files to gain information about the context of the artists' works.

- Students participate in the culminating aesthetics dialogue about art that is meant to look real. They discuss reasons why people might prefer art works that look like photographs.

Assessing Art Learning of Two Encounter Activities: Rating Scales

Art Criticism Experience

Imagine a group discussion of a poster- size art reproduction of Constable's *Salisbury Cathedral*. Note that this is part of the instruction, guided by teacher questions that elicit students' observations and thinking. The recording of the quality of student responses is not a test so much as a record of daily participation and the quality of students' thinking.

In this sample art criticism activity, the teacher examines the discussion to determine how well students learned (i.e., met the art criticism objective of the encounter). How well did each student

1. Identify objects that were indisputably part of the reproduction viewed?

2. Recognize how the artist composed the objects in the art work?

3. Interpret the painting?

The teacher could have a sheet with these questions for each student, but this becomes cumbersome to handle and record, while continuing to ask questions. If available, a teacher's aid who recognizes each student by sight and name could be trained to help. Either the teacher or an aide could make a chart with the students' names alphabetically arranged vertically and key words for the three questions (each criterion or expectation) heading a column. In the three columns, the teacher puts a number corresponding to the degree of learning evidenced by each student. Fully meeting expectations for the grade level being checked, could merit a "4" in the appropriate column on a scale of 0 to 4.

The assessment questions are asked silently by the teacher in regard to each child, while the tone of the discussion remains natural and is an actual learning experience. As the students respond to the teacher's guiding questions, the teacher marks on the prepared sheet to indicate who participated and with what quality as applicable to each criterion. If the teacher does not wish to fill in the chart during the discussion, he or she could note the students' participation by recalling the discussion at the end of the day, however, details are frequently lost by waiting to note them. Probably the best approach is to videotape the art criticism sessions and record the participation later as the videotape is viewed and reviewed.

Figure 8.1—Art criticism behaviors cumulative rating scale

Criteria

		Identified objects in the reproduction					Recognized the way the artist composed the work					Gave reasons for interpreting "natural"				
Students	Observation:	1	2	3	4	5	1	2	3	4	5	1	2	3	4	5
1 Jessica_____		3					4					4				
2 Mia _____		3					3					1				
3 Mark _____		4					3					2				
4 Henry _____		4					4					3				
5 etc.																

Coding Key: 0 to 4 with 4 fully meeting expectations down to 0 for no participation.

Also, the coding system could more simply be a plus (+) for an extended, supported judgment or interpretation of meaning; a tally (I) for a short, simple observation of an organizational fact; and a minus (-) for an incorrect or irrelevant response. The record of participation from a first art criticism experience (Observation 1) might look something like Figure 8.1.

Let us assume that the four scores given in Figure 8.1 were typical for the entire group and for each of the five art criticism activities. The teacher would observe that all students achieved at or above an acceptable level (3 or 4) in identification of objects that artists depict in a work (criterion 1), and in recognizing how artists compose the elements of line, color, space, texture, color, and shape or form in works of art (criterion 2). The column for interpreting works of art (criterion 3) has a wider range of scores for these third-graders. Thus these initial results indicate a need for improving instruction that encourages closer, more thoughtful examination of works of art for their meaning and evaluation. Subsequent samplings of student responses to similar art criticism experiences with different works of art should show improvement in these art criticism process behaviors.

Appendix B contains a blank form of Figure 8.1 for recording student capabilities in art criticism content and process behaviors. Teachers can make minor modifications to the wording of the criteria without changing the student outcomes and content area assessed.

Aesthetics Dialogue or Seminar

Art criticism discussions can continue smoothly into aesthetics dialogues—discussions about the basis for making judgments about worth of a particular work of art. Aesthetics looks at the big picture of the art world—what is called art and why, what good is art, and related issues about art.

To help expand the focus from the art classroom to the role and value of art beyond school, the teacher of our hypothetical encounter might ask open-ended questions about the meaning of the art experience for everyday life. The teacher may suggest that students refer to contrasting landscapes such as a Fragonard and a Kirchner where the artists chose to follow different rules of landscape painting to depict different attitudes, yet both are considered art by experts.

Asking for relationships between the activities of the encounter is one way to start, for example,

- "What did we try to do in our cut paper pictures that artists we studied also did?"

- "Why do we learn this if all artists don't have to draw or paint by these rules?"

- "Does something have to show depth to be art?"

- "Why would an artist follow the rules we learned in making 2-d art?"

The same coding system used for the art criticism activity, or a less specific one, could be used for oral or written responses. Figure 8.2 depicts the less specific coding system. Because a teacher cannot sum and average these marks without conversion to equitable numbers, assessment of group or individual learning would be a verbal translation summarizing recording codes over repeated incidents of dialogue or essay activities.

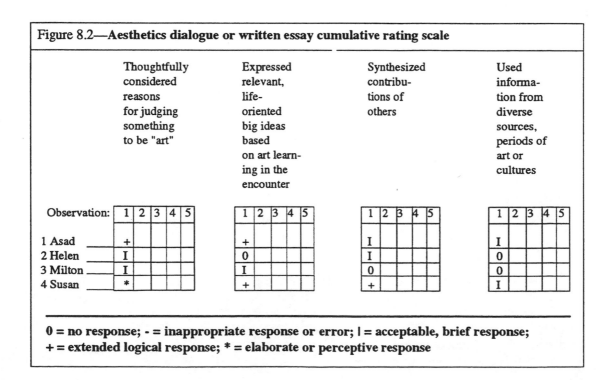

Figure 8.2—Aesthetics dialogue or written essay cumulative rating scale

Observation:	Thoughtfully considered reasons for judging something to be "art"					Expressed relevant, life-oriented big ideas based on art learning in the encounter					Synthesized contributions of others					Used information from diverse sources, periods of art or cultures				
	1	2	3	4	5	1	2	3	4	5	1	2	3	4	5	1	2	3	4	5
1 Asad	+					+					I					I				
2 Helen	I					0					I					0				
3 Milton	I					I					0					0				
4 Susan	*					+					+					I				

0 = no response; - = inappropriate response or error; I = acceptable, brief response; + = extended logical response; * = elaborate or perceptive response

A Seventh Grade Encounter Called "Deprogramming"

The seventh grade lesson meets the same general art goals as the third grade lesson. However, it takes account of and expands on what students learned in previous grades. "Deprogramming" means to overcome those visual constancies or ruts which interfere with seeing accurately, for example, seeing doors always as rectangles, even when in perspective they are trapezoids.

Encounter Objectives

Please see the third-grade encounter for a definition of encounter objectives. Objectives for this seventh grade encounter include

- Each student will read library material and write a two page report about the means used to suggest depth by artists of a certain culture or period.
- Students place sketches, drawn in the manner of the culture or period studied, on a visual image timeline at the appropriate date in history.
- Students as a group will describe, analyze, interpret and evaluate the importance of *Utrillo's St. Romaine Quarter* by closely examining, for comparison and contrast, poster-size reproductions of Evergood's *Sunny Street* and Springer's *Town of Enkhuizen*.
- Several visual analytical experiences facilitate development of concepts related to creating an illusion of depth. The teacher tapes a transparency to a window pane through which can be viewed a city scene demonstrating one-point perspective. Students then use a marker pen to draw over the contours of the buildings and parts of buildings that are viewed within the area of the transparency. Students, through analysis and discussion of their diagrams, will inductively formulate the principles that govern visual distortion of shapes as they recede from the viewer.
- Students will match swatches of construction paper with the colors of colored photographs of cities (from calendars or magazines) to perceive changes in intensity of colors.
- Using a contrasting color of marker pen, students draw details of near objects on their transparency diagram of the buildings, and the amount of detail that they can see on a similar, but very distant object.
- The students will use colored pencils to draw a 12"x18" cityscape that creates an illusion of about a twelve block depth by varying detail, varying intensity of color, and using a one-point perspective system in addition to means of showing depth learned in earlier art classes.
- The students will
 - Reflectively participate in a group discussion.
 - Respond to the teacher's question "To what extent is it important for an artist trying to create a cityscape to make it look photographically correct?"
 - Give logical reasons for opinions that are defensible by qualities in the works of art studied.
 - Respect other students' responses.
 - Synthesize others' responses with personal ideas when appropriate.

Activities

- The teacher guides students in an art criticism experience using the Evergood and Springer reproductions to compare and contrast as needed to help students perceive qualities in the Utrillo work.
- Students visually analyze the view out a window by diagramming the contours of a city view, differentiate colors near and far in photographs of city views, and compare details observable near and far in a city view.

- Students create a colored pencil cityscape.

- Students select a culture or period about which to investigate the means employed to indicate depth, write a report and make drawings, in the manner of the culture or period, to place appropriately on the art history timeline.

- Students participate in a culminating aesthetics dialogue about art that is meant to look real.

Traditional Test Variations

The following five examples on "Deprogramming," the seventh grade encounter, model traditional, forced-choice items for assessing art learning. A nontraditional option—a modified "comment line"—is added to the True-False item. A machine-scorable, noncued version of the completion item (Brallovsky, Bordage, Allen & Dumont, 1988) is given as a sample of recent attempts to foster more analytical thinking. The items reflect some of the concepts (needed for related art-production activities) that are developed by the visual analytical experiences and that are reinforced by the art history and art criticism activities of the "Deprogramming" encounter.

True/False. Mark true statements T and false statements F. On the lines below each item, rewrite false statements, by changing the underlined words, so that the statement is true.

1.___In our study of how people show depth in two dimensional art, deprogramming refers to what one's mind knows is true about objects (like tables or buildings) seen from a distance and drawing them that way.

Answer: F In our study of how people show depth in paintings and drawings, deprogramming refers to what our mind knows is true about objects (like buildings) seen from a distance and how our eyes see differently, creating the need to distort the known shapes when drawing them on a 2-d surface in order to look "right."

Completion. Refer to the alphabetized list below and, on the blank, write the number of the word which specifically and correctly completes the sentence.

2.___ Unless your view is almost directly up or down in drawing a cityscape, verticals are _____ to the sides of your paper when using the formal system of perspective.

1 adjusted	6 drawn	11 joined	16 parallel
2 attached	7 extended	12 made	17 perpendicular
3 bunched	8 faced	13 nearer	18 related
4 colored	9 focused	14 necessary	19 scaled
5 directed	10 held	15 overlapped	20 sketched

Answer: 16

Matching. Write the letter of the reproduction (shown on the separate sheet) that is best characterized by or matches each of the following phrases:

 ____3.1 employs a one-point perspective system to indicate depth
 ____3.2 uses aerial perspective
 ____3.3 only color values create depth
 ____3.4 extreme size variation creates deep space
 ____3.5 no attempt at realistic illusion of a 3-d space
 ____3.6 technique creates an illusion of form by a visual blend of color
 ____3.7 represents Bauhaus break with tradition
 ____3.8 multiple vanishing points

*Multiple Choice.*___4. Write the letter of the reproduction (posted on the bulletin board) that demonstrates the artist's use of two-point formal perspective principles.

*Unlimited Multiple Choice.*___ 5. Write the letter(s) of the reproductions (posted on the bulletin board) that clearly demonstrate(s) foreground, middleground, and background.

High School Encounter Called "Art of the Human-made Environment"

The high school Art I encounter meets the same general art goals as the previous encounters at grade levels 3 and 7, but expands on what students learned as indicated by the encounter objectives. (Encounter objectives are defined under the third grade encounter.)

Encounter Objectives

• Students will compare and contrast two of the following depictions of interiors by artists of two different cultural or time periods in a written paper: Toyohiro. *Four Accomplishments No. 2*; Memling, *Presentation in the Temple*; DeHooch; *The Pantry*; Van Gogh; *Railway Bridge* and *Restaurant LaSirene*; Matisse, *Flowers and Parrots*; and Woodville, *Waiting for the Stage.*

• Students will examine architectural drawings and observe strategies of architects during a class visit to an architectural firm, noting ideas in a sketchbook.

• Having discussed theme parks that they have visited, the students will photograph clusters of buildings or potential structures for a theme environment using a box camera, so that a wide range of values is achieved.

• Students will visually analyze the photo prints taken in terms of the mood suggested by the value range of a print.

• Students will orally describe, analyze, interpret and evaluate DeHooch's *The Pantry* after individually writing responses to the questions posed by the teacher.

• The student will make an imaginative watercolor painting of the interior of a theme shopping mall, using principles of formal perspective to accurately depict structures involving two or more vanishing points.

• The student, after examining architectural magazines, will construct a 3" to 6"–deep relief of an original and inviting facade to the thematic mall's entry using cardboard, paint, and other materials.

Activities

The students engage in art historical research as they compare and contrast paintings depicting interiors or views involving multiple vanishing points. They should focus on the attitudes of people at different times and places that effect the depiction of reality. The choice of theme for a mall invites thought about the effects of universal interests and concerns on decisions of architects who plan aesthetic environments for entrepreneurs.

The visit to an architectural firm involves visual analysis of drawings and analysis of the behavioral processes or strategies of the architect as a functional form is given aesthetic qualities. The sketchbook or portfolio, in which students collect their graphic and verbal ideas, is the subject of later analysis and reflection before beginning the art production activities.

Analysis continues as students select a site and subsequently review prints of structures in terms of the effects of light and dark on the illusion of depth and mood.

Students engage in the inquiry behaviors of art critics as they discuss the DeHooch interior noting the different degrees of depth and use of the formal system of perspective to depict deep space in a human-made environment.

Students synthesize ideas and apply concepts of depicting three dimensional objects on a two-dimensional plane as they create their watercolor. The problem of the cardboard construction involves actual depth and can be a companion presentation piece with the water-color.

The discussion of these finished products is planned to lead into an aesthetics dialogue and inquiry into the form-versus-function issue of structures in the human-made environment. The teacher may lead into the discussion with the questions like "What kinds of liberties can an artist take with the form of functional objects or structures? Why is there a limit to the artist's license to do so, or why not?"

Art Production, Behaviors

Art Production and Art Related Behavior

The criterion-referenced rating scale depicted in Figure 8.3 assesses both conceptual content evidenced in the art product and art behaviors shown as the student worked on the project. The behaviors check the students' inquiry approach to solving the problem. That is, did the student show originality, serious engagement or exploration evidenced by the challenge accepted and complexity of the idea or product, and the care that results in fine technical quality. Other criteria represent concepts that, if grasped by the student, enable success in making this problem solution a work of art.

Figure 8.3's key to rating the quality of student work on each criterion assumes that the top rating means top *within that range of the continuum of success that can be expected for the high school student group involved* (not as a mature artist nor as a second grader). The teacher and student may have duplicate assessment forms if student self-evaluation is desired. Ratings are marked in the open squares where a task and a criterion intersect. Where the square is shaded, that criterion does not apply to the activity. Thus, the two end products, numbers 4 and 5, must meet more criteria than activities 1, 2, and 3 that are designed to *prepare* the student for the production activities. Actual depth is important to the construction, but it figures into the assessment of only one activity. The criteria averages may be weighed differently if some are deemed more important to the outcome than others.

Assessing the concepts learned as evidenced in the art products is educationally sound. It also allows those averages to be totaled with other concepts' averages for a summative

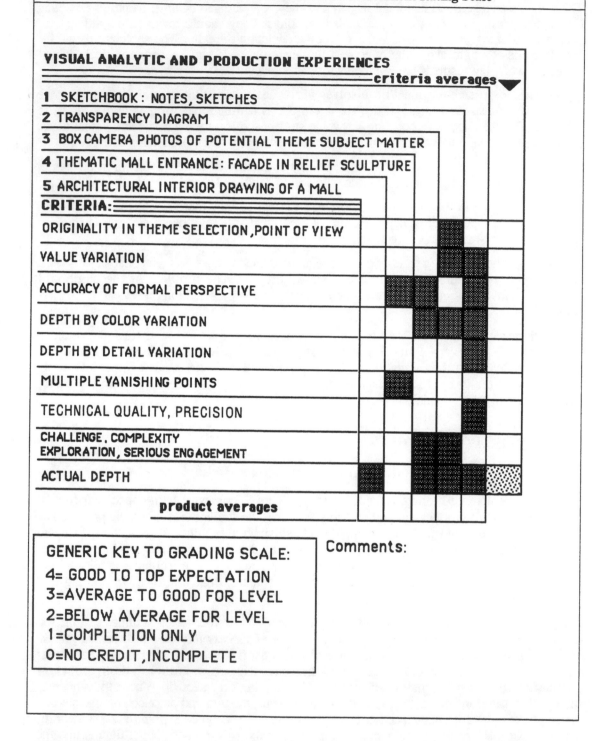

Figure 8.3—Encounter: Art and the Human–Made Environment Rating Scale

VISUAL ANALYTIC AND PRODUCTION EXPERIENCES

criteria averages ▼

1 SKETCHBOOK: NOTES, SKETCHES
2 TRANSPARENCY DIAGRAM
3 BOX CAMERA PHOTOS OF POTENTIAL THEME SUBJECT MATTER
4 THEMATIC MALL ENTRANCE: FACADE IN RELIEF SCULPTURE
5 ARCHITECTURAL INTERIOR DRAWING OF A MALL

CRITERIA:

ORIGINALITY IN THEME SELECTION, POINT OF VIEW

VALUE VARIATION

ACCURACY OF FORMAL PERSPECTIVE

DEPTH BY COLOR VARIATION

DEPTH BY DETAIL VARIATION

MULTIPLE VANISHING POINTS

TECHNICAL QUALITY, PRECISION

CHALLENGE, COMPLEXITY
EXPLORATION, SERIOUS ENGAGEMENT

ACTUAL DEPTH

product averages

GENERIC KEY TO GRADING SCALE:
4= GOOD TO TOP EXPECTATION
3= AVERAGE TO GOOD FOR LEVEL
2= BELOW AVERAGE FOR LEVEL
1= COMPLETION ONLY
0= NO CREDIT, INCOMPLETE

Comments:

assessment of student learning of art concepts. Group averages for concept attainment can also be calculated from such accumulated records.

Sketchbook or Portfolio

The portfolio contents could include journal entries, relevant notes from outside class experiences, thoughts that might work in future ideas, and the like. A teacher log book could note student contributions that do not fit the criteria at this time, but indicate other qualities that coincide with art learning goals and objectives. The student self-evaluation may be in narrative form or done on the same format as the teacher uses. It can be a cooperative process with the teacher and student, or each can be completed independently with comments added and discussed later. Depending on the specific assessment means, occurrences like repeated trends or frequency of types of comments can be noted in narrative form by the teacher portraying individual progress, dominant group responses, or unanticipated evidence of learning.

Summary

The samples explained in this chapter can be reviewed as follows:

ENCOUNTER	GRADE	CONTENT AREA	DATA SOURCE	ASSESSMENT INSTRUMENT
When eyes tell lies	3	art criticism aesthetics	group discussion group discussion essay (upper grades)	rating scale rating scale
Deprogramming	7	art history	traditional test nontraditional changes	multiple-choice true/false matching comment line, noncued completion unlimited multiple choice
Art of the Human-made Environment	HS	art production visual analysis art behaviors	unit criteria for art products sketchbook, journal, student self-evaluation	rating scale comments, notes, self-report, comments

The reader is encouraged to plan comparable situations for gathering information about what students are learning and adapt these instruments to the criteria which the lesson addresses. Unfamiliar methods of assessment become more comfortable as they are used in particular art education situations. Teachers can try one until it seems to be working well, then try another until evidence of student achievement of all important outcomes or goals is being recorded for assessment.

9

PROCEDURES FOR DEVELOPING ASSESSMENT INSTRUMENTS

The recommendations in chapter nine are based on the foundation of previous chapters. The art content and behaviors described in chapter four are built into the sample activities in chapter eight with a preview as to how learning in those activities might be assessed. In chapter six, art content and behaviors are matched to goals and suggest assessable art learning situations. Chapter nine continues the analytic-holistic marriage in an effort to avoid the hazards of uninterpretable data (i.e., scattered bits of information or fuzzy, global assessments). The basic issue of validity is followed by general assessment guidelines, information about decisions related to constructing instruments, variables in determining expected achievement levels, piloting instruments which may lead to revision, and procedures for establishing reliability of assessment methods.

Does an art education consist of knowing that lines can vary in thickness or that Gauguin painted in Tahiti? Why do we teach contour drawing? What is important to learn in art? What assessment instruments are needed—traditional fact-recall items or something else? What is worth assessing ?

Authentic Experiences

Specific bits of information do contribute as people solve problems in real life situations. Likewise, specific components of art encounters should contribute individually and interactively to meaningful creating of and thinking about art. Meaningful art tasks, or authentic experiences, are enticing to students because they have real life intrigue, ambiguity, and complexity; enable purposeful interaction of subordinate learnings; and encourage synthesis of a variety of kinds of experiences (Wiggins, 1989; Zimmerman, 1992)

Authentic art experiences encourage higher order thinking. In discussing student formation of higher order rules or problem solving, Gagne and Briggs (1974) write:

> In attaining a workable solution to a problem, the student also achieves a new capability. He learns something which can be generalized to other problems having similar formal characteristics...a 'putting together' of certain rules

which may not have been previously applied to similar situations in the past history of the individual who is solving the problem. (p. 45-46)

[Excerpt from PRINCIPLES OF INSTRUCTIONAL DESIGN by Robert M. Gagne and Leslie J. Briggs, copyright © 1974 by Holt, Rinehart and Winston, Inc., reprinted by permission of the publisher.]

Students are challenged to engage in higher order thinking by real-life tasks—case studies, problems to solve, or scenarios—that they perceive as meaningful. Battin et al. (1989) offer puzzles about art—problems to which students can bring previous learnings to bear in order to arrive at solutions or conclusions, or formulate generalizations or "big ideas" about art. A puzzle could be an aspect of a larger real-life task for which students would need to research, write, design and/or create art. News items about art (e.g., fakes, environmental issues, public art) can be the subjects of authentic tasks identified by teachers and/or students.

Authentic art experiences, integrated encounters, or focused portfolios involve many behaviors and areas of content, provide multiple indicators of achievement, and thus, require multiple means of assessment and varied criteria for validating the learning that occurs (Gitomer, Grosh, & Price, 1992).

Validity

Art assessment should have validity. This means that (1) the instruments assess what they claim to—the curricular goals or outcomes (content validity) or (2) the definitions and applications of criteria, used to assess behaviors in an authentic experience, accurately represent the construct (construct validity).

Content Validity

The triad of curricular goals, instruction based on those goals, and assessment of outcomes resulting from instruction contributes to content validity. Content validity of a total assessment program would assess student outcomes that represented attainment of each curricular goal. Figure 6.2 shows a way to begin to establish validity of an assessment program by analyzing the relationship between content, behaviors, and goal or outcome statements. Planning authentic experiences to meet goals, and to comprehensively address the knowledge and behaviors identified, still allows for recognition of unanticipated learning. This systematically valid assessment approach may involve more challenging logistics of preparation, administration, and scoring, but "the efficiency in current testing practices is greatly outweighed by the cost of using a system that has low systemic validity" (Frederiksen & Collins, 1989, p. 32). In other words, simple ways of assessing do not tap the meaningful learning that art educators want their students to achieve.

Resnick (1980) recommends "item-banks" to make content-customized measures of achievement which, by definition, are content-valid measures. Wiggins (1992) suggests much the same idea as a "tool kit" of exemplary tasks and criteria through which students could provide evidence of achievement of art goals and outcome statements. Refer to Figure 6.3 for help in beginning to create such a content-valid tool kit. Types of art learning situations are indicated that would meet a goal through the content and behaviors addressed in such a situation. One could plan the specific scenario of an authentic assessment task to fit within those general parameters. For example, "Given a choice of reproductions of portraits, plan a birthday party for someone who looks similar to the portrait chosen. Based on your critical examination and interpretation of the portrait, and historical research of the possible contextual influences on it, create whatever is necessary to plan an appropriate party (invitations, sketches, finished drawings, or paintings of the decorated setting, etc.) for the portrait's real life 'twin'. Document your research, reflections and decisions during this planning process in a journal."

Three benefits derive from referring to carefully considered outcomes or goals to guide the comprehensive design of authentic assessment tasks: validity of the assessment, meaningfulness to the student, and curricular improvement. Recommendations for designing

assessment necessarily are general, but by analyzing the birthday task just described an assessment could be based on observations of such goal-related performances (Figure 6.2 goals) as:

- Student inquiry and organizational abilities evidenced by *relationships perceived* between art historical facts or contextual influences and the qualities of the portrait (Goal 5, meanings of art of other cultures).

- Student perceptual and organizational abilities in *interpreting* the portrait (Goal 6, support interpretations with reasons).

- Student *experimentation leading to control* of and ideas for using media and technical skill in depicting the imagined scene (Goal 7, control of tools and media).

- Student *innovative, divergent thinking* in conceptualizing the translation to a party for a contemporary person (Goal 1, solve problems innovatively).

- Student *deliberation and synthesizing* ability (Goal 8, reflect on and synthesize art experiences).

Achievement of goals not addressed in this task would, by design, be assessed through other tasks.

To ascertain whether the assessment instrument(s) adequately assess the goals or outcomes stated, one needs a sympathetic, informed critic (a knowledgeable art educator) to examine the assessment instrument(s) for the cohesiveness of goal statements, instructional experiences (art content and behaviors that enable students to meet outcomes desired), assessment tasks, and intentional evidence of learning (criteria).

Construct Validity

Art assessment should also meet the requirements of construct validity. The definitional fit between a psychological construct of a goal (e.g. reflective thinking), assessment criteria, and the observable evidence can demonstrate construct validity. Frequency of answers in an art criticism experience is not a valid criterion for reflective thinking, whereas thoughtfulness in answering could be one indicator.

Direct, Subjective Systems Assessment

Because objective, indirect tests (achievement inferred from multiple choice, true-false, or completion items) frequently miss valuable outcomes of art education, Frederiksen and Collins (1989) recommend systematic valid assessment that is direct (observation of actual behavior) and subjective (requiring scorer judgment). Norris (1989) supports a direct assessment, also, of critical thinking. In his research, as respondents made credibility judgments, the teacher/assessor compared the students' multiple-choice test answers to their verbal reports of thinking (tape-recorded thinking aloud, justifying multiple choice answers, or thinking prompted by specific information in the multiple choice question). It is reasonable that Frederiksen and Collins' direct and subjective systems approach could also produce more viable implications for curriculum and instructional change in art. Wiggins (1991) also suggests that long-term assessment of performance assessments might be judged valid by their effect on teaching and learning (sometimes referred to as consequential validity).

The sensitive teacher is at the hub of assessing art learning. Eisner (1992) asserted that such a teacher must invent assessment systems congenial to his or her values. Creative art teachers who are sensitive to the nature of art can use their divergent thinking capabilities to design ways to observe student achievements that are compatible with the goals of art education. They can reflect on the kinds of informal verification of student learning in art that they subliminally

ingest, accept, and appreciate, then convert these incidents of informal verification to structured means for consciously and systematically recording the evidence that, heretofore, they have casually accepted.

Task-tool Appropriateness

Obviously, creating meaningful tasks precedes the choice of assessment procedures and must continue the process of establishing assessment validity. Figure 9.1 reviews the process explained in Chapter 6 (shaded areas) and continues the analysis of a hypothetical authentic task. In Chapter 6, comprehensive content and behaviors, derived from the disciplines most closely related to art education, were identified. Sample goals were inserted on the figure where the goal inferred certain behaviors interacting with certain content. Subsequently, types of art learning situations were added where they could provide evidence of meeting a respective goal.

The art behaviors, consistent with the emphasis on assessing performance, serve as a bridge from the curriculum structure to the instructional experience aspect of establishing validity of the assessment. In the middle section of Figure 9.1, components that might comprise a teacher-designed authentic art experience exemplify evidence of learning related to the art behavior under which they are placed. The authentic experience may meet one or more art goal or outcome statements. The contributing components include concept or skill development activities, knowledge acquisition activities, reflection and relating activities as well as problem solutions.

When authentic tasks have been created that enable students' performances to provide evidence of learning, assessment instruments to record that evidence must be appropriately matched to the nature of what is being observed. Below the components, in roughly similar positions, are assessment instruments that could be used to record student learning from each situation. Situations suggested on Figure 6.3 could be analyzed for task-tool appropriateness in similar fashion. Decisions about appropriateness may be based on such criteria as level of thinking expected, unobtrusiveness, the fugitive nature of the evidence (as in a discussion), need for openendedness, the instructional nature of the activity, or the nature of the students.

Figure 9.2 shows a broader scheme for deciding on the types of assessment instruments that might be used depending upon the fit between the content and behaviors addressed in art education learning experiences. An attempt is made in this illustration to limit the types of assessment instruments, but each instrument can be used with a variety of content or experiences as follows:

1. Trend studies (TS), with journals or "think sheets" for evidence of continuing conceptual experimentation, evolving questions and insights, patterns of behavior, trends that contribute to successes or unproductive ends, and/or emergence of new directions.

2. Checklists (C), for noting or tracking in-process behaviors, interaction in discussions, student-to-student respect, informal concept-developing exercises, or work sheet completion.

3. Content analysis (CA), for cataloging contents of student-initiated stories, comments, letters, journal selections, sketches, newspaper clippings, plans, or the like, any or all of which may be included in a portfolio or exhibit of individual projects.

4. Tests or quizzes (T), for checking recall of factual information.

5. Rating scales (R) to assess the quality of student interpretations of an art work in a group discussion; of art products by criteria, for example, the "logical combination of incongruous objects" or "employment of transformations to create a fantasy world"; of art history reports; of essays; of aesthetics dialogues, and so forth.

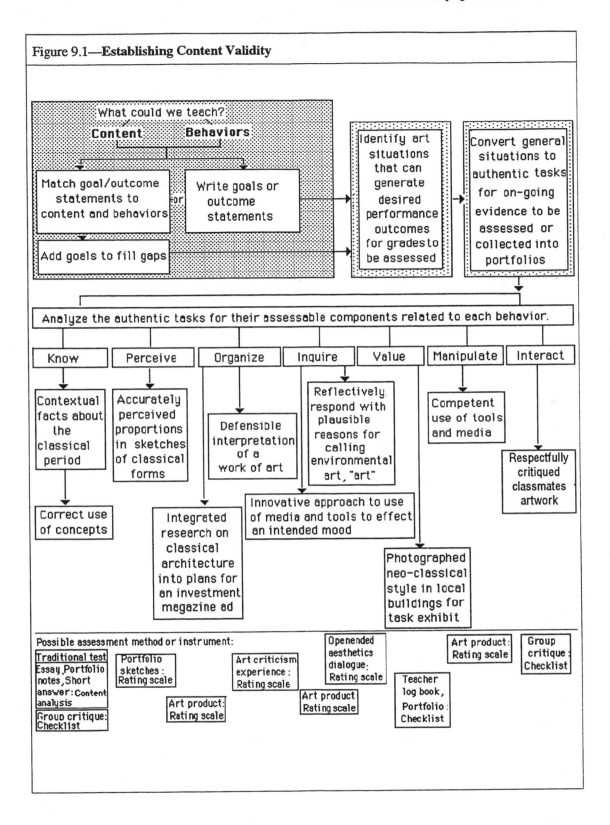

Figure 9.1—**Establishing Content Validity**

Figure 9.2—Suggestions for instruments by which to assess the interaction of art behaviors and content

ART CONTENT	Know	Perceive	Organize	Inquire	Value	Manipulate	Interact/Cooperate	Community Concern
Aesthetics								
Contextual value: Art world/social world			R	R				
Characteristics: Aesthetician's approach, aesthetic experience				C	TS		C	
Theory/Issues categories: What is art?	W		R	R	C		C	
Art Criticism								
Criticisms written by critics				R				
Types of criticism			R	R				
Stages of the critical process				R	C		C	
Art History								
Research methods	W			C				
Contextual influence: attitudes/institutions			R	R	C		C	
Facts, attribution: time, location	T		C					
Assoc. w/style, artist, period, culture	T		C					
Art Production								
Synthesis: Creative problem solution			R	R	CA	R	C	
Strategy, technique			TS	TS	CA	R		
Tools, materials, equipment	T	W	CA			R		
Processes, areas	T		CA			R		
General: Visual arts disciplines								
Elements of visual art		W		C		W		
Principles of organization	W	W				C		
Community concern for content								

ART-RELATED BEHAVIORS

KEY: Assessment tools or instruments:
C = checklist CA = content analysis TS = trend study R = rating scale
T = traditional test or quiz (multiple choice, unlimited multiple choice, true-false, completion matching)
W = Worksheets, educational games

6. Worksheets (W), for assessment that is part of instruction and on which further successes depend, such as learning games.

There are some ways to ease the assessment task. One criterion can appear on assessment instruments used with different content. For example, interaction (i.e., positive regard for peers, cooperation, respectful disagreement) can be a criterion during art criticism experiences, an observation logged by the teacher, a revelation in student journals, or an item on a checklist

kept during student critiques of their art work. An inquiry approach can be noted in regard to aesthetics dialogues, media experimentation, art criticism interpretations, art history activities or research, or the development of art work. Organize behaviors are observable likewise in oral, written or art productions. Values can be expressed in regard to historical/cultural works of art, peers' work, one's own art work, art in general, or any experience of art education. Multiple criteria on one assessment format allows the efficiency of observing a variety of evidence from any single situation.

In addition to multiple use of fewer instruments, assessment may focus more on the end outcomes identified. In such a case, rather than individually check specific learnings, the teacher assesses how contributing learnings were synthesized effectively and with intent (high level of organization for "x" grade level).

That is the result of a different approach to establishing content validity shown in Figure 9.3. In this approach, major goals or outcome statements relating to the discipline's content provide the structure.

Experiences planned to address that content were placed in a column below each goal together with the type of instrument that fits the situation. Through analyzing each learning experience, the behaviors critical to the students' successes are identified. Where lower level behaviors can be inferred by the success of higher behaviors, no specific assessment is made. For example, interpretation and judgment (organize behaviors) depend on perception. If the assessment instructions alert students to consider all necessary contributors to an interpretation of a work of art, a teacher may fairly assume operation of the *perceive* category of behaviors (description and formal analysis stages). Specifics about the elements contribute to relatedness between and organization of all elements in a work of art, so each element or variation need not be separately assessed.

Choices and Decisions

Specific and Holistic Assessment

The specific or holistic decision could be determined by how much time the teacher can spend on assessment. Hamblen (1992) warned against the temptation to simplify the qualitative aspects of art education to easily testable, but meaningless, data. Rather than focus on each bit of knowledge or each individual skill, the assessment should focus on their integral, combined contribution to the solution of the problem. For such holistic assessment, one can use appropriate criteria to guide the observation (e.g., "The student incorporates variations of elements and imagery that consistently contribute to the overall mood of the work"). The degree to which this criterion is achieved is noted by the teacher who, considering the many possible variations of the elements incorporated, looks for meaningful relationships created by the elements and imagery chosen. It may be that several elements relate differentially to the mood. Even carefully making global judgments which involve teacher inference can lead to inaccuracies or inconsistencies—a reliability issue addressed in this chapter.

External Preordinate Versus Internal Responsive

Part of the threat of state tests is the possibility that what is deemed comprehensive to external test makers might not match local art curriculum goals nor actual instruction. There is a feeling of more ownership when teachers assess what they know they have taught. If this internal responsive assessment is the choice, teachers must examine the comprehensiveness of their art goals and goal-relatedness of the actual classroom experiences provided students (Table 6.3), and assess those experiences. Planning assessment procedures and constructing instruments is

Figure 9.3—Sample assessment options in reference to goals

GOALS

The student will:

interpret works of art based on sensory, formal, technical, and expressive qualities and cultural values evident in the work.	create meaningful visual syntheses which effectively employ media, processes and tools to convey ideas through visual qualities and symbols.	solve problems that entail search into the historical and contextual influences on works of art across time and cultures.	reflectively form pervasive generalizations about the nature and value of art that have meaning in today's world.
Rating the quality of student responses to teacher questions in group discussions of an artwork or reproduction **O,I**	Rating the use of concepts taught in art product **O**	Criterion-referenced rating of oral or written reports on artist periods,cultures, styles. **O,K**	Rating responses to open-ended questions in group discussions about the nature or value of art related to the big idea of the art lesson **O,V, I**
Multiple choice questions about art reproductions in test or posted in the room **K**	Correctly describe the concepts used in making own artwork effective. Checklist. **O**	Nontraditional tests asking for diagrams to illustrate concepts used in reproductions displayed **O**	Rating the content and quality thinking in term papers on issues about art **O, I,K**
Matching games of sample techniques, or titles with un-familiar reproductions **P**	Show innovative thinking in evaluation of own art works as checked by a check-list periodically **I**		Rate journal entries for evidence of voluntary visits to art shows,insight-ful comments **V,P**
Rating the quality of a short essay describing a work of art displayed includ-ing its organization, meaning and worth. **O, I, V**		Behavior checklist: experiments to discover unique use of media appropriate for the idea **I, M, (K)**	Constructively critique fellow student work **C**
		Rating scale for technical quality of art products **M**	

> **KEY:** know (K), perceive (P), organize (O), inquire (I), value (V), manipulate (M), and interact/cooper-ate (C)

challenging and time consuming. Teachers will need to resist the convenience of traditional assessment formats which inadequately match actual art experiences and learning to be achieved through them.

Low-cost Traditional Versus High-cost Authentic Assessment

Qualified inspectors must approve the construction of a physical building. Likewise, it takes trained human resources to make judgments about student learning in art. Making judgments from direct observations of student performances involves a high level of inference and, therefore, of expertise. Low inference only is needed to summarize directly observed evidence of learning. Objective tests involve low inference in scoring, but high inference when those scores must be given meaning and interpretation about student learning, because they are indirect indicators of the actual art learning experiences. Student critiques and self-assessments are meaningful only when parallel time costs are accepted and precautions taken for psychological safety. Making judgments from direct observation of authentic tasks has a high time and expertise cost resulting from the need for creating recording procedures and instruments; obtaining art reproductions for equal opportunity, defining the criteria by a range of exemplary diagrams for scoring accuracy, and so forth. More time is involved to administer, analyze, summarize authentic assessments than traditional objective tests, but the costs are justified by the validity of the conclusions. Just as in teaching art, if what the assessment demonstrates is inaccurate, what is its point? Teach, and assess, *less* (in amount), but *better* !

Audience Expectations: Comparability or Autonomy

Art teachers confront expectations about assessment from a wide audience of concerned persons, some of whom worry about the consequences of high-stakes, one-shot accountability tests (Brandt, 1992). Nevertheless, some states have developed goals for the fine arts and parallel, one-shot assessment instruments. And it is still to be determined how national arts standards will be interpreted across the U.S. in terms of assessment.

Some school districts interpret the need for local assessment to mean the creation or enhancement of a summative, district-wide arts assessment instrument. Many meetings may be needed to build consensus among arts specialists, whose varying agendas influence ideas of the instrument's proper content and context. Often it is believed that the wider the coverage of a single assessment tool, the greater the comparability between districts or between schools within a district.

Ongoing assessment of authentic experiences represents a great deal of autonomy. But some districts will accept, in addition to or in place of a single district-wide instrument, ongoing assessment as part of the art instruction. Some districts may want a combination of traditional instruments and nontraditional assessment of authentic experiences. According to Meyer (1992), if the portrait task described earlier in this chapter was selected, after the fact, from a collection of work done under natural classroom conditions, its assessment would be classified as an authentic performance assessment. If it were conducted during a separate test time—a contrived context—it would be classified simply as a performance assessment.

Regardless of the teachers who have their curriculum and particular audience expectations, ongoing assessment plans in good shape can probably work with any requirements with integrity.

A teacher can always assess in excess of mandated procedures if they should seem incompatible with one's curriculum in challenge, authenticity, or comprehensiveness.

Vocabulary and Age-level Conceptions of Time

A teacher's instruction should be at the conceptual level of the student, in order to build onto the sophistication of concepts already held. Introducing ideas beyond the conceptual level of students contributes to student confusion. Likewise, terms should be used in assessing learning that students understand or have been taught.

Fine arts goals that focus on art history must consider the child's understanding of time in both teaching and assessing learning in that discipline. With primary level children, teachers should use terms "long ago" and "way back when." Working with a simplified time line (color coded and to scale) is a concrete means by which to develop a spatial sense of time. A question "Was this art work made this year or long ago like when your grandparents' grandparents lived?" uses a concept of long ago based on a relationship familiar to most children.

Preadolescents can associate quantitative information to general time terms. They will understand ideas like "colonial times which were about 300 years ago." This age group can order periods or events and associate events with a time span and dates. A teacher could ask preadolescent students to place Impressionism, Post-Modernism, the prehistoric era, and the Renaissance in the order in which they occurred in time.

Twelve-to fourteen-year-olds generally can grasp the meaning of such terms as "decade", "century", and "generation" (20 years). They can understand and use interchangeably such time indicators as the 1700's and the 18th Century. Given appropriate instruction, these students could respond to a question like "What economic conditions influenced art in the decade beginning in 1925?"

As a general rule, the frequency and concentration of time terms used should be fewer in teaching and assessing elementary students than junior high or high school students.

Language Neutrality

Language used in teaching and assessment should consciously avoid contributing to continuing any kind of bias. Bias can occur based on ethnicity, socioeconomic status, gender, religion, geographic region, disability, or age. More complete research about these concerns exist in the field of art education (see Collins & Sandell, 1984; Turner, 1990; Young, 1990). It is perhaps, enough to state here that any student should be allowed an equal opportunity to provide evidence of learning without the distraction of bias in the question being addressed. Thus, stereotypical conceptions of status or strength should be avoided in phrasing assessment questions. For example, in an attempt to give primary credit to the source of influence, the completion item "Picasso borrowed imagery from African masks for his painting_____." could be restated as "The imagery of African masks motivated Picasso's painting, _____."

Gender bias occurs in reference to occupations, activities, roles, and emotions stereotypically ascribed to either sex. To counter bias, teachers can

- Consciously connect references to women or men to their nontraditional occupations, activities, roles and emotions.

- Balance references to traditional ascriptions with nontraditional ones (e.g. , females as gallery directors, site-specific sculptors, major artists, and "courageous" or "strong" without the addition of "for a woman").

- Avoid assuming that a female and child is a mother and child.

- Be careful of assumptions about the gender of children in works of art where it is not very apparent.

- Avoid stereotypes in regard to careers, jobs, or lifestyles and expectations that disregard choices for women and men. (The question: " In general, who were the people whose portrait commissions helped women artists survive?" has a double bias. There is a bias in favor of the "good" rich social class and a bias against the woman artist who, supposedly, could not survive without help).

- Ascertain that terms used to refer to a nationality, race, or ethnic group are currently acceptable to that group. Usually, greater specificity is preferred to general terms, slang, colloquialisms, or awkward phrasing.

- Look for opportunities to use art exemplars in planning assessment that represent both genders and multiple cultures.

- Avoid questions that have a favorable bias to groups of a certain social or economic status.

- Interpret artworks showing people with disabilities as integrated with other members of society, as contributors, and not as objects of curiosity.

Appendix C contains a list of suggestions for substitutions of terms to avoid bias.

If teachers should assess what has been taught, then the recommendation of content inclusiveness means that art history should represent the cultural diversity represented in our nation for a well rounded education for all. The National Evaluation Systems' 1990 book, *Bias concerns in test development* maintains, "While people of different backgrounds participating in group activities should be depicted as equals in a social and political sense, this should not be done by neutralizing the distinguishing characteristics of diverse minority groups" (p. 9).

Determining Achievement Level Expectations

Even though criterion-referenced assessment, by definition, assigns a top rating to "mastery," an alternate interpretation conceives of mastery as being the top of a range that is appropriate for the grade, age, or conceptual level of the students being assessed (not as an artist's achievement level).

Teaching experience at a variety of levels helps teachers to know what range of responses to expect within a grade level. If undecided teachers could pilot a questionable item or task at several levels to establish approximate expectations. If teachers lack experience, or the time for pilot testing, they could base their expectations on developmental psychology texts for the proportion of students at a given grade level that may meet described performance standards. For example, Rouse (1971) suggested age-based levels of perception, cognition, decision making, and performing. Clark and Zimmerman (1978) suggested discipline-related levels of performance for four levels of naive to sophisticated learners.

Figure 5.2, in Chapter 5, shows levels of attainment relative to basic art behaviors. The highest performance levels for which the task is designed for a particular grade level would suggest a mastery level of performance expected unless a no ceiling, "above expectation" rating is established. National arts standards and grade levels of achievement indicated for each may also serve as a guide. Or one might establish slightly lower expectations of achievement for baseline data of first assessments, with the anticipation that showing improvement is possible at subsequent ones, after teachers make curricular and instructional modifications.

Not all school districts are comparable in the personnel and materials resources that can be provided. If national standards suggest a level of mastery for all students at a grade level, some school districts can anticipate lower achievement levels—baselines from which to improve. Where lower standards are the reality, Wiggins (1989) recommends equating them to some credible wider world standards. If a teacher or district is confronted with a very heterogeneous group, a baseline indicating percentages of the group expected to meet two or three levels of passable achievement might be established.

To define each level of achievement for scoring tasks or items accurately, a teacher can use examples, written or graphic, to show what qualities would be credited at each level. Examples of answers for each rating of a student responses should clearly indicate that the ratings are *descriptive* (e.g., gave two reasons observable in the artwork, gave personal opinions, did not support judgments), not *comparative* (e.g., bad, good, best).

Teachers need to ascertain district or state positions on assessment of students with disabilities or language barriers. In some cases, advocates of assessment see excusing students with disabilities as disallowing them to demonstrate what they can do. However, excusing students with severe disabilities from assessment tasks may be valid when the reason for their inclusion in the art class is for motivation and social contact with peers.

Piloting and Revising Instruments

Piloting an assessment instrument means giving it a trial run in a natural situation. The purpose is to improve the instrument by analysis of the responses. Sensitivity to contextual differences, such as looking at responses to the same item at a sequence of grade levels, would help in specifying different expectations due to the age variable.

Some elements to consider when piloting or revising an assessment instrument include

- *Expansion or deletions.* Assessment instruments, where students generate responses, may reveal unintended or unanticipated learning. Comment lines or spaces on objective instruments can expose misunderstandings, not just a wrong response due to a remote possibility. Content analysis of written work and voluntary task extensions may suggest additional criteria or omissions of meaningful emphases.

- *Clarity.* Interviews with students may verify the need for clarity of instructions, intent, visual diagrams or reproductions, or format. There may be a need for rewording if a reading specialist analyzes the written components for grade level readability. Examples should be clear and the reproductions of works of art should have good contrast, if not color.

- *Friendliness.* Authentic experiences are intended to be meaningful to the student, so student attitudes and perceptions about assessment of such tasks should be sought. The administrator of the assessment may have made important observations about student reactions. An observer can note whether the administrator read instructions with normal inflection of the voice.

- *Fairness.* Fairness is challenging with heterogeneous groups with different reading levels, disabilities, and language barriers. Some schools translate verbal instructions to the language of the student and retranslate student responses back to English for assessment. The structure of the instrument, specificity of the criteria, and definitions of the ratings should be examined to overcome tendencies toward favoritism and generosity errors. Accuracy of recording evidence can be checked by an additional rater or raters with comparable qualifications using inter-rater reliability techniques discussed under the reliability section of this chapter.

- *Function.* To ascertain how an instrument is apt to function, a teacher would ask if the instrument is adaptable to a variety of situations and feasible in terms of time, preparation, recording and scoring, and resource needs. Authentic performance assessments should be usable in a natural classroom setting as opposed to a contrived test situation. Finally, do students perceive the social usefulness of the task as a meaningful, real-life application?

Reliability

An instrument for observing art learning—test or other means—may be valid, but in addition, it must demonstrate reliability or consistency. Consistency means how similarly the student performs in close repetitions of a measure (dependability). Reliability can also mean that two or three qualified judges (art teachers) rating the same art works and using the same criteria would similarly rate the products.

Parallel Forms

Reliability can be determined between matched questions on a traditional instrument if items are divided on two equivalent forms of a test that aims to assess the same learning (parallel forms) at two sessions spaced about three months apart. Consistency would be demonstrated by students responding the same on the second test to each matched item on the first form of the test. A matched item should measure the same content or behavior and be equal in difficulty. The "parallel forms overlap" is a variation which involves immediate sequence.

Split-half

A split-half check for reliability plans two equated items in sequence for each response expected. Each half of a test is administered separately (i.e., odd numbers on the first form, even numbers on the second).

Test-retest

The identical tests of a test-retest procedure should be separated by two weeks to discourage student's recall of specific answers.

Intra-rater or inter-rater reliability

Consistency is important in teachers' judgments when rating art products, oral discussions, and journal entries. One teacher's ratings of the same evidence on two occasions is intra-rater reliability whereas a comparison of two raters' independent ratings of the same experience is inter-rater reliability. Repeated ratings by a teacher may be made "live," as during an art criticism experience or, if videotaped, after the experience. Ratings may be used to assess such art activities as art products, classroom behavior, qualities desired in an aesthetics dialogue, and so forth.

The procedure and reliability calculations for inter- and intra-rater reliability follow the same format. If the correlation between ratings of several teachers on scale criteria is near .80, it seems reasonable to accept the ratings of one of the raters for the many instances when that criterion on rating scales is appropriate. Without the opportunity to demonstrate inter-rater reliability, the teacher must remain diligent in maintaining objectivity and consistency in nontraditional assessment of art learning. Systematic sampling is a move in that direction.

Systematic Sampling

Many think of assessment as end-of-semester tests, but assessment can occur at a "formative" stage as a natural part of the instruction. Formative assessment gives ongoing, in process feedback to students through assessing their art learning progress.

Authentic tasks present many opportunities for formative assessment, such as art history work sheets, art criticism participation, checks on journal entries, teacher notes on thinking processes observed, tallies that describe the quality of student participation in discussions, or observation of daily experimentation related to the development of an art product.

Because formative assessment occurs in the most natural context, it avoids some criticism made of the inherently contrived nature of testing. At the same time, insistence on reliability checks at every step of the way in this ongoing assessment would interrupt the learning process and is just not feasible. One must weigh the meaningfulness of context–appropriate assessment and valid assessment of the art–related process behaviors against the benefits of typical ways of estimating reliability.

Assessment in the natural context of the art encounter involves preparation in order to capture many fleeting observations. Structured work sheets, created to efficiently record intentional evidence of learning, can include space for students to note subjective impressions. Coding sheets, structured with columns in which to code the quality of anticipated student behaviors, can include unidentified columns for noting unanticipated responses. Structured tally sheets could be prepared to help organize the random comments of student journals for content analysis and summary.

Systematic sampling makes use of structured formats for recording observations in natural contexts. In adapting this concept for assessment from research, instead of selecting individuals with regularity (every fifth subject of the possible group) to include in a research study, a sample of experiences of one kind would be assessed. Perhaps on each sixth day of a high school class, the teacher would observe whether the students were showing flexibility in their thinking, or during every third or fifth art criticism experience, student responses would be coded for the same qualities.

Systematic sampling allows the teacher to regularly observe those behaviors that occur consistently or those that suggest change with the intervention of teacher-guided experience. The teacher can repeatedly assess the same thinking process, but it may be in reference to different content, such as in different art exemplars. A teacher might check for "uses reasons that are observable in the art work to support statements" at every third art criticism discussion. Eisner (1991) wrote:

> In seeking structural corroboration we look for recurrent behaviors or actions,...that inspire confidence that the events interpreted and appraised are not aberrant or exceptional, but rather characteristic of the situation. (p.110)[1]

Systematic videotaping can contribute to accuracy in interpretation. Eisner supports the use of videotape as one means of observation, and points out that:

> Using videotape has very important advantages. Tapes can be replayed. ...students [of schooling] must be able to refer to the qualities on the tape that support their descriptions, interpretations or evaluations of what they have seen. (Eisner, 1991, p.232)[2]

In assessing learning in a natural context, it is unreasonable to expect that each child will respond orally to every question or even during every art criticism experience planned. Good record keeping will let teachers know which students tend to respond less, and the teachers' questions can then, in a friendly way, encourage oral responses from all students.

Other teachers give students time to make notes on questions that the teacher will be asking. Looking over students' shoulders while walking around the classroom, the teacher can give individual help and observe the written answers of students who normally do not volunteer ideas in group discussions. During the oral discussion that follows, the teacher can encourage a shy student by acknowledging a good written comment of the student and asking him or her to share it with the group.

While art teachers creatively employ strategies to help all students meet all objectives, some argue that all students do not need to respond evenly to the same item within an assessment instrument since the results represent group levels of achievement, not individual levels. This may be true if a certain quality of oral response is the criterion to be assessed in multiple checks within other lessons during the year.

[1] Reprinted with the permission of Macmillan Publishing Company from THE ENLIGHTENED EYE: Qualitative Inquiry and the Enhancement of Education Practice by Elliot W. Eisner. Copyright ©1991 Macmillan Publishing Company.

[2] ibid

Reliability of scoring is enhanced by specificity (i.e., making implicit feelings into explicit descriptions of what might be observed). Precise definitions of different ratings can indicate the quality of responses—oral, written, or graphic—that can be anticipated. Such a sample of possible responses, based on employment of knowledge and skills taught, contributes to reliability on nontraditional assessment instruments by minimizing subjectivity and general impressions. Such diagrams or descriptions function as an overview of probable responses that could be verified by scanning all responses to the same criterion or item at once. They help conscientious, prepared scorers to avoid drift, fatigue, bias or misinterpretations of intent.

Whereas teachers are rarely trained to calculate reliability and may not have the resources for precise reliability tests, there are some simplified ways to check instruments or raters. Sometimes one looks for growth over a period of instruction rather than consistency. Sometimes reliability is not an issue; for example, how would one check the reliability of student journals? Concerning reliability of portfolio assessments, Elbow (1991) writes:

> When a portfolio increases validity by giving us a better picture of what we are trying to measure ...(the student's actual ability) it tends by that very act to muddy reliability—to diminish the likelihood of agreement among raters or graders...Neither literary theory nor philosophy give us grounds for deciding on right or even better readings of texts...reliability *should* be under strain. (p. xiii)

Reliability is important in assessment and some school districts may expect stringent demonstrations of reliability. However, if teacher-administered, nontraditional assessments more validly assess the objectives of a visual arts education than traditional means, then systematic, in-process sampling will need to be accepted for satisfying the requirement of reliability.

Validity takes precedence, and responsible sampling procedures should be practiced in lieu of the traditional means of demonstrating reliability of many alternative assessment instruments.

Summary

Both analytic and holistic viewpoints contribute to the preparation for and development of assessment instruments. Challenging choices and decisions are a part of this development process. Teachers must establish expected achievement levels, pilot and revise instruments, and establish instrument reliability and validity.

10

CONSTRUCTING AND MODIFYING TRADITIONAL ITEMS AND TESTS

After some definitions of terms, this chapter focuses on the construction of traditional, machine-scorable and human-judgment items by which to assess factual information as well as higher order thinking in art. It offers some alternatives to, or ways to modify, typical completion, true-false, and multiple choice items. Recommendations are included for forming item banks and for constructing comprehensive traditional tests. The examples are not to be construed as an art test.

The replacement of the usual term *hand-scored* by the *human judgment* term in the introductory paragraph above consciously calls attention to the role of the human in assessment. To be certain, humans control the construction of and even the automation that is suggested by *machine-scored*. Human controlled events can be shaped and improved. Human shaping can be sensitive and mindful of the valid purposes of assessment. *Machine scorable* is meant to suggest that the format is such that the instrument lends itself to being scored by a machine, whether it is or not.

Other assessment terms also suggest false dichotomies. Is there no objectivity possible in an instrument assessed using human (i.e., *subjective*) judgment? What is typically regarded as *objective* items are *low-inference* items when scoring a test, (i.e., answers are either correct or incorrect). However, there is *high inference* involved when attempting to create meaning from aggregates of such objective test scores. On the other hand, assessing learning through oral discussions or essays involves high inference while scoring the item or instrument. For example, coding the quality of student talk about art requires on-the-spot analysis and judgment. However, because the meaning has already been defined through the criteria used to make the judgment, there is low inference involved in summarizing the results of repeated judgments of the same quality (e.g., for supporting statements with reasons). What initially involves human subjectivity becomes objective in summary, and test items that are objective require human subjectivity to conclude what those items mean in terms of student learning.

The association of the term *qualitative* assessment with *quality* might suggest that *quantitative* data is somehow of lesser quality. Many assert that traditional, machine-scorable items tend to be used to test minutia that is easily translated to a number of correct answers. This does not have to be the case. With thoughtful construction for assessing meaningful outcomes, the quality of machine-scorable items can be increased.

Machine-scorable assessment items call for *selection* type responses, (e.g., true-false, multiple-choice), whereas short-answer or essay type questions ask for students to generate or *supply* evidence of learning in *restricted* or *extended* lengths, respectively. Alternative or nontraditional assessment relies on students to supply evidence of learning through their performance (e.g., talk, art work, or other observable behaviors).

Key to Sample Item Codes

The examples of assessment items in this chapter are intentionally varied by certain parameters which should be considered in designing assessment items. The groundwork for these parameters was laid in earlier chapters. (See Figures 6.3 and 9.2.) The intent of each sample item will be coded as follows:

> The content may be related to: art history (AH), aesthetics (AES), art criticism (AC), or art production (AP).

> Behaviors may fall into the categories of: knowing (K), perceiving (P), organizing (O), inquiring (I), valuing (V), manipulating (M) or interacting/cooperating (I/C).

> The levels of behaving may also vary from low level (L), middle level (M) to high level (H), for example, encouraging higher order thinking or evolving consistent value systems (See Figures 5.2 and 5.3.).

> The grade level indicator suggests appropriateness of the item for: primary (P), intermediate (I), junior high (J), or high school (H) groups.

The goal indicator, left blank in the examples, would be where teachers would insert the number of the goal (from their list of student art goals or outcomes) that the item assesses, indicating that student achievement of the item contributes to meeting that goal.

A sample format might be:

Content/Behaviors/Level/Grade /Goal
AH/ I / M/ I /

Coding of sample items in Chapters 10 and 11 demonstrates how assessment items can fit specific, identified learning outcomes, resulting in an item-by-item validity check.

Recommendations for Constructing Machine-Scorable Items

Reservations about objective assessment items are well known. Gitomer (1991) cautions,

> The relevant point is that the last thing students need is more little pieces of inert knowledge. It is only when students have a sense of where things fit, of how and when the facts they have learned are meaningfully applied, that we can say real learning has occurred. (p.5)

However it is possible to structure worthwhile objective questions. As D. J. Davis (1993) writes,

> It is possible through merging qualitative and quantitative approaches to develop tools that assess progress toward attaining expected outcomes. Actually, qualitative approaches to assessment can often lead to quantitative

measurements that are readily understood by educational decision makers. (p.87)

Following recommendations for constructing traditional assessment items should help accomplish what D. J. Davis suggests. Some general principles are:

- Align art activities with student goals, objectives or outcomes expected. In turn, assessment should be closely aligned to the kind of knowledge or behaviors students experienced in order to procure evidence of outcome achievement. A quality curriculum is basic to quality assessment.

- Make certain that objectives or learner outcomes are written in observable terms that are clear and not too open. "The student will be able to understand the styles of artists" is not only too broad, but "understand" needs greater definition. The objective might be stated more specifically as "Given specific works of art, the student will be able to describe the qualities that differentiate one artist's style from that of others."

- Create items to assess the intellectual level for which the art experiences prepared the students. For example, if an objective is written at the knowledge level and matching games were the practice given in the art experience, then testing should not include analysis-type questions.

- Do not introduce new formats for learning at testing times.

- Keep questions succinct to avoid lengthy sentences and too much time taken up in reading. Keep language simple unless the point is to answer in terms of concepts that were taught and should be understood.

- Avoid double negatives, obvious rhetorical tricks, or confusing language or sentence structure. If the use of a negative is necessary, highlight it in some way, such as "Which of the following colors is NOT a primary color?"

- Focus questions on one learning. Avoid double questions which look for evidence of two behaviors in one question.

- Ask clear questions, avoiding the guessing games brought on by trick questions or ambiguous wording. Avoid "How about...?" questions.

- Ask worthwhile questions, not those with obvious answers.

- Avoid questions that have the answer within them.

- Be certain that items are nondiscriminatory to any group—racial, gender, or economic level.

- Write questions clearly. Readability of test questions should be consistent with student language proficiency.

- When creating questions designed to elicit evidence that students learned what the teacher intended to teach, care should be taken in the phrasing of questions by using key words that direct the student's thinking clearly toward the expectation. (See Figure 5.4.)

- Sequence questions logically to help students step from simple to more complex thinking.

- Consider the entire wording of a question and its intent. The stem of a multiple choice question that asks "In what century was the Mona Lisa painted?" requests selection of a factual information response. However, *what* can be used also in open-ended questions, such as, "What are your reasons for saying that this object ought to be considered art?" or "What is realism in art?"

Examples of Machine-Scorable Items

Matching

In matching items, students relate two things having a logical association. Typically, a left column contains the longer *premise* (i.e., items for which a match is sought), and a right column contains the shorter *response* (i.e., items from which selections are made). In constructing matching items, Gronlund (1981) cautions:

- Avoid padding a match item with either important or unimportant facts.

- Use short lists of homogeneous premises (e.g., sculptors, or art media).

- Use an unequal number of premises and responses with instructions that "each response may be used once, more than once or not at all" (p.173). Some suggestions for pairs of premises and responses are:

Premises: **Responses:**

rules (creating depth)..examples (reproductions)

concepts...symbols

reproductions of characteristic, but

 unfamiliar, works by artists studied.............. artists' names

interpretations of artworks............................. xerox reproductions of artworks

characteristics of style.................................... names of periods or works of art

descriptions of art of cultures......................... names of cultural groups

Content/Behaviors/Level/Grade /Goal

 AH / I / M / I /

For example:

On your answer sheet, blacken in the number(s) of the color(s) from the column on the right that correctly match(es) the item in the left column using responses once, more than once, or not at all.

In western European tradition, which color(s) typically symbolize(s) each emotion listed in the left column?

 ___a. extreme anger 1. green

 ___b. calm, controlled 2. red

 ___c. deep sadness, sorrow 3. tan

 ___d. love 4. black

 5. yellow

Content/Behaviors/Level/Grade /Goal

 AH / I / M / J /

The following terms each refer to the reproductions around the room. Note that these reproductions are numbered. Blacken the number on your

answer sheet that corresponds to the art work that is best described by definitions of the art movement listed. Use a reproduction once, more than once, or not at all.

__a. surrealist __b. pop __c. environmental __d. neo realistic __e. post-impressionist

Figure 10.1—**Style –reproduction matching**

Content/Behaviors/Level/Grade /Goal
AC , O,I , M , J ,

On your answer sheet, blacken the number of any of the six reproductions on the next page (or on display) that match items on the left. Use responses once, more than once, or not at all.

Which art reproduction(s) best illustrate the phrase(s) in the left column?

__a. employs a one-point perspective system to indicate depth

__b. uses aerial perspective

__c. color values contribute most to an illusion of depth

__d extreme size variation creates deep space

__e. no attempt at creating a realistic illusion of 3-d space

Figure 10.2—**Complex concept–reproduction matching**

Content/Behaviors/Level/Grade /Goal

AC / P,O / L / P /

On your answer sheet, blacken (or write in) the number of the reproduction in the bottom row that correctly matches a real-life object in the top row using responses once.

In which works of art shown has the artist created a similar effect to one of the real-life photographs in the top row?

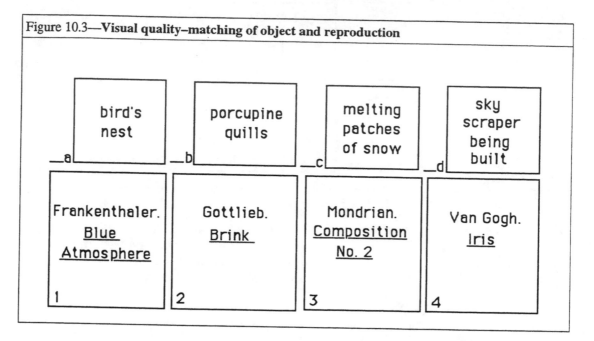

Figure 10.3—**Visual quality–matching of object and reproduction**

_a bird's nest
_b porcupine quills
_c melting patches of snow
_d sky scraper being built

Frankenthaler. Blue Atmosphere 1
Gottlieb. Brink 2
Mondrian. Composition No. 2 3
Van Gogh. Iris 4

Content/Behaviors/Level/Grade /Goal

AP / K / L / I /

Figure 10.4—Art Card: Definitions of Terms

A	R	T
formal balance	fore-ground	pattern
movement	comple-mentary colors	coil pottery
visual texture	value contrast	organic shapes

To play Art Card, students take turns drawing definitions from the draw stack (see Figure 10.4). Art Cards can be made from paper the same size as individual blocks on the art card. If the definition fits a concept word on one's card, it is placed on top of the concept. If the definition does not seem to fit a concept on the card, it must be discarded. Drawing definitions continues in turn (reusing the discard pile) until the students have covered as many spaces as possible with correct definitions for the concepts underneath or time runs out. Empty spaces and/or incorrect matches between concepts and definitions subtract from the total score of 9.

Note: Arrangement of concepts on cards can be scrambled. There should be an art card and complete set of definitions made for all players. Crossword puzzles are another way to help students commit definitions to memory if that is a desired outcome.

Content/Behaviors/Level/Grade /Goal

AC / O,I / M / I /

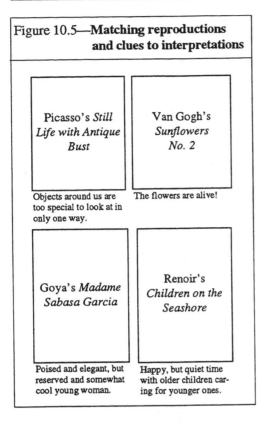

Figure 10.5—**Matching reproductions and clues to interpretations**

Picasso's *Still Life with Antique Bust*

Objects around us are too special to look at in only one way.

Van Gogh's *Sunflowers No. 2*

The flowers are alive!

Goya's *Madame Sabasa Garcia*

Poised and elegant, but reserved and somewhat cool young woman.

Renoir's *Children on the Seashore*

Happy, but quiet time with older children caring for younger ones.

Blacken the number on your answer sheet (or circle the letter) of the clue that best fits the picture and its meaning. Each reproduction posted (or below) has a meaning written under it. Match the clues (what the artist did to make people arrive at that meaning) with the correct picture and its meaning.

__a. the brightly colored shapes twist and turn.

__b. soft colors, position, and proximity of subjects to each other.

__c. value contrasts, erect posture, detail of lace, and fabric texture.

__d. limited color, emphasis on shapes, different viewpoints of objects.

Matching modification. By asking students to supply a reason for their selection, the following example introduces a human judgment component to the matching item which is scored subsequently to machine scoring.

Content/Behaviors/Level/Grade /Goal

AES / O,I / M / H /

Figure 10.6—**Matching theory and reproductions**

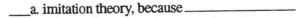

On your answer sheet, blacken in the number of the reproduction on the right that correctly matches the item in the left column using responses once.

Which of the reproductions shown is the best example for each art theory? After you have matched each reproduction with the theory it exemplifies, explain why each of your choices is a good example of the respective theory.

____a. imitation theory, because_____

____b. expressionism theory, because_____

____c. formalism theory, because_____

____d. social institution theory, because_____

Alternative Response Items

The purpose of alternative response items is to assess reflection and critical thinking, that is, determine if students can

- Identify the correctness of a statement, definition, or principle;

- Differentiate facts from opinions or beliefs of a group or individual;

- Perceive cause and effect relationships or logic.

Alternate response items may offer response selections to students, such as: True-False; Fact-Opinion; Yes-No; True-False -Converse is true-Converse is false, or, True-False-Opinion (Gronlund, 1981).

In writing alternative response items, avoid specific determiners (e.g., always or never) which are clues to false answers, or generally and sometimes which are clues to true answers. To guard against chance correct guessing on alternative response items, key words can be underlined with the instructions that any false statement must be rewritten with a correct substitution for the underlined word. It is possible that a student can correctly select a response but not know why. The intent of underlining the key word is to focus the student's attention on relevant content of the statement and to guard against simply changing a positive statement to a negative one, for example, by adding the word not. Examples of these options follow.

PURPOSE: Differentiate fact from opinion

Content/Behaviors/Level/Grade /Goal

AH, AES/ I / M/ H /

Read the following statements and carefully decide if they are true , false, or a matter of opinion. Blacken the space on your answer sheet that corresponds to T or F or O [or, appropriately mark each statement with a T or F or O.]

___ 1. Social dancing was the theme of one or more paintings by Brueghel, Lautrec, Motley and Renoir.

___ 2. Paul Klee created art with the same intent as Pieter Brueghel (the Elder).

___ 3. Georgia O'Keeffe's abstractions of nature camouflaged sexual meanings.

___ 4. To be art, artists' works should demonstrate the Western principles of design/ composition that were included in the art and cultures course.

PURPOSE: Recognize logic

Content/Behaviors/Level/Grade /Goal

AH, AP/ I / L/ I /

Both parts of the following items are true. Does the part on the right explain the part on the left? Blacken the space on your answer sheet that corresponds to Yes or No [or appropriately mark each statement with a Y or N.]

___ 1. Art is expressive, because artists experience trauma in their lives.

___ 2. Wedging clay is important, because impurities must be removed.

Content/Behaviors/Level/Grade /Goal _____

AES , I , M , H , _____

*The following statements may be true or false. In addition, the converse, or opposite, of the statement may be true or false. Blacken the space on your answer sheet that corresponds to **T** or **F** [or circle either letter] and then, if the converse is true, mark the **CT** space or circle it. If the converse of the statement is false, mark the **CF** space or circle it . Mark two answers.*

T F CT CF 1. Art should imitate nature.

T F CT CF 2. Colored reconstructions of ancient sculptures are art.

Modifications of alternative response items that require human judgment

The following example involves teacher judgment in consort with the machine-scorable response. This rewrite of false responses guards against correct guessing being credited as learning.

Content/Behaviors/Level/Grade /Goal _____

AC , K,O , L , J , _____

Blacken the space on your answer sheet that corresponds to T or F [or appropriately mark each statement with a T or F]. Rewrite any statement that you mark false, changing it to a true statement. The underlined parts might need to be changed.

T F 1. According to Feldman, our class critiques of projects take a *journalistic art criticism* approach. _____

Comment lines could be added to any question to invite explanation or elaboration if the student felt the need. Another possible addition to machine-scorable tests is to invite students to add relevant content which they studied, but was not tapped by items on the test. Teacher judgment would determine the quality of what is added and whether it warrants additional points, extra credit, or notation in the teacher's log.

Multiple Choice

Multiple-choice questions are used to determine if students learned terminology; know specific facts; have knowledge of principles, methods, or procedures; recognize the relevance of information; and understand and can apply knowledge. Understanding should enable students, in situations new to the student, to identify applications, apply principles, interpret cause-and-effect relationships correctly, recognize assumptions or inferences, interpret experimental findings, or justify methods and procedures.

A multiple-choice item is most difficult to write because of the variables that must be controlled. A multiple-choice item usually consists of a stem, distracters (the incorrect answers) and the key (the correct answer). A stem is a problem stated as a question (preferred for younger students) or an incomplete statement. Choices may be in the forms of verbal phrases or statements, diagrams, art reproductions, or other graphic material. Some recommendations for writing multiple-choice questions include

- Present a definite problem in the stem. Use negatively stated stem only if the outcome necessitates it.

- Identify one answer out of the set as correct or best, but all should be plausible. Avoid ridiculous choices.

- Avoid ambiguous statements, wordiness, complex sentence structure, unclear instructions or illustrative material, and difficult vocabulary.

- All responses should be grammatically consistent with the stem.

- Do not relate one question to another in such a way that one answer is dependent on the correctness of an answer to a previous question.

- Refrain from using "all of the above" or "none of the above" unless knowing what not to do is important.

- Some novelty is permissible, but avoid very unfamiliar choices.

- When placing a key answer among the options make certain that its location is not in a patterned order. In other words, c. is a common placement for the key; therefore make certain that the key is scattered from letters a. through e., but not in a predictable order, throughout the test.

- Distractors and key should be similar in length.

- Keep distractors to a minimum, probably up to four in primary grade testing , and five to six for older students.

- Avoid grammatical clues (a, an) or verbal associations with a process.

- Anticipate the chief types of typical mistakes that students make and incorporate them into the distractors to encourage careful discriminations.

- Create the stem from behaviors that have been taught, but which students must apply in new contexts or with new material.

Some multiple choice examples follow:

Content/Behaviors/Level/Grade /Goal

AP / K / M / P /

Blacken the number on your answer sheet that corresponds to [or circle] the correct answer.
The following question seeks to investigate the student's knowledge of principles for hand-building pottery.

1. Think about your additive clay animal. When scoring clay, it is important to:

 a. roughen up the surface with a tool (Key)

 b. flatten the edges with a paddle. (Distractor)

 c. allow the piece to dry to a leather hard stage and then roughen up the surface with a tool. (Distractor)

 d. brush slip on to the edges and press firmly. (Distractor)

A student must know that scoring to bond two pieces of clay requires a. roughing up the surface with a tool. The distractor b. is opposite in effect, c. disallows moisture to be a factor, and d. does not refer to the act of scoring the clay. However, all answers relate to the process. This tests the clarity of the student's understanding of the principle of scoring in joining clay bodies.

Content/Behaviors/Level/Grade /Goal

AC / O,I / M / I /

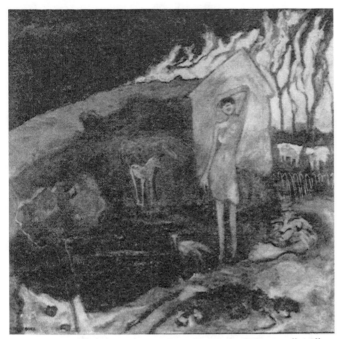

From *The Rescue Party* by Mary–Glynn Boies. Kay Garvey Gallery, acrylic on linen. 48" x 48". Copyright 1989. Permission granted by Mary–Glynn Boies.

Blacken the number on your answer sheet that corresponds to [or circle] the correct answer.

We may judge the work of art pictured here to be successful primarily because of:

a. objects that one can pick out

b. good observation and drawing skills

c. expressive positions of the bodies

d. effect of its message about life

e. amount of photographic detail

The following example illustrates the use of the multiple choice format for a value question.

Content/Behaviors/Level/Grade /Goal

AES / V,I / H / I /

Blacken the number on your answer sheet that corresponds to [or check] the best answer, in your opinion.

Art is important to have around us because:

__a. the world is beautiful with art work.

__b. artists can be crazy and call new stuff art.

__c. it helps us feel better, not alone with problems.

__d. we are important if we have art in our homes.

__e. artists show particular truths about life through art.

Content/Behaviors/Level/Grade /Goal

AC / 0 / M / J /

Blacken the number on your answer sheet that corresponds to [or circle] the correct answer.

Compare the objects pictured to decide what visual quality they share.

a. pattern

b. formal balance

c. realism

d. illusion of 3-d

Figure 10.7—**Multiple choice: Concept Selection**

Content/Behaviors/Level/Grade /Goal

AC / 0, I / M / P /

Blacken the number on your answer sheet that corresponds to [or circle] the correct answer.

Renoir. *By the Seashore*

We may judge works of art as good, even if we don't like them personally. A good reason why this picture might be judged successful is:

__a. It shows a girl in pretty clothes sitting in a chair.

__b. It has soft tones that I like.

__c. It took training to paint someone so realistically.

__d. It all looks calm because of the tones, seated girl, and quiet seashore.

Content/Behaviors/Level/Grade /Goal

AP / I / M / J /

Blacken the number on your answer sheet that corresponds to [or circle] the correct answer:

The major purpose for experimenting with ink and tools is to:

___a. loosen up your muscles and relax about using ink

___b. associate techniques with possible applications in art work

___c. develop skill in using ink drawing instruments

___d. discover the delightful effects of wet ink on wet paper

Content/Behaviors/Level/Grade /Goal

AC / 0 / M / J /

Unlimited multiple choice.

In this question, circle all the correct statements . Do not mark statements that do not support the interpretation given for this work of art.

The interpretation of the reproduction posted (or xeroxed on the page) that *wars cause terror and death* is supported by the following observations:

a. Humans and animals are not in upright position.

b. Strong value contrasts and sharp angles suggest drama.

c. Symbols suggest aspects of war in contrast to the peace of freedom.

d. Body parts are scattered and distorted.

Picasso. *Guernica*

Other Considerations

Videotape offers an alternative to the typical multiple choice test. In this mode demonstrated by Fitzner (1988), questions are viewed by students one at a time. After presenting the stem of a question, and a view of all choices, each distractor and key are viewed separately and again together. The test is timed and students pace themselves by noticing the amount of time remaining for considering an item in a corner of the monitor.

Also, it is necessary to obtain copyrights for colored reproductions used in a district test. It may be mutually beneficial for art museums and school districts to cooperate in making reproductions of works in the collections of area museums available for assessment purposes.

Another alternative to the typical multiple-choice written test works with classes of about 12 students or less. It permits immediate feedback plus it can be structured to allow students to clarify their answers or express exceptions to either the stem or the choices. This alternative multiple-choice assessment requires an overhead transparency of each item using colored squares instead of letters to differentiate the distractors and key choices. Each student has a pack of 2"x3" cards corresponding in color to those used to code the choices, plus a *caution* card of whatever color the teacher chooses. A class list is made out by the teacher with as many columns as there are multiple-choice items to be presented. Students sit alphabetically from left to right in a single row facing the teacher and display the color card that indicates their response to each item, one at a time, of course. The teacher immediately credits correct responses on the class list. If any students have doubts or exceptions to explain, they would display their caution card.

After recording correct responses, the teacher calls on students displaying the caution card to orally, or in writing, explain their indecision. If their explanations demonstrate the understanding desired, they are given credit and the teacher can reveal the correct response to the class. Any clarification can be handled on the spot or given more time later. A word from the teacher about the hazards of conforming to colors that other students seem to display is usually enough to discourage peeking. If not, small windows cut into cardboard box stations for each student to use when displaying his or her colored card would encourage independent decisions.

Human Judgment Items

Completion or short answer items. Completion and short-answer items ask students to generate or supply a response. That response may be knowledge of a fact or principle, planning and listing steps in a process, interpretations, or problem solutions. Unlike most traditional assessment items, completion items generally involve human judgment. Some examples are:

Content/Behaviors/Level/Grade /Goal

AH , K,0 , M, I /

The work of art shown is from

the _____ culture.

Content/Behaviors/Level/Grade /Goal

AES , 0,I , H , J,H/

In your words, give three reasons why tax monies should support public art.

1._____

2._____

3._____

Content/Behaviors/Level/Grade /Goal

AC , 0,I , H , J /

Write a phrase which characterizes a defensible interpretation of the reproduction displayed.

Content/Behaviors/Level/Grade /Goal	At the stage of throwing clay onto the wheel, the first crucial skill is
AP / K / L / H /	

Normally completion items ask for students to supply answers that must be read by humans. However, they can be constructed so as to ask students to generate answers that are machine scorable. A research study with medical students (Brallovsky et al., 1988) demonstrated weaknesses of forced-choice, cued questions. In response, a machine-scorable substitute for the completion type answer was developed, where students are not easily cued to select the correct answer but must know it and be able to generate it. The test maker provides a numbered, alphabetized, extensive list of words that contain the correct answer. The student must know the answer, seek it, and record the number of the answer on the answer sheet. Medical educators pointed out that practitioners in the field are not faced with four possible choices, but must generate decisions based on their observations. Related to art, there are similar situations as people make aesthetic decisions in many possible contexts in life and may reject all four choices in preference to an independent idea. An example of this alternative to the typical completion item is example number 2 on page 65.

Completion items can tap different levels of thinking as the examples that follow indicate.

Knowledge can be assessed by asking for simple recall, as in the following item:

Content/Behaviors/Level/Grade /Goal

AH / K / L / I /

Write in correct words to complete the sentence or mark the correct numbers on your answer sheet.

1. Three women artists are _____, _____, and _____. If this item were to be machine scored, students would select the correct answers from a list of artists' names that could be male or female. If human judgment is used, the student would need to write three names of women artists by recalling them.

Content/Behaviors/Level/Grade /Goal

AH,AC / 0 / H / J /

The following item is an interpretive task that utilizes knowledge of contextual influences. *Each of the reproductions of art shown suggests a different contextual variable which can influence artists' works. Write the contextual variable that influenced the work under its reproduction.*

Figure 10.8—Completion: Contextual influences

Goya, F., *The Execution of the Rebels of the 3rd of May, 1808*	Millet, J., *The Gleaners*	Boticelli, S., *Adoration*	Evergood, P., *Sunny Street*

rs/Level/Grade /Goal

/ M / J /

...ram: Concept illustration

a

b

c

d

In the next example, students must generate graphic definitions of verbal concepts.

Diagram the following ideas in the squares provided.

a. texture that suggests one feeling even though it is varied

b. expressive facial contours

c. left-to-right value reversal of multiples of an object.

d. variation of a live form to a dehydrated dead state.

Content/Behaviors/Level/Grade /Goal

AP / K, O, I / H / J, H /

Figure 10.10—Visual problem solution

Solving problems can be addressed by completion items. The teacher would judge the quality of the pattern and drawing by whether (a) a pattern was created, (b) the curvature of pattern contours suggested that it was on a form, (c) the pattern parts related to the form itself, and (d) value was added to indicate depth created by the pattern incised in or applied to the form.

Instructions:

Enhance this diagram of a pottery form by drawing to show how an aesthetically pleasing pattern would look on it.

Essays, short answer items. The essay is another traditional assessment item that requires human judgment to score. Essay questions have been used in attempts to assess higher order thinking. Art goals or outcomes that require complex behaviors (e.g., select and organize ideas; express relationships; observe, reason and make inferences; and support judgments in written form) call for the relative freedom of essay questions. Specific higher levels of art behaviors (Figures 5.2 and 5.3.) could be assessed by restricted essay questions.

Restricted essay questions limit the content and form of the response by restricting the scope of the topic or ask for focus on a specific problem. Gronlund (1981) suggests outcomes that are specific behaviors identifiable within the basic art behaviors toward which students can be guided by clear phrasing of the question. Some higher order behaviors and essay questions (translated to art) follow:

Compare

Content/Behaviors/Level/Grade /Goal

AC / 0 / M / J /

Compare two painting techniques in terms of the different interpretations to which each technique could contribute.

The following item extends the simple compare behavior within one item.

Written assessment: Comparing and contrasting two artists' different approaches to common subject matter

Content/Behaviors/Level/Grade /Goal

AC / 0,I / H / H /

Look carefully at the two pictures shown. Compare the ways that the two artists who made them (Seurat and Toulouse-Lautrec) showed action and depth at a circus. How are their two paintings Le Cirque and Le Cirque Fernando the same or different? What are some possible reasons why each artist painted his picture the way he did? Are both paintings "art?"

You have time to think and write paragraphs to answer the questions asked. Use good English and write one-half to one page. You have 30 to 45 minutes to do this.

Criteria: The student:

gave reasons for the arrangement of objects	0__ 1__ 2__ 3__ 4__
related the action of objects to the meaning	0__ 1__ 2__ 3__ 4__
contrasted the effect of techniques for showing depth	0__ 1__ 2__ 3__ 4__
reasoned how composition contributed to meaning	0__ 1__ 2__ 3__ 4__
gave contextual reasons why the styles differed	0__ 1__ 2__ 3__ 4__
supported interpretations that differed in the two works	0__ 1__ 2__ 3__ 4__
used concepts correctly	0__ 1__ 2__ 3__ 4__
organized/expressed ideas in correct grammatical form	0__ 1__ 2__ 3__ 4__

Connect influences with art produced

Content/Behaviors/Level/Grade /Goal

AH / O / M / H /

Explain how contextual variables affected the environmental art movement.

Create viable if-then statements to research

Content/Behaviors/Level/Grade /Goal

AES / O, I / H / H /

If there were a war on the US mainland, how might the art world react and what would be the most likely effect on art and US-held art work?

Form generalizations or big ideas about art

Content/Behaviors/Level/Grade /Goal

AP / O, I / H / H /

What general statements can you formulate about post-modern art which accommodate the variety of types of art that cluster under the post-modern label?

Describe how art "rules" are applied in creating art

Content/Behaviors/Level/Grade /Goal

AP / O / M / J /

Describe what you would do to create a work of art that would give the illusion of being 3-d.

Support positions on issues about art with pertinent reasons

Content/Behaviors/Level/Grade /Goal

AES , I , M , I ,

For what reasons do you agree or not agree with the idea of an artist's license?

Support a generic interpretation of the work of art shown.

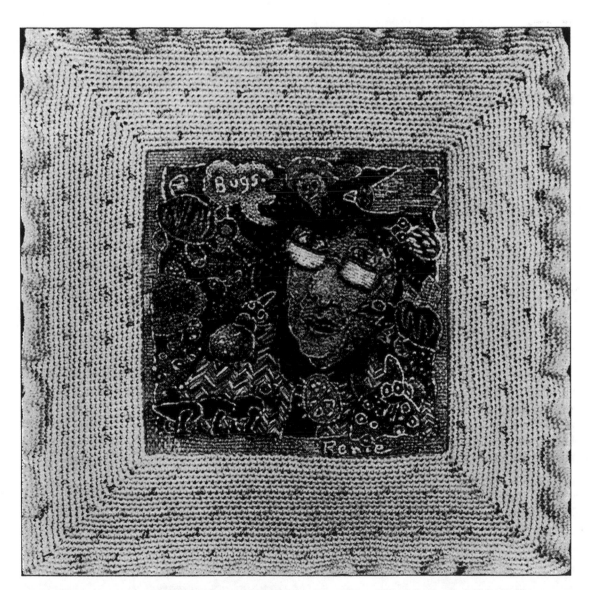

From *Bugs* by Renie Breskin Adams. Mobilia Gallery, embroidery and crochet. 6 1/2" x 6 1/2". Copyright 1991. Permission granted by Renie Breskin Adams.

Recognize needed information for making decisions

Content/Behaviors/Level/Grade /Goal

AES / I / M / I /

What would we need to know in order to tell if an artist painted expressively because he/she saw the expression in the subject, felt that the subjects felt that way, felt that way him or herself, or wanted the viewer to feel that way?

Identify prerequisite conditions for drawing conclusions

Content/Behaviors/Level/Grade /Goal

AES / O,I / H / H /

What would one need to assume in order to plan for the preservation of art in an information society?

Recognize and explain processes and stages

Content/Behaviors/Level/Grade /Goal

AH,AC / O,I / M / I,J /

Group the 12 reproductions of art objects in at least three ways. Write a key word for each grouping, and regrouping. Defend your basis for doing so in terms of the objects put together.

An extended response essay, less useful for indicating specific outcomes, enables the student to bring all kinds of information to bear on a subject and to give evidence of judgment and organizational abilities. According to Gronlund (1981), extended response essays can be used to observe a variety of outcomes, which, translated to art could include giving form to unique ideas, interrelating the arts and other disciplines, creating in the abstract and concrete, and making informed judgments about ideas and art.

Give form to unique ideas

Content/Behaviors/Level/Grade /Goal

AP / O,I / H / J /

Examine this work of art, then speculate beyond its meaning to create your own extension of the creation.

Interrelate the arts and other disciplines

Content/Behaviors/Level/Grade /Goal

AP , O,I , H, H ,

Putting together all relevant variables, describe your plan for the design and construction of stage flats and props for the production of Goethe's Faust.

Create in the abstract and concrete

Content/Behaviors/Level/Grade /Goal

AP , O,I , H, J ,

Utilize the op art principle of vibration as it occurs in a natural setting to call attention to an environmental concern in a poster.

Make informed judgments about ideas and art

Content/Behaviors/Level/Grade /Goal

AP , O,I , H, H ,

Using, but going beyond the format of art criticism proposed by Feldman, interpret the meaning of the work of art posted and evaluate the worth of its concept for today giving support for your judgment.

For efficiency, essay questions should be restricted to what cannot be measured by objective tests. Questions should be worded to elicit the behavior specified in a student goal or outcome statement. Clearly worded instructions enable students to organize their knowledge in addressing the task. Noting space and/or time limits helps students to pace themselves.

The practice of allowing students to elect one of several questions to answer is not a good practice. If there is no comparable content for students to organize, there is no common basis for assessing learning. The global approach to problem solutions, such as in planning a solution to a real-life problem, could be described verbally in an extended response essay or by portfolio-type approaches using multiple assessment items or instruments.

Developing an Item Bank

An item bank consists of multiple items by which one could assess the same content and behavior combinations. For a valid assessment, items must assess how well students achieved the expected outcomes or goals for which the art experiences prepared them. Because all that is taught cannot be assessed, the concept of sampling is important. Representative achievement is accepted in lieu of assessing every bit of learning.

- Representativeness of assessment items is necessarily linked with the value assigned to the student goals or outcomes. Therefore, assessing art goals and experiences equitably must be qualified by the weight given each goal (i.e., each goal or outcome may not be valued and stressed the same through instruction). This makes it necessary to ascertain what proportion of emphasis is due each goal or outcome statement. For example, if perceptual experiences are engaged in briefly (5% of classtime) and for purposes of enabling students to interpret or create meaning effectively, other experiences—such as the more complex, higher order, organize and inquiry behaviors—would receive a much greater proportion of the questions and time estimated to answer them.

- Test items designed to measure achievement of the same behavior may involve content from art history, art criticism, art production, or aesthetics experiences. Balanced attention to the contributions from all these disciplines may be translated to equity in numbers of question items, but again, factual art history questions demand less time in responding than questions that ask for relationships between contextual influences on art of a certain period. The higher order questions demand longer thought time, hence fewer, but more worthwhile, questions.

- There should be an equal cluster of items related to each student goal or outcome given the same value. However, the items may represent different levels of difficulty for the age group being assessed.

Multiple items also make it possible to rotate items assessing the same outcome on several different forms of tests, thus having parallel forms to use. Variations in specific experiences through which different teachers teach toward the same basic behavioral outcomes could be accommodated by comparable items with content variations. Exemplars used in the items can be substituted with little effort.

Finally, items should be organized on separate cards in a file and/or computer document. It would facilitate selection of items for a test to have the items categorized by behaviors being assessed and subordinately by content being assessed. Another level of organization would be to order or code the items by difficulty or grade level.

Constructing Machine Scorable Tests

Teachers may elect to develop a summative test for an art course or a grade level. It can serve as baseline information for comparative purposes with the same group at a later date. Art teachers may be involved in constructing an art test for a school district where they may have addressed common content and behaviors of the curriculum through quite different experiences. The commonalities must serve as the basis for selection or construction of assessment items.

- A matrix of test items in a test (vertical axis) and the basic art behaviors (horizontal axis) could show at a glance how the traditional assessment items accommodate the student goals or outcomes expected. Instead of a check mark where item x assesses organize behaviors, the mark could be a code letter for the type of content addressed in the item, (e.g., *AP* for an art production question). This suggestion, which is specific to the item considered for use, is an extension of the matrix in Figure 9.2.

- Arrange test items in a logical order. This means moving from more simple, *select* items, (e.g. true-false) to more complex, *supply* items, (e.g., essay) and from concrete examples to abstract ideas. Clustering similar item types together means that students must read fewer sets of instruction and can work in the same mental set for longer periods.

- Because knowledge of facts is prerequisite to using intellectual skills, questions requiring recall of information should precede questions asking students to use that information to form new concepts, to look for relationships, or to synthesize information in a meaningful way (i.e., to generalize or form a big idea about what was learned).

- Measurement specialists generally recommend a variety of difficulty levels for each behavior and in reference to each content area if the test is to determine levels of achievement. If a school district wants mastery tests, the highest level of thinking that was taught for at a particular grade level is the level expected of all students. If so, test items written for that level of behaviors are selected from the item bank. Knowledge of facts may be incorporated into items demanding more complex thinking.

- When creating questions designed to elicit evidence that students can perform the behaviors or outcomes of learning for which the teacher has taught, care should be taken in the phrasing of questions by using key words that aim the student's thinking clearly toward the expectation.

- Arranging groups of items by their similar outcomes will assist the teacher's interpretation of the test results. The accuracy of inference from objective items will increase as the teacher reviews clusters of test items related to the same behaviors since they have been not only clustered, but individually coded (as in examples given in this chapter).

Format considerations. There are practical reasons for formatting a test to be visually pleasing. Generous spacing, and margins and bold headings contribute to the readability of the test. Organize answer spaces consistently (e.g., down the left side) and number items consecutively. If reproductions are photocopied, check them for the clarity and detail needed to answer the questions that refer to them.

Instructions should be succinct, but clear, about the behavior expected. Responding on answer sheets is preferable except for young students, short tests, or if only a few students are taking a test. If it is a district test, the tests may be reused if responses are written on answer sheets. It is generally advisable to recommend that students answer all questions, but not to guess wildly since some students may tend to too much boldness and others to over-cautiousness.

Summary

Traditional assessment has value to the art educator, but quality and meaningfulness, rather than triviality, must be a constant guide in the construction and selection process. Traditional, restricted essay questions shown as examples can assess higher order thinking, but they require human judgment (not machine scorable). It is important that each item is identified by the basic art behavior involved and that the demanded level of sophistication within that behavior is identified in order to meaningfully interpret the results of the assessment.

11

CONSTRUCTION OF ALTERNATIVE ASSESSMENT ITEMS

In this chapter, alternatives to traditional assessment are justified. Some challenges to nontraditional assessment are acknowledged and answers are offered. General and specific recommendations for alternative assessment criteria are provided. Some suggestions precede examples of observation and performance instruments.

Of two basic assumptions in this chapter, one is that meaningful art learning integrates contributions from the art disciplines in solving real-life problems. Many art education professionals have contributed to and advocated for this integration. An early State of Ohio curriculum guide promoted the idea of art encounters composed of clusters of activities. That idea was applied in a description of how aesthetics generalizations can be the advance organizers of sociologically-connected discipline-based art encounters (Armstrong, 1990b). The encounters, meaningfully integrating activities drawn from the art disciplines, address problems related to social institutions of all evolving cultures. Zessoules and Gardner (1991) described the classroom conditions that enable students to have such authentic learning experiences. They write, "such rich modes of assessment cannot be activated in a vacuum.... [There is] need for a classroom culture that will sustain the values, merits, and practices of more authentic forms of assessment" (p. 49). The Comprehensive Holistic Assessment Task (CHAT) approach (Lovano-Kerr & Roucher, 1993; Wilson, 1992) features authentic, socially-relevant, integrated discipline-based experiences in art that are fused with assessment.

The second basic assumption underlying this chapter is that art teachers will build the resources and make the necessary time adjustments to plan for art experiences and their assessment. Resources and time are both critical elements of an art program whose art encounters give balanced attention to and successfully integrate the four art disciplines. Such encounters—including as they can—meaningful, life-oriented experiences—expand our conception of art education and its assessment. In light of this expansion, attempting authentic assessment of a strictly production-oriented general education in art is demonstrably inconsistent.

Sorting out the New Terminology

Changes in curricular goals and structures and in their assessment can lead to a sometimes bewildering array of terminology. In this book, "alternative," "nontraditional" and "performance" are considered umbrella labels that have similar meanings for art educators.

Alternative assessment is an alternative to what is *traditional* (objective tests and essays). *Nontraditional* is the same, but what is nontraditional to most educators includes ways by which art teachers have typically made judgments about how well students have learned in art. The way those judgments are made is by the students' *performance* (i.e., observable evidence of what they know and can do). It is recognized that although essays are traditional, they also require students to perform (i.e., supply or generate verbal responses. Writing portfolios are generally considered a performance alternative to tests of the rules for writing). Chittendon (1991) makes the point that alternative assessment is teacher-mediated and theory-referenced (in contrast to externally designed and administered, and norm-referenced).

Authentic assessment implies alternative assessment procedures that are performance-based. Authentic performance includes real-life decisions and behaviors of aestheticians, architects, art historians and critics, artists working in all forms including folk artists, persons who confront art in their daily lives, and persons whose avocational activities relate to art. Authentic, or legitimate, assessments are intellectually challenging, but responsive to the nature of the student and/or the school. Such assessments should provide the opportunity to discuss or clarify responses as one would do in real life.

Authentic learning in art implies purposeful, meaningful application of relevant information as opposed to acquiring factual knowledge for itself. Persons who plan authentic assessment of art may be motivated to reform their curriculum. In fact, change in curricular practices can be expected when implementing valid authentic assessment according to Lockwood (1991).

Holistic education advocates point out the value of learning when pieces are related to each other. Holistic assessment may assess ongoing processes as well as summative performances. This suggests the use of a variety of modes of assessment, each appropriate to an outcome that is a meaningful aspect of a larger task. Holistic assessment need not be interpreted as one score or grade; in fact, it is difficult to interpret lumped assessment of unlike behaviors. If assessment is to inform and improve instruction, teachers need to be able to focus on specific behaviors. Assessing real-life performances demands a variety of assessment approaches to provide feedback about the different behaviors involved as students deal with content that related to the focus, thematic idea, or issue of the encounter (Wilson, 1992).

Need

Do art teachers need to change anything? Bridgeford and Stiggins (1986) speak for many art educators with these words:

> A student's painting...contains within it ingredients that cannot be judged via standard paper and pencil questions and answers. They need instead to be profiled, praised, and criticized in relevant multidimensional feedback to students and parents. (p. 40) [Excerpt from *Design for arts in education*, 88(1), 40-42. Reprinted with permission of the Helen Dwight Reid Foundation. Published by Heldref Publications, 1319 18th Street, NW, Washington, DC 20036-1802. ©1986.]

Portfolio and exhibition assessment practices, traditionally used by art teachers, seem to have served as initial models for alternative assessment in other fields of education.

Art teachers have less to change to embrace alternative assessment than do teachers in other academic fields. In 1986, Stake explained his idea of evolutionary change which—in contrast to sudden, band-wagon type change—emerges from new experiences that cause examination of problems. Art teachers may want to enhance the opportunities for alternative assessments already present in most art classrooms by a bit of organizing and systematizing.

Nontraditional methods of assessment promote the value of art education by revealing a wider spectrum of student achievements. Influenced by Guba's (1978) emphasis on naturalistic inquiry, alternative techniques include open-ended interviews, observations, questionnaires, introspection revealed to the evaluator, and unobtrusive measures (Rubin, 1982). In art

education, unobtrusive measures could be counts of incidents, notes on observations, or noting trends in student journal entries.

Wiggins (1989) questions whether traditional assessment can be relied on for accurate information—whether correct answers mean thoughtless recall and incorrect answers obscure thoughtful understanding. Still other educators claim that traditional objective tests foster convergent thinking, a narrow curriculum, specific skills, and underrepresent performance of low socioeconomic students. The sample true-false question in Chapter 10 which instructs that false statements should be rewritten as correct statements is one small attempt to rectify such criticisms. However, direct observation of decision-making leaves less doubt.

Classroom Setting for Alternative Assessment

The ethos of assessment changes with alternative methods. Instead of one summative test, ongoing activities provide direct evidence of learning that is related to meaningful tasks. (Zimmerman, 1992; Wiggins, 1989). Assessment of accumulated knowledge has shifted to focus on students' behaviors or capabilities to integrate learning of all kinds meaningfully. Students' behaviors then occupy the key position in contemporary assessment.

Focusing on behaviors opens the assessment process to include those subtle existence proofs that art teachers know exist. They casually note incidents that are personally confirming, but which may not happen "on command" and rarely have been systematically documented and reported. This ongoing assessment allows art teachers to

• Appreciate the complexity of the art experience.

• Discern pervasive, but subtle, indicators of positive attitudes.

• Hear student-initiated testimony or casual comments.

• Observe results in art products that reveal comprehension.

They hear elaborations that speculate beyond a work of art being discussed and observe changes in students' reflection about and serious appraisals of art. Such persuasive evidences of learning can be caught and documented by nontraditional methods if teachers have appropriately modified "grade sheets" to include, for example, reaction forms, checklists, and rating scales.

Figure 11.1—Classifying informal evidence of learning and ways to record it

Evidence	Basic art behavior	Recording tool
comment about art in interview	value	teacher log
student to student listening, expanding	interact/cooperate	checklist
integrative thinking	organize	rating scale
critical thinking, support with reasons	inquire	rating scale
self-initiated thoughtful questions	inquire	teacher log
creates innovative solutions	organize, inquire	rating, log
intrigue with observation of details	value, perceive	log, checklist
enthusiasm in discussing works of art	value	teacher log
openness to risk, experiment	inquire	rating, log
presents work with care	value, manipulate	checklist
goal-related body language	value	teacher log
skill in control of a particular medium	manipulate	teacher log

Bridgeford and Stiggins (1986) recommend rigorous assessment of student achievement through systematic evaluation of performance. Systematic observation is the key to legitimizing informal evidence of learning. Specific evidence needs to be considered to see if it can be subsumed under one of the basic art behaviors. Figure 11.1 gives some examples of this process and identifies possible forms of recording the behavior.

After logically classifying the myriad of possibilities, a teacher needs to prepare checklists that could accommodate expected and unanticipated behaviors. Separate checklists for each behavior category (e.g., value, inquiry, interact/cooperate) could be color coded to quickly identify the category.

Disadvantages of Alternative Assessment

The need for a comprehensive picture of art learning was recognized by Wilson (1970) in designing the National Assessment of Educational Progress in Art (NAEP, Art) test. Its scope included aspects now considered nontraditional assessment, but the results were never completely analyzed and summarized due to the expense involved. Because alternative assessment involves human judgment, it takes more teacher time even if it is an ongoing in-class activity. Once a teacher plans what, and how, to systematically record evidence of learning, the ongoing administration (which in rating student response is also the scoring) can become a natural part of the daily routine. Art teachers who are experienced in juggling art materials and time between several school buildings will find life just a bit more complicated initially as they learn how to conduct ongoing assessment using some new methods and come to recognize needed curricular or instructional changes.

For district-wide assessments, time to plan good assessment is not only a cost factor to the school district, but it may be an uphill battle for art teachers to convince school assessment experts of the viability of alternative approaches. Given careful construction of assessment procedures and tools addressing student learning goals or outcomes, content validity can be claimed. However, teachers must be trained so that administration and scoring procedures are consistent and bias and discrimination checks must be built into the assessment process. Systematic sampling of a behavior also contributes to reliability—a quality easier to demonstrate with traditional assessment. It may be helpful to point out that other disciplines, even mathematics, are valuing the balance offered by performance and, in cases, authentic assessment.

Recommendations

Recommendations for constructing alternative assessment instruments center on the criteria, the behaviors, and discipline-specific approaches.

Criterion-referenced Assessment: Behaviors

Wiggins (1992) asks, "What are the most salient and insightful discriminators in judging actual performances?" (p. 26) Teachers need to take the time to reflect on questions like that. Such reflections will help avoid situations like Popham's (1974) description: "A criterion-referenced test that doesn't spell out its criterion satisfactorily might just as well be a cloud-referenced test for all the good it will do" (p. 615). Some specific recommendations include

• Focus on performance capabilities as criteria; this reinforces the idea that behaviors are the major focus of instruction (F. Davis, 1972; D. J. Davis, 1971). Criterion-referenced assessment records a student's performance related to goals and outcome statements (Ebel & Frisbie, 1986), or a well-defined domain of behaviors (Popham, 1974). The criteria of performance assessments involve art-related behaviors which, for purposes of this book,

have been categorized as know, perceive, organize, inquire, value, manipulate, and interact/cooperate. Zessoules and Gardner (1991) recommend authentic experiences because of the behaviors that are encouraged in student work, (e.g., complex under-standing [organize behavior], reflective habits [inquire behavior], documenting evolving understandings [organize and inquire behaviors], and learning from the assessment experience [organize, possibly value, behaviors]).

- Allow for flexibility. Zimmerman (1992) points out that portfolios allow students to be observed "taking risks, solving problems creatively, and learning to judge their own performance and that of others" (p. 17). *Risk-taking* and *creativity* are behavioral approaches to handling information (i.e., inquire behavior), and *solving a problem* and *learning to judge* involve relating and synthesizing knowledge in order to decide, an organize behavior. Thus, portfolios, like other art experiences, can provide assessment data on more than one behavior.

- Instructions must clearly inform students of the nature of the behavior expected by alter-native assessments. Hamblen (1992) suggests being explicit about the kind of answer that is *not* acceptable. Criteria should alert students to utilize contributing knowledge without formalist concerns or technical skill becoming the focus of the performance. How well do students interpret meanings or create meaning in their art? What relationships are perceived and used for effectively communicating? What reflective behavior is evident?

- Assess what was taught for and experienced by students. Assessment must not reward one student (to the detriment of others) for a good quality not encouraged in all students. (Although, again teachers' logs can note unanticipated, positive qualities). Day (1985) points out that an art experience where students are to explore a medium would be inappropriately assessed by a student's ability to convey specific information not part of the experience of all students (e.g., humor added to a poster when the instructions to the class did not suggest humor as a desirable quality, i.e., a criterion).

- Consider the wording of questions carefully. Greer and Hoepfner (1986) describe the open-to-closed continuum along which the wording of questions or instructions can vary, for example, from replication of an image (closed) to creation of an unspecified art work (too open to score). Criterion-referenced assessment instructions that allow some student choice and, thus, fall between these two extremes are optimal.

- Assess the ultimate behavior rather than each small contributing bit of knowledge or capability. While value contrast is a concept that the students learned, that knowledge is in service of the meaning it communicates (e.g., *value contrast* significantly contributes to the effectiveness of the communication). Hence, the ultimate assessment criterion is the students' organizing behavior of *synthesize*—a high level of the organize behavior category—and where value contrast is one contributor to the communication.

Strands of Evidence

The behaviors developed through art experiences can be observed through three strands of evidence (Chittendon, 1991)—observation (the student may or may not be aware of the obser-vation), performance samples, and tests. Figure 11.2 clusters tasks under these three strands (similarly to Figure 7.1). Students may be involved in clusters of art activities from both obser-vation and performance strands selected by the student and/or teacher because of portfolio, encounter, or authentic approaches. The diversity of clustered experiences supports a multi-instrument assessment approach.

Since Chapter 10 dealt with objective test items, essays, and some ways of modifying them, this chapter will focus on the remaining two assessment strands—observation and performance samples. As with many of the human judgment items in Chapter 10, it could be argued that the

problem solving drawing task (Figure 10.10) is nontraditional assessment, but it was included with the traditional instruments to illustrate graphic problem solutions in a test mode. Performance assessment may be conducted formatively (within the instructional setting) or summatively (at a designated time and location in, or away from, the instructional setting). Observation usually, occurs within the instructional setting, but not always, as, for example, during field trips or cooperative learning situations.

Figure 11.2—Strands of evidence wit illustrative instructional situations and locations

Strand	Situations providing evidence	Location
OBSERVATION	Think Sheets Classroom cooperation Care of materials Productive time on task Student-Student interaction Opinion surveys Interviews Student journal entries	Classroom
PERFORMANCE SAMPLES 　**Authentic tasks** 　**Portfolios** 　**Independent tasks**	Self-check of performance activities Media experiments Aesthetics puzzles debate News articles about art Written art history tasks Art history activities Sketchbook process documentation Art products Sketches Peer criterion-referenced critique Aesthetics dialogue Group art criticism discussions of art Anecdotal records Dead end starts analysis Sorting perceptual tasks Question box	Classroom stations Ongoing assessment of natural learning situations Problem-solving task in designated test setting Exhibition
TESTS	Quizzes Worksheets Summative traditional class test Essays Periodic district test	Classroom

Observation Instrument Construction and Examples

The observation strand includes checklists, interviews, journals, and parent questionnaires as categories. The performance sampling strand includes a wide variety of applications of criterion-referenced rating scales, documentation (video, audio, photo, bank of product samples, exhibits, computer saves), learning activities, worksheets, games, written notes to essays, and sketchbooks.

Chapter 8 includes some alternative assessment examples in the context of a lesson. Observation examples appear in the Grade 3 encounter to demonstrate how to record students' perceiving, organizing, and inquiring behaviors during the art criticism experience and aesthetic dialogues. The high school art production task criteria assess inquiry behaviors (e.g., originality and serious engagement), organize behaviors (e.g., conceptualization of the role of color, detail, and value variation, for showing depth; formal perspective; and multiple vanishing points), manipulative behavior (e.g., precision/technical quality, actual depth), interacting behavior (e.g., cooperation between teacher and student), and valuing behavior (e.g., challenge). The content, behavior, level of behavior, grade level, and goal of each example will be shown using the code system explained in Chapter 10.

Checklists

Checklists are used to indicate presence or absence of a classroom expectation such as respect for others' work, clean-up, cooperation with others, self-reliance, or some condition set for an

Figure 11.3—**Art classroom checklist**		
	Content/ Behaviors/ Level / Grade / Goal	
	/ I/C / M / P /	
Art classroom checklist		Month: _____
Student	**(- = disruptive, / = cooperates, + = contributes, * = responsibility)**	**Comment**
1 Morgan		
2 Miles		
etc.		

art product. Teachers may want to record how frequently students are observed cooperating (or being disruptive). Indicating a 0, -, /, +, * behind a name would be a way to indicate evidence of group interaction for a time period (see Figure 11-3).

Teacher Record Sheets

Clark (1975) recommended converting teachers' subjective impressions to intentional observations. A structured response sheet can minimize the time involved in writing out notes (Gronlund, 1981) about some of the more elusive student behaviors that affirm art learning. The first step in doing so is to reflect on the nature of the evidence. Try to identify which of the basic art behaviors (know, perceive, organize, inquire, value, manipulate, interact/cooperate) it can fit into, considering the broader list of behaviors that each represents (Figure 5.2). Specific recurring behaviors can become the criteria for tracking the subtle indicators of learning. Figure 11.1 provides examples of elusive evidence, classifies each as related to a basic art behavior, and identifies a nontraditional tool for documenting that evidence. Figures 11.4 and 11.5 show two approaches to recording these behaviors.

Figure 11.4—**Teacher record sheet—Evidence: expresses opposing ideas tactfully**

	Content/ Behaviors/ Level / Grade / Goal
	AC / I/C / M / I /

Teacher inserts date when the behavior was observed (+) or opposite behavior was observed (-)

Student

1 Bridget
2 Nolan
etc.

Figure 11.5—**Teacher record sheet—Evidence: presents work with care**

			Content/ Behaviors/ Level / Grade / Goal	
			AP, AH/ M,V / M / J /	

Student	**Date**	**+** = yes; **/** = no	**Action taken**	**Date: Results**
1 Charlotte				
2 Keith				
etc.				

Student Project Checklist

Checklists may be given to students to keep record of their progress through a complex project and to serve as a reminder to use the research resources provided or suggested. A checklist (Figure 11.6) of assessment criteria for a portfolio or project could be given to students to do a self-check on their comprehensiveness prior to turning work in.

Figure 11.6—**Student project checklist**

	Content/ Behaviors/ Level / Grade / Goal
	AP / O,I,V / H / H /

Initial each item upon satisfactory completion. Provide reasons why any item that is not initialed is not applicable, and turn in this sheet with your project.

____My art work has a meaning or purpose to serve.

____The way the parts are organized helps the meaning.

____The main focus is clear.

____The technical quality contributes to the effective message.

Checklists may be used with performance samples to note correct use of media or tools or meeting the minimal size of the project, and so forth. Entries can be a matter of "yes" or "no" since they are not the critical art learning intended.

Interviews/Questionnaires

Interviews vary from casual comments as a teacher walks around the room talking with students about their work in progress, to formal and private one-on-one discussions about a body of work and its direction. Interviews may include questionnaires to parents. A structured course evaluation, by which students respond to teacher-composed questions, constitutes a simultaneous (one-sided) group interview. Likewise, attitude surveys can provide information that can be used to modify curriculum or instruction.

Students may be more capable of observing student-to-student interaction than the teacher. Therefore, a peer group appraisal, as seen in Figure 11.7 may enlighten—or verify—the teacher's observation of the way students work together.

Figure 11.7—How we worked together

Content/ Behaviors/ Level / Grade / Goal

any / I/C / M / P /

On the line, write the name of the person or persons in your group that fit the description on the right. Any person's name may be used once, more than once, or not at all.

Ginny, Debbie, Sandy, Blanche	have good ideas.
Linda, Tom, Jeannie	took charge to help us get our task done.
James	always is willing to help others.
Carol	finishes what was assigned to be done.
	is a good clean-up member.
Mac, Larry	helps us think ahead about possible results.
	listens to other persons well.

After a test or survey, tape-recorded interviews allow students to clarify or expand upon points that were raised. A fruitful type of question in such cases is, "What was the role of 'x' in your decisions?" Maeroff (1991) reports a trend in modifying the extensive note-taking of individual interviews. She suggests that one could decide what information is the most important to gather and structure a check-off list with space for comments. Some element of standardization is thereby introduced.

Besides typical, verbal, Likert-type scales (agree to disagree), photographs, as in Figure 11.8, may be the stimuli used with any age to elicit students' attitudinal responses.

Figure 11.8—A picture of this year

Content/ Behaviors/ Level / Grade / Goal

(all) / V / P / M /

Please rank each of the ten numbered snapshots of our class activities by:

1. most important to least important___ . ___ . ___ . ___ . ___ . ___ . ___ . ___ . ___ . ___
2. most liked to least liked___ . ___ . ___ . ___ . ___ . ___ . ___ . ___ . ___ . ___

1 2 3 4 5 6 7 8 9 10

Structured Think Sheets, or Self-appraisals

Structured questions provide a service to both the student and the teacher. Students may need sugggestions as to types of things to note lest they doubt the importance of observations, connecting thoughts, reproductions in books, newspaper clippings, and so forth. Young children might be guided by think sheets with focusing, open-ended questions. (See Figure 11.9). Many variations of a suggestion box can be useful in order to observe through the eyes of your students.

Figure 11.9—**Think sheet time**

Content/ Behaviors/ Level / Grade / Goal

AH,AC/ P,O,I / M / I /

Name_____ Date_____

1. What do you see downtown, at home, or elsewhere that has something to do with what you are doing in art?_____

2. What have you noticed about other works of art that are about a topic similar to yours?_____

Students who are encouraged to review an accumulation of sketches, notes, and comments kept in a folder or journal are more apt to perceive relationships and trends in their work.

Teacher Log Book or Anecdotal Records

The information collected by teacher logs is not in response to direct questions, but may have developmental, media, art form, thematic or no focus. The teacher's log book might be keeping records of classroom behaviors of certain students where the assumption is that making a written note of easily forgotten incidents will show a pattern of repeated behaviors that have some significance. A gradual change in a single direction could be the basis for modifying instruction.

A teacher log book is like a diary of notes to help the teacher remember casual observations that may or may not add up to future insights. A log tracks issues raised, questions, attitudes, discussions, and the kind of unanticipated evidence of student learning that keeps teachers going, but which is fleeting when it comes time to remember specific examples to support a position. Certain characteristics of the art learning situation and/or students may be "followed" in a log to observe trends or consistencies. This is a documentation process and it may contribute to a narrative portrayal of art learning in a summary statement. Figure 11.10 is just one simple form that the log might take.

Figure 11.10—**Teacher log**

Content/ Behaviors/ Level / Grade / Goal
(all) / (all) / (any) / (any) /

Student	Date	Period	Activity

Parent Questionnaires

Parent questionnaires are not new, but they are still likely to carry the message that a teacher cares about what a child is learning. An invitation to be involved in giving feedback can result in unexpected insights. One suggestion is a monthly note requesting parents to ask their children about their art task that week, write down the child's responses and return it. These could be kept in a folder for each child or a class portfolio. With some consistency, these returned notes could reveal a pattern that would have useful information for individual help, individual direction to resources, or curricular or instructional import. Reports on questionnaires sent home with students vary from 70% return (Hyndman, 1993) to very few. Their usefulness seems to be dependent on the school and/or community. Take-home questionnaires cannot compete for reliability as assessment for several reasons: (a) self-reports are subject to individual interpretation of purpose and responses vary accordingly; (b) the school has little control over the value of, and attention paid to, a questionnaire in the context of the home; and (c) questionnaires indirectly delivered and returned cannot truly represent the art student population with any confidence.

Performance Instrument Construction and Examples

The major tools explained under the performance sampling strand (Figure 11.2) are checklists and other documentation methods, and rating scales as instruments for collecting and/or recording evidence of student outcomes.

Performance Checklists

Performance checklists may be used to note items in a student journal; student-to-student interaction in group work or individually; manipulative skill achievement; participation; or inquiry behaviors related to performance in aesthetics, art criticism, art history, or art production activities.

"Scored" Checklist for Art Games/Learning Activities/Worksheets

Figure 11.11 is an example of a work sheet checklist where the art history activity was preliminary to the production task. Here the emphasis is not on the information gathered, but on the research activity and translation to an authentic task.

Participation Checklists

Again, a preliminary activity can be checked before a student moves into a production component of an encounter. In-depth media experiments build process concepts that enable the student to give form to an idea effectively.

Production Checklists

Most art production tasks are expected to produce evidence of what students know and can do. They also generally have certain parameters within which the student is to work (e.g., media, theme, size, incorporation of subject matter, time, dimension, or art form). The parameters may be part of a teacher's plan to expose students to some breadth in the curriculum or some in-depth focus. Figure 11.12 is an example of an in-process teacher-student check on meeting the expectations.

Figure 11.11—**Work sheet completion checklist**

Content/ Behaviors/ Level /Grade/Goal

AH /K I, O V/ L / I /

Name_____

Who, when, where, why about _____ art

1. I found information about the art period I chose in

2. The art of the _____ period can be described
 as:_____

3. The purpose of art in the _____ period was:

4. An art form that I could make that would serve a good purpose
 is _____

5. Images, symbols, or shapes I could use to enhance my art form
 are_____

6. Other interesting ideas that came from the study of the _____
 period are:_____

Completed item		On time		Comment:	
	yes	no	yes	no	
1.					
2.					
3.					Score_____
etc.					

Figure 11.12—**Individual student–teacher product checklist**

Content/ Behaviors/ Level / Grade / Goal

(AP) / I/C / L / I /

Coding: 0= absence; / = presence; + = commendable

Teacher_____

Student_____

Art experience:_____

Checked by: Student Teacher

Conditions to be met*

1. Sarawanee_____ _____

2. Pius _____ _____

etc. _____ _____

Comments.....

*Teacher supplies conditions appropriate for the project.

Documentation

Seeing is believing; and that fact may make more sense to many parents than grades. elementary art teacher sends a schedule of classes to parents with the invitation to participa a class with their children for an arts week event. Many parents cannot do this, but then other ways to bring the classroom to the parent and to document the learning that occurs the.

Classroom Video Documentation

Videotaping of group discussions for assessment at a later date contributes to accuracy of the ratings of student responses and is also available for art program promotion uses. Parents are easily convinced that their child has learned what they never expected if they see a videotaped art criticism discussion at a school or community meeting, or while waiting in turn for a parent-teacher conference. A videotape of students working on a project or in small research groups in the resource corner give a broader picture of art education (i.e., one worth talking about), than most parents experienced. Subtitles can be inserted on videotapes to ensure that critical points are recognized. Some narration about how assessment results support the value of students' talk about art would, along with the observable evidence from the videotape, make the figures more meaningful.

Photo/Audio/Computer Documentation

If time or equipment is limited, parents with cameras could be asked to periodically take photographs of students creating, talking, conducting teach-back lessons, and studying in art. Cameras can capture the ethos of a contemporary art classroom that will contrast favorably with parents' school experiences. Newspapers interested in school items are a way to tell many persons about the nature of learning in art education.

Computers can scan art works and build a documentary file of art performance—a bank of product samples and written work from art classes. With more space, actual samples can form a record of quality work for reference when assessing student work of the same level year after year.

Student Journal Documentation

Much has been and continues to be written about student journals as individual documents. Individually, the journal is a record of, often unperceived, evidence of learning; a composite of all the journals can be a source of evidence of group learning. Student journals are concrete records of thoughts and events upon which students can reflect, and about which they can obtain feedback from the teacher and from their own reflection. A teacher's review, with the objectivity of distance, can assist students' insights. The teacher may suggest possible meaningful experiences, relevant events to investigate, or media exploration.

The journal can be within a portfolio, folder, or sketchbook. It can be a diary, think sheets with prompt questions, or any other form that encourages free responses and collection of other relevant items.

Rating Scale

Rating scales indicate degrees of success for each criterion, and assessment takes on greater specificity and objectivity than global scores. Students do not either learn something to the fullest extent or not at all.

The criteria are expected outcomes based on what students have experienced through their art encounters and should be made clear to them. Student input in identifying the criteria has a two-fold benefit: First, it reviews the focus of the art experience and, second, additions from a student perspective may reveal meaningful expression or elaboration of the criterion. Clear definitions of each rating on a scale (see Chapter 12) contribute to consistency by the observe or rater in assessing success from student to student. Rating scales are useful for assessing learning in a great variety of art experiences.

Aesthetics Dialogue Rating Scale

An aesthetics dialogue is a group discussion about the nature and value of art, or other philosophical issues related to art in general. Discussions encourage behaviors such as critical thinking, listening, relating, and reflecting about reasons before making decisions. Aesthetics dialogues may emanate from a variety of situations (e.g., art production activities, art criticism experiences, comparisons of art forms from different eras, or art created for different purposes). For example, the teacher might suggest that students compare two portraits, both considered art by some experts but painted in different eras and therefore, depicting different attitudes. A rating scale such as Figure 11.13 could be used to observe the quality of student thinking exhibited during the discussion.

Figure 11.13—Aesthetics dialogue about the value of art from different eras

Content/Behaviors/Level/Grade /Goal

AES , O,I , H , J ,

CRITERIA

	Thoughtfully considered reasons for judging something to be "art"	Expressed relevant, life-oriented big ideas based on art learning in the encounter	Synthesized contributions of others	Used information from diverse sources, periods of art or cultures
Student				
1. Sze-Oi	_____	_____	_____	_____
2. Brian	_____	_____	_____	_____
etc.	_____	_____	_____	_____

Art Criticism Rating Scale

Imagine a group discussion of a poster-size art reproduction. As the students respond to the teacher's guiding questions, the teacher marks on the prepared sheet to indicate who participated and in what way. Individual student scores could be efficiently coded on a recording sheet similar to the one depicted in Figure 11.14.

Figure 11.14—Art criticism rating scale

	Content/ Behaviors/ Level / Grade / Goal
	AC / O, I / H / P /

Criteria :	Observed objects that shape the meaning	Gave reasons for artist's decisions about organization	Offered a meaning of the work and supported it with reasons
Student			
1 Jaclyn	_____	_____	_____
2 Jack	_____	_____	_____

From *Untitled* by Yih-Wen Kuo. Loeb Art Gallery, porcelain, glaze, 6" x 5 1/2" x 3 1/2". Copyright 1991. Permission granted by Yih-Wen Kuo.

Art History Report Rating Scale

Children can engage in art historical inquiry to detect contextual influences and place art works in relative positions in time to each other by kinds of clothing depicted or other Figure 11.14 information in the work. They can compare the art reproduction with photographs from time periods where clothing matches that in the art work. Colored time spaces on a timeline can guide placement of color-coded reproductions to show spatial relationship to the present. The rating scale in Figure 11.15 could be used by an aide or teacher listening to a student's response to oral or written questions or recording answers on audio tape. A work sheet could be the format of the simply written questions.

Figure 11.15—Comparison: Art subjects in different periods

Content/ Behaviors/ Level / Grade / Goal

AH,AC/ O, I / M / P /

Comparison of similar art subjects in different periods: Goya's *Don Manuel Osorio* and Steinlen's *Girl and Three Kittens*

Student:	Child image differences	Animal theme similarity	Identification of art work closer in time to present
1. Susi	_____	_____	_____
2. Roberto	_____	_____	_____

Art Encounter Rating Scale

Figures 11.16 and 11.17 show rating scale formats for an art encounter integrating activities derived from art history, art criticism, aesthetics and art production. The encounter objective is: To contribute to a group multicultural quilt, each student will neatly make a pattern (on an 8-

Figure 11.16—Art encounter rating scale

Content/ Behaviors/ Level / Grade / Goal

AES,AH,AC/ O, I / M / P /

CRITERIA

Student:	Determined characteristic colors of a culture	Identified meaning of the symbol	Reasons for functional objects being "art" or not
1. Karen	_____	_____	_____
2. Mark	_____	_____	_____
3. Becky	_____	_____	_____
4. Neal	_____	_____	_____

Figure 11.17—Art product rating scale

| | | Content/ Behaviors/ Level / Grade / Goal |
| | | AP / O,I / M / P / |

	CRITERIA		
	Used color characteristic of the culture	Technical quality contributed to meaning	Created pattern with symbols
Student:			
1. Karen	_____	_____	_____
2. Mark	_____	_____	_____
3. Becky	_____	_____	_____
4. Neal	_____	_____	_____

inch square of construction paper) using multiples of a motif, cut from gummed paper tape. The motif is derived from a meaningful symbol and uses characteristic colors of a particular culture. The student will also write (a) a description of the meaning of that symbol in the culture, and (b) reasons why objects enhanced by symbols of a culture that were made for their functional value should or should not considered "art." In an exhibit, the written papers will be exhibited in positions that correspond to the squares on the quilt. The research that preceded the art production is checked by the criteria of Figure 11.16 and Figure 11.17 demonstrates the art product rating scale. However, if desired, the assessment could be combined on one sheet.

Authentic Performance Task Rating Scale

Authentic experience must exist as part of authentic assessment. An authentic task must be analyzed for the purpose and outcomes expected before deciding the criteria of a rating scale.

Imagine the following instructions for an extended problem.

> "Your class visited the art museum which had acquired pieces of the facade of a Turkish mosque. You were impressed by the history, meaningful structure, and enhancement of this architecture. What kind of a structure would you plan that could be as meaningful in your middle-size town in the U.S.? What are the comparable variables to consider in planning such a structure? What research, news items, sketches, or other activity would help you make your decisions? In what form would you present your ideas—sketches, finished drawings, three-dimensional model—to the city council for approval? This task must be completed in ten class periods plus the time needed outside of class to research and report your process."

The purpose of this task is to have students find and solve a specific problem, within the societal parameters of a "meaningful structure," and to document the thinking process that contributed to that problem solution. The instructions suggest pursuing resources for ideas, ways to demonstrate the solution, and ways to present ideas to others. While this task is a high school level task, it could be geared down to a grade school level by changing the context and structure to captivate the interest of young students.

Figure 11.18 presents possibilities for rating scale criteria that would accommodate the divergence that this problem invites.

Figure 11.18—Authentic task rating scale				
			Content/ Behaviors/ Level / Grade / Goal	
			(all) / O, I / H / H /	
			CRITERIA	
	Structure contributes to societal meaning	Elaboration contributes to societal meaning	Presentation of project	Report of process is effectively documented
Student:				
1. Ingrid	_____	_____	_____	_____
2. Jaimie	_____	_____	_____	_____
etc.	_____	_____	_____	_____

Concept Application Task Rating Scale

Preliminary concept formation or problem-solving tasks in an art encounter may be designed for formative assessment as a check on concepts needed for successful art production. Examples follow of tasks to assess students' abilities to apply concepts—concept of shape variation to a new situation (Figure 11.19) and concept of value to create the illusion of form (Figure 11.20).

Journals/Sketchbooks Modified Rating Scale

Student journals are self-reports that are adjunct to teacher observations. They can show students' perceptions or how they want to be perceived. Should student journals reveal discrepancies, that in itself is informative. If the purpose of the journal is a free flow of personal thoughts without any aspect required, assessment is inappropriate and counter-productive (Gronlund, 1981). A journal might be suggested to raise questions, express feelings, react to a course, reflect on procedures, or trace new insights. Given an unstructured journal assignment, students most frequently use it as a means to get to know themselves and make common sense reflections. Some use journals as written dialogues between teachers and students. Journal "rules" must be clear to students in accordance with state mandates to teachers, such as, referring students who show even possible evidence of abuse or suicidal tendencies. Analyses of the predominance or trends of disparate journal notes is discussed in Chapter 12.

A teacher may have established some basic expectations for student journals or sketchbooks. A modified rating scale could be used to record the quality of components of the sketchbook that were required and for which students were told the criteria on which they would be rated. For example, the journal could be expected to show relatedness perceived between new and old information. The purpose determines if, and what, would be rated for achievement. Figure 11.21 is a sample of a modified rating scale for journal analysis which uses a code for frequently used comments rather than a scale of degrees of quality. It assumes that these characteristics were encouraged through the art experience. Where group results are needed, students can respond anonymously.

A teacher may add codes and criteria appropriate for the stated art goals or outcome statements.

Figure 11.19—Concept application performance assessment: cutting

In social studies class, quilts were studied as a social group activity and in art, as a beautiful and culturally meaningful folk art form. The task for art class includes making a group quilt out of paper, using geometric shapes and variations of them. Each student is given nine of the same geometric shape--square circle or triangle-- to put in one block, for example:

Instructions:
Cut into the round shapes given you so that each appears round, but each one is different from the next.

Example:

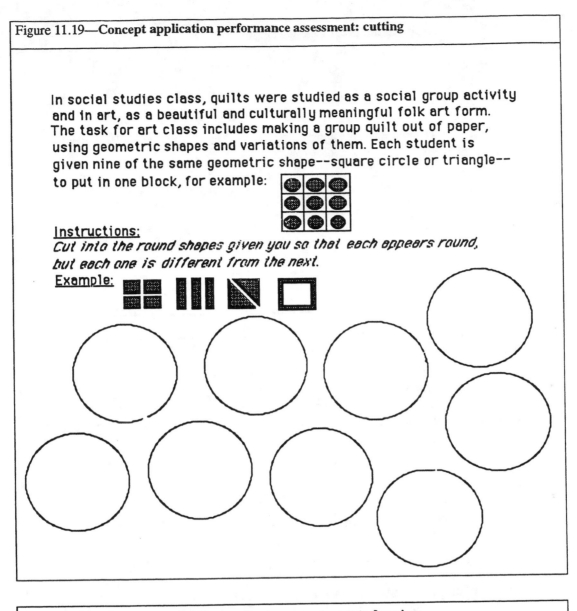

Figure 11.20—Concept application performance assessment: drawing

Instructions: Using a pencil, add value to each figure below to make it seem three-dimensional, and as if a spotlight was pointed at at each from the lower right hand corner of this page.

Figure 11.21—Student journal or sketchbook description

Content/ Behaviors/ Level / Grade / Goal

AC / O,I / H / H /

Coding system: 0 = no entry; / = entry; I = insightful; S = synthesizes information; P = potential idea;
R = reflective approach; RT = recurring theme

Student	Notes on visual observations	Comments make clear associations to art experiences	Germinal sketches	"Big idea" statements about art and life	Comment on art observed in out-of-school contexts	Other
1. Jill	_____	_____	_____	_____	_____	_____
2. Miguel	_____	_____	_____	_____	_____	_____
etc	_____	_____	_____	_____	_____	_____

Stoddard (1993) reported on an interesting variation—the walking journal—where a small group of students rotated a response to an instructor-chosen issue, or one which they expressed themselves. The response of the first student was passed to the next in the group, and so forth. The reflectiveness of the first response seemed to set the stage for the tone of subsequent responses.

Peer Critique Rating Scale

Peer appraisal is as real as the glance across the art table or on the way to pick up supplies, but teachers usually are not privy to hearing comments at those time or reading minds.

As quick as students are to comment in some situations, they can become speechless for a group critique. In the peer critique, student groups orally discuss the art work they have produced. It is advisable to prepare the students for the oral discussion by having them write responses to particular questions or to the criteria for the task assigned. A critique sheet could be prepared for each student giving a report. Each listening student would mark a "yes" or "no" for each criterion and give the sheet to the reporting student. This can then be followed by small group interviews (Maeroff, 1991; Waanders, 1986).

Used another way, meaningful criteria of the task agreed upon by student and teacher could be the basis of individual student scoring of their peers' art work. This could be followed by a group discussion where students would be prepared to identify art work that met particular criteria well and explain how other peers did so in similar or different ways. This procedure is instructional in that it helps students avoid global, summative judgments based on partial evidence. Rather it encourages the interaction of multiple criteria while allowing any student a chance to get a "stroke" for success on one criterion even if other criteria were bungled.

This approach to the peer critique assessment also attempts to overcome inequity in oral responding. Both critiques would be facilitated by the art teacher asking questions that encourage constructive, reflective comments based on evidence in the work, information gleaned from art history or art criticism experiences, and concepts taught. Students need to be encouraged to respond in thoughtful ways and need practice in reflective, higher order thinking.

In addition, giving students an opportunity to respond in a written format is important because it allows the teacher to know the student's initial feeling and thoughts before being influenced by others in an oral critique, or stifled because of discomfort in a group discussion. With time to read written responses or with quick over-the-shoulder glances, the teacher is aware of the contributions that individual students are capable of making in the oral critique and can plan the questioning strategy designed to draw out those contributions if they are not voluntarily made.

During the critique, the teacher has less time for making judgments, but usually can make tallies or plus signs on a prepared form to indicate extended responding or evidence of critical thinking. Videotaping gives another alternative to tallying responses during the oral group critique. The same criteria and form is used for recording both oral and written responses (see Figure 11.22).

Figure 11.22—Peer critique assessment				
			Content/ Behaviors/ Level / Grade / Goal	
			AC / O,I / H / J /	
	CRITERIA			
	Reflective, analytical thinking approach	Discusses with appropriate objectivity	Supports interpretation or judgment with observations	Points to role of concepts taught in the project
Student:				
1. Erica	_____	_____	_____	_____
2. Michael	_____	_____	_____	_____
etc.	_____	_____	_____	_____

Student Self-Appraisal of Art Production

An often-used variation of the teacher rating scale for justifying the quality of student art work is a combined student and teacher format. Teacher and student ratings will be closer if students are given the specific criteria by which to rate their products and the explicit meaning of each rating. Students do the rating first and then the teacher rates the work and adds any comment or explanation that is helpful.

Art Production, Unit, or Portfolio/Exhibit Rating Scale

An art product may be assessed on an individual basis, as part of an art encounter integrating discipline-based activities, as part of a unit of study, or within a portfolio. Portfolios vary in format from notebooks to large-size art portfolios or folders. Portfolios can be presented as informative exhibits.

Portfolios vary in definition from the precise requirements of the College Board's Advanced Placement portfolio to a *collection of things*. They may consist of art products only or include lead-in experiences, sketches, student notes about the work, and student comments about art or life experiences that relate to production experiences. Assessment portfolios are documentation of students' process and growth, whereas showcase portfolios focus on end products.

Formative assessment portfolios are considered working portfolios while summative assessment portfolios are considered a presentation portfolio (MacGregor & Gilchrist, 1993). The portfolio may be related to a single project, a unit of work, a semester, or a year or more. It may be ordered chronologically, but teachers may choose other organizations. A "theme" or "focused" portfolio would contain work by a student or groups of students that represent continued work in a common vein (e.g., extended study of "The Planets," "Work," "Realism in Art," facial features, charcoal drawing, or action figure drawing).

Figures 11.23 and 11.24 show individual-product and unit-product rating scales. Figure 11.25 shows a generic format for a criterion-referenced assessment of a portfolio.

A portfolio of individual work or groups of student portfolios can be exhibited and assessed. A group of student art work that comprises a unit of study would cover a shorter span of time, but would probably encompass the same variety of performance examples as shown in Figure 11.25.

Figure 11.23—Art production: Individual-product rating scale

Content / Behaviors/ Level / Grade / Goal
AP / O,I,M / M / I /

Instructions: Make a 12" x 18" pencil drawing of a significant event showing crowds of active people both close and far away. Draw the very best that you can, using what you have learned about showing depth. Use all of the hour of time that you need.

Student _____ Score _____

	Low				High
People in action	0	1	2	3	4
Objects in proportion	0	1	2	3	4
Depth enhanced by close detail	0	1	2	3	4
Depth by overlapping	0	1	2	3	4
Depth by position on the picture plane	0	1	2	3	4
Depth by size variation	0	1	2	3	4
Visual emphasis of the vent	0	1	2	3	4
Conceptual significance	0	1	2	3	4

Figure 11.24—Art Production: Unit-products rating scale

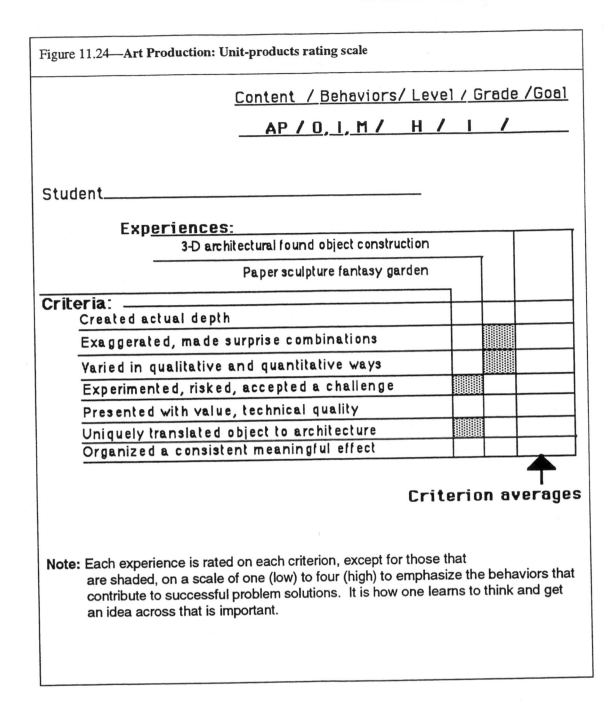

Content / Behaviors/ Level / Grade /Goal

AP / O, I, M / H / I /

Student _____

Experiences:

3-D architectural found object construction		
Paper sculpture fantasy garden		

Criteria:

Created actual depth			
Exaggerated, made surprise combinations		▓	
Varied in qualitative and quantitative ways		▓	
Experimented, risked, accepted a challenge	▓		
Presented with value, technical quality			
Uniquely translated object to architecture	▓		
Organized a consistent meaningful effect			

⬆ Criterion averages

Note: Each experience is rated on each criterion, except for those that are shaded, on a scale of one (low) to four (high) to emphasize the behaviors that contribute to successful problem solutions. It is how one learns to think and get an idea across that is important.

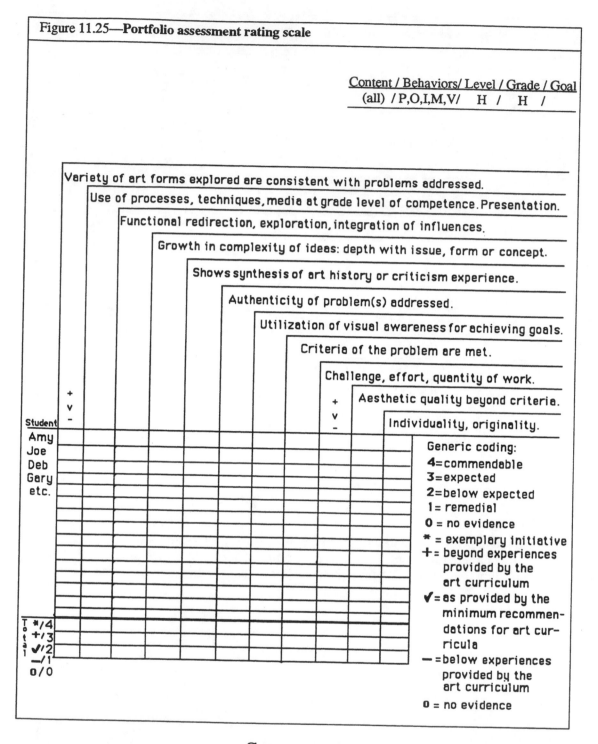

Figure 11.25—**Portfolio assessment rating scale**

Content / Behaviors/ Level / Grade / Goal
(all) / P,O,I,M,V/ H / H /

Variety of art forms explored are consistent with problems addressed.
Use of processes, techniques, media at grade level of competence. Presentation.
Functional redirection, exploration, integration of influences.
Growth in complexity of ideas: depth with issue, form or concept.
Shows synthesis of art history or criticism experience.
Authenticity of problem(s) addressed.
Utilization of visual awareness for achieving goals.
Criteria of the problem are met.
Challenge, effort, quantity of work.
Aesthetic quality beyond criteria.
Individuality, originality.

Student
Amy
Joe
Deb
Gary
etc.

Total

*/4
+/3
✔/2
—/1
0/0

Generic coding:
4=commendable
3=expected
2=below expected
1= remedial
0 = no evidence
***** = exemplary initiative
+= beyond experiences
provided by the
art curriculum
✔= as provided by the
minimum recommen-
dations for art cur-
ricula
—=below experiences
provided by the
art curriculum
0 = no evidence

Summary

Alternative assessment fulfills a need for valid assessment in art where actual outcomes of learning are difficult to observe by traditional measures. Direct observation of student performance is consonant with the curriculum-instruction-assessment relationship in art. Systematic sampling of ongoing assessment is recommended. Depending on the intended purpose, art teachers can select from or create a great variety of instruments to assist in recording evidence of learning in art.

12

ADMINISTERING AND SCORING ASSESSMENTS

Chapter 12 provides guidelines for administering and scoring traditional and nontraditional assessment instruments that seem most pertinent to art education. Administration includes preassessment preparations, ongoing and summative assessment administration, and, in some observation assessment situations, on-site scoring. Preassessment considerations include deciding which methods of gathering information about student learning are scorable and which are generally not scored. Examples are given for defining achievement levels for criteria that convert to ratings or scores.

Administering Assessments

Preassessment Recommendations

The educational purpose for assesssing student learning is the foremost consideration in making specific decisions. If assessment is to be a meaningful part of learning, all subsequent choices (e.g. instruments, items, content and levels of behaviors assessed, specific criteria, scoring approaches, atmosphere) hinge on that purpose. Teachers may respond positively to the validity of assessment approaches proposed, but the challenging aspect is to set the criteria. Also, for each criterion, achievements that merit each performance level (or rating) need to be spelled out for raters and students alike (Maeroff, 1991).

Select, Practice, and Refine

The great variety of assessment procedures means that local developers must be selective and down-size to what is possible. Popham (1993) suggests matrix sampling—item sampling and student sampling combined. He maintains that it would not be necessary to assess all authentic outcomes in every test if teachers understand that any number of the outcomes could be assessed in regard to any content domain. Schools can be randomly sampled as well as students within those schools. Teachers can prepare students for recognizing transferable, life-oriented, process behaviors involved in solving problems across content domains. (See Figures 6.2 and 6.3.)

In planning an assessment program, remember content validity—including assessment methods that tap curricular emphases in proportion to the weight given them in goal or outcome statements and instruction. Consider what is the most important learning to observe and select or create credible assessment instruments which avoid gaps in specified outcomes as well as unnecessary duplication.

Teachers can be selective by using a few short assessment measures that could assess their present activities and offer the possibility of meaningful conclusions about student learning. Instruments can be pretested with a group of students similar to groups to be assessed. This pretest can check for conceptual appropriateness for that age level, clarity of instructions, and bias-free language. Diagnostic pretests given to groups to ascertain needed instructional emphases can be used for comparative purposes at posttesting. When the identification of valid instruments is complete, plot the components of each assessment procedure—preparation, systematic sampling, administration, scoring—on a timeline to ascertain what is feasible and how to organize for conducting assessments that you chose.

Location Decisions

The environment in which assessment is conducted can influence student outcomes. Assessment should be conducted in situations equitable for all students, with the least possibility of influences that might interfere with students' ability to perform at their highest level. Whether assessments take place in a large-group testing situation or in the comfortable environment of the students' regular classroom or art room, human or noise interruptions, uncomfortable physical conditions, removal of students for individual help, time and materials all need to be controlled for basic fairness. Adequate resources, equipment, reproductions of art work, media, tools, good lighting, adequate workspace, and appropriate seating for the age level are basic to a fair assessment.

All materials needed by students for the assessment task can be organized for easy distribution. Kits, individual game items within an envelope for each student, envelopes containing all materials and tools needed, or equipped work stations are some approaches that have been used. If photocopied reproductions are used on test pages, they should be clear and colored poster-size reproductions of the same works should be visible to all students.

In addition to the assessment location, one needs to arrange for space to store tests or performance pieces, score student work, return work, and retain selected work for permanent files.

Training

Herman (1992) maintains that teachers need substantial training and follow-up support in both *suitable* assessment techniques and appropriate instructional strategies. One effective, long-term approach is informal modeling. If classroom teachers see an art teacher assessing an ongoing art criticism experience, they may be intrigued by hearing their students performing in ways they had not anticipated in art. Then, through individual conversation and more specific questions, other teachers are apt to become curious enough to try this or other alternative approaches.

However, teachers are not always the persons to administer assessments. External evaluators may be involved in district-wide or state testing. A teacher's aide may be trained to assist in assessment of small groups of students while the remainder of the class continues working. Art teachers can help external assessment administrators by writing out answers to anticipated student questions about procedures, seating or task locations, what the test or task is like, reading or repeating directions, distributing materials, time limits and enforcement, and collecting tests or tasks. If an aide is to code student responses to an art criticism experience, a training period is necessary so he or she can conceptualize the point of the experience,

recognize levels of responses, and make such judgments quickly and accurately. Training involves the teacher and aide independently coding videotaped group discussions for practice and for determining the agreement between their ratings. Persons trained to assess actual performance using agreed upon criteria can attain a high degree of reliability (Greer & Hoepfner, 1986; Wiggins, 1989) and should practice ongoing reliability checks.

Frederiksen and Collins (1989) recommend a library of exemplars for assessment administrators and scorers to refer to as models for the many different ways in which students can do well. Student performance, digitized and categorized on the computer, can document stages of development of an idea, problem solutions, or components of portfolios and authentic tasks. Examples of qualities that merit different ratings or scores on a criterion can be stored for training in order to facilitate attaining reliability of raters. Videotape can record exemplary art criticism experiences and critiques as situations which elicit the primary traits or behaviors selected as criteria for assessment of such experiences. The human judgment assessments may warrant periodic reliability checks on a random sample of performance tasks, or review by an independent examiner, such as another art teacher.

Preparation of the Students

In accordance with school district or state requirements, special students require preparation appropriate to their needs. Some schools have persons to translate tests into the language of a student and translate the student responses back if the teacher speaks only English. Some students with hearing impairments have signers to enable their participation.

State or school district policy may determine whether all or a sample of students are assessed, at which grade levels, and for which subjects. Portfolios reviewed in the presence of students who can orally explain their presentation may verify a teacher's review, but this is demanding in time (Maeroff, 1991). Costs in time and money enter into decisions of feasibility.

Mastery levels may be identified for a district assessment. Although projecting percentages of students expected to reach that mastery level may be part of a required assessment plan, more typically a percentage of students will achieve at each of several levels.

Students need to share in the preparation for assessment by knowing what kinds of evidence they can provide (i.e., clearly communicate the performance standards, criteria, and evidence expected for each achievement level to them). They need to know the nature of constraints under which they will be assessed, such as time, available resources, or restrictions. If students know the anticipated outcomes of art education and parameters within which they will operate, they have greater motivation for working toward exhibiting their capabilities. Learning and its assessment then becomes a cooperative venture for teachers and students.

Administration of Assessment Instruments

General Recommendations

The demeanor of a person who administers assessment tasks should convey calmness, kindness, consistency, fairness and a concern for the students' ability to demonstrate learning well. Assessment administrators should take every precaution against interruptions by emphatic signs posted where outsiders will observe caution. Assessment should not be threatened punishment for misbehavior, not reading assignments, or reluctance to respond orally in discussions.

Tests

A test is an instrument to help students show what they know. Therefore, within the parameters of equity, the facilitative role of the teacher can prevail. For example:

- Multiple samples can be provided.

- Teachers can demonstrate the use of the answer sheet on the blackboard.

- Prompts, or reminders about major approaches or considerations in doing an assessment task, should be provided for all students or none.

- In published tests, the printed instructions of the test maker should be followed.

- Directions should be read aloud in a normal fashion—not monotone nor with exaggerated inflection of the voice as clues.

- Consistency from group to group is necessary, especially in cases where the groups will be compared.

Clarification of the meaning of words for individual students depends on whether understanding the word is what the question is designed to assess. If not, announce the clarification quietly to the entire class after getting the attention of all students. Avoid clarifying statements or giving hints to some but not all students, but keep interruptions to a minimum.

Give the full time announced without taking any more time than necessary in the beginning of the assessment period. Timed tests and individual response styles can cause some questions about fairness. Should reflective students be penalized for the very cognitive strategies that the teacher has encouraged in so much of the art experience? Is a student taking a longer time to respond because of a tendency to persist in spite of inadequate review of the material being tested? If students have other obligations that mandate a limited time for taking a test, is it fair to let others have a longer time? A compromise may be considered where a specific amount of time could be extended until about 85% of the class finished or a specified number of minutes after that point. Assessment that focuses on creative, critical, and reflective thinking, or other inquiry behaviors, should be scheduled where no time restrictions will inhibit a student's performance.

Observations

Assessment based on observations entails unobtrusive measures for the most part (e.g., reviewing journals, noticing classroom interaction, viewing videotaped discussions). Observation assessments that are integral parts of classroom instructional activities may or may not be recognized as assessment by students. The natural setting and activity is conducive to accurate evidence of performance. The teacher-administrator role in conducting such assessments is to facilitate students' ease in providing that evidence. If a teacher is calling on particular students and recording their participation or quality of response during a discussion, the slower pace may be noticeable, but that may not be a negative.

The teacher may focus on fewer than all criteria in one discussion. A part of the class may be checked during one art criticism experience, rotating the check to responses from other students in subsequent discussions. Each behavior should be focused on at regular intervals in a semester. Many feasible systems for regularly observing and recording students' art-related behaviors are possible. For example, taking turns in a predictable way leads to expectancy on the part of students, provides structure for low socioeconomic students, and reduces attention-getting butting in of other students (Brophy, Evertson, Anderson, Baum, and Crawford, 1976). Structuring discussions to teach approaches to fruitful conduct of discussions is a real-life

learning for students and contributes to manageable on-site coding when sampling for assessment.

One teacher plays a game that she calls "Drop pen" where, when some students are not volunteering, she selects who is to respond to each art criticism question by seeming to drop her pen on the list of student names (making sure that all students get to respond over several art criticism discussions)—a playful way to encourage participation from shy students. Although this regiments the discussion somewhat, it is a plausible solution for the teacher who has no assistance while first learning to record student comments. This is also one way to counter the possible inequity of assessing oral discussions. It is also important to systematically sample such discussions so that all students will have repeated opportunities to answer questions designed to elicit oral responses at all thinking levels.

For oral discussions, each student needs equal access to the information about which questions are being asked. There are several ways to accomplish this:

1. Have students form a close cluster around poster-size reproductions with large enough images that important details are evident to any person in the group.

2. Provide color reproductions for each individual.

3. Distribute individual sets of postcard reproductions, or

4. Photocopy black and white individual reproductions on forms with poster size color reproductions posted and numbered correspondingly to the individual black-and-white exemplars.

Students may volunteer answers faster than the teacher can record them and a difficult class may take advantage of the situation. Because eye contact is diminished if the teacher is recording, coding of student responses by a trained aide is preferable. Without an aide, another approach is to videotape the discussion and rate responses at a later viewing. Some teachers set the video camera so that it is focused on a central location and conduct the discussion as normal. Enough will be recorded for a teacher to know which student was responding even if not in range of the camera. To discourage interruptions, a "VIDEOTAPING" sign can be placed on the classroom door.

Teachers can regularly encourage students to make entries in journals, to compile and comment on news items, or write up observations relevant to the creation of a portfolio. As an alternative to journals, a constant supply of think sheets, and calling attention to them, would encourage their use, especially for young students, and provide the teacher a chance to observe self-reflective evidence of learning.

Brouch (1973) cautions that keeping anecdotal records is difficult with normal teaching schedules and classroom activity. Each teacher must weigh the importance of this kind of evidence. It may be possible with a student teacher, aide, interested parent or efficient planning of classroom activities to allow a quick pass by the desk to make necessary marks that can be interpreted more fully at the end of the day. One could keep an audiotape running for every class, immediately rewinding each class that did not produce some evidence that needed to be saved and recorded. That would only take a few seconds—at the end of a class and beginning of the next.

Teachers can be prepared with checklists for recording common classroom behaviors. Some teachers carry a clip board around the classroom containing a checklist with columns to accommodate the most likely kinds of evidence and space for efficient notes or added behaviors.

Interviews are observations in which the student is knowingly an active participant. The purpose is to gain insight about each student's development (i.e., progress or growth), interests, and strengths from his/her explanation of the portfolio contents and process. Gitomer et al. (1992) describe the role of the teacher in this formal, structured interview. They call attention to

the important role of teacher questioning when interviewing students about their portfolios. The questions encourage reflection and direct the discussion for focus. Teachers model the reflective process and massage student questions into reflection, redirection, or peer interaction.

Performance Samples

Preparation for performance samples involves defining criteria accepted as evidence of learning and the levels of performance (ratings) for each criterion by which the performance is to be assessed. Criteria can be specific or open-ended and can include:

- Verbal paragraphs differentiating the quality associated with a rating.

- Lists of characteristics or behaviors to correspond to numerical rating.

- Diagrams of acceptable answers for each rating.

Examples specific to the source of evidence follow in the section on scoring. Persons who are to score performance assessments must be trained in using the coding system and demonstrate interrater reliability just as in coding discussions. Commonality of access to media or tools for art production can be ensured by prepared kits of materials as described in the preassessment section. If there is a designated time and place for a performance assessment task, problem-solving stations or booths can assure privacy, independent thinking, and common equipment.

For portfolios, the teacher's role is not so much to act as an assessment administrator, but rather to be a guide in establishing focus, to advise about thematic content and ways to document a process, and to encourage self-reflective thought about creating art. To encourage such metacognition among students, a portfolio night to which the parents are invited could be planned for small groups of students (Hebert, 1992). There, the students show not only the art they generated but also related and influential evidence of the thinking process that culminated in the art form.

Elbow (1991) describes a written portfolio assessment procedure where instructors of the same course rotate as external assessors for each others' groups to lend objectivity to the process. Mandatory meetings on the use of a program-wide response sheet on sample portfolios are conducted to maintain reliability.

More commonly in art, portfolios are checked for their inclusiveness for the time period designated. They may be assessed on some specific characteristic related to the task addressed or on improvement, variety of related information, organization, imagination, or personal conception. Students may help establish criteria for assessment of their progress. Whatever form an assessment portfolio takes, teachers who post the criteria for it give their students needed motivation to meet the standards.

Scoring Assessments

Assessment may be conducted to arrive at baseline data about what individuals or groups of students know and can do in art. It may be used to compare groups of students, schools, or districts. Even if this is the case, group data is derived from a summary of evidence gleaned from individual students. Therefore, it is possible, but not necessary, to use that data for individual grades for students.

Some school districts have accepted the idea that a single grade is an inadequate indicator of learning in a particular discipline. With greater emphasis on multiple assessment approaches, multiple grades for students in art makes a great deal of sense. Students may not think the same when working with different content, and they enter school having learned different ways of processing information.

Most art education standards infer some learning that is directly taught, observable, and measurable, and some that is encouraged, but imprecisely observed. Self-report data is known to be spurious, and much as we value students' self-reflection, journal notes, attitude question-naires, insightful comments, or self-evaluations, it is difficult to defend assigning a score or grade to such feedback. These kinds of assessments, which can be summarized descriptively in narrative form, are categorized as nonscored assessments.

Criterion-referenced assessment is based on observable evidence of qualities in a perfor-mance for which the student has been prepared by art education experiences. The expected range of achievement depends on student conceptual level, physical capabilities, and verbal development. For example, third graders are not expected to have the critical thinking skills of tenth graders. Sometimes levels within the expected range of achievement are determined by percentages of the designated range. However, Wiggins (1989) cautions against expecting a normal curve distribution of scores. Such an expectation, appropriate for description of large numbers of subjects, assumes that teachers have only a random effect on their students.

For scored assessments, the scoring system should bear the same interpretation across school subjects and within the same subject. For example, if a numerical score of 3 on a scale of 1 to 5 indicates average performance in inventiveness in creating art, a 3 in an aesthetics dialogue criterion of providing reasons to support a statement about art should also mean average. On a scale of 1 to 10, a 3 would be quite a different story and contribute to confusion.

Recommendations for scales vary. Some recommend a scale of four points which could start at 0 to 3 or 1 to 4; but others recommend scales ranging from 3 to 9, 1 to 7, or 1 to 5. An argument for the range of seven points is that people tend not to rate the extreme, so the remaining choice of five points encourages a greater spread than the common five-point scale. The four-point scale tends to force raters away from a noncommittal middle point. The rating choice of 0 can be used for absence whether that means evidence of a particular criterion was missing, or that a student did not participate.

Test Scoring

Test items can be scored by the level of thinking required by a question, by choices of infor-mation offered, or by a student-generated response. It is possible to score a traditional forced-choice test simply by a point for each correct answer. Modifying traditional items (e.g., extended completion items, corrected true-false items, diagram or drawn responses, restricted essay and extended response essay items) would change the weight of an item. This seems warranted by the complexity of the student-generated response. One can reason that when a choice of given information is needed, a single point is appropriate. That credit may be doubled when the student must recall and supply a specific response. When, in addition to knowing a category or concept, an application must be generated the item may be valued at three or more points depending on its complexity. Thus, the higher the order of thinking involved—relating, analyzing, reconstructing, synthesizing, creating—the greater the credit points given an item. Because the number of items on a test and the numerical value of each would depend on the complexity of thinking demanded in student responses, a 100-point test could have few or many questions.

Figure 12.1 gives an example of how scoring might be handled for the graphic problem-solving task presented as Figure 10.10 in Chapter 10. The requirements are that (a) the student should enhance the given pottery form in such a way that it was patterned, (b) the pattern should visually relate to the form, (c) it should look like it is a form, and (d) depth on the pattern should be indicated by use of value. A point could be scored for each of the four criteria.

The graphic score guide allows for divergent responses which still meet the criteria. It also allows for partial success. For example, a student might draw a pattern but one that does not

Figure 12.1—Scoring Guide for Figure 10.10

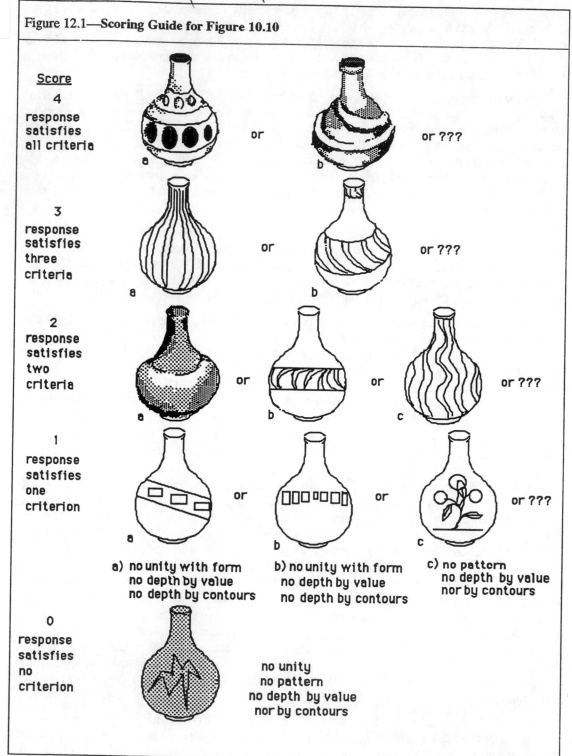

Score

4
response
satisfies
all criteria

or

or ???

3
response
satisfies
three
criteria

or

or ???

2
response
satisfies
two
criteria

or

or

or ???

1
response
satisfies
one
criterion

or

or

or ???

a) no unity with form
no depth by value
no depth by contours

b) no unity with form
no depth by value
no depth by contours

c) no pattern
no depth by value
nor by contours

0
response
satisfies
no
criterion

no unity
no pattern
no depth by value
nor by contours

have visual unity with the form or the student-drawn pattern may not conform to the three dimensional form nor use value to suggest depth. Another student might create a pattern that has unity and uses value to show depth, but does not modify the contours to appear that it is adhering to the form.

Observation: Checklist Scores

A variety of evidence may inform us about art education or students merely by keeping track of the frequency that certain student behaviors occur. A teacher determines what is meaningful to observe and devises a record sheet on which to track that behavior; practices observation of that evidence using the record sheet in a study period with another teacher, supervisor, or teacher aide; and compares observations to informally check reliability.

A teacher may wish to code observations from watching videotapes of a classroom. Observations can be recorded by a teacher as he/she passes the desk during a class. Because the criteria are familiar behaviors in art classrooms, outstanding process behaviors may be recalled and noted at the end of each week. Figure 12.2 shows a checklist approach to tracking evidence of behaviors encouraged in the art classroom.

Figure 12.2—Behaviors checklist					
			Content/ Behaviors/ Level / Grade / Goal		
			(all) / I, M / M / J /		
		CRITERIA			
	Works at appropriate level.	Thinks before answering.	Shows experimental flexible, open attitude	Accepts a challenge	Supports opinion with reasons that are observable
Student					
1 Noemia					
2 Hilton	——	——	——	——	——
etc	——	——	——	——	——
	——	——	——	——	——

The purpose of this checklist is to note the presence or absence of each desired behavior. A simple tally whenever the behavior is observed can suffice, or a teacher could in addition, indicate exemplary evidence of a behavior with a plus (+) or evidence suggesting a need to work on that behavior with a minus (-). This informal, unsystematic observation could result in a narrative description but not a score unless the behaviors had been specifically encouraged as part of instruction.

Figure 12.3 demonstrates a guide for describing the attainment of value, interact/cooperate, and inquiry behaviors. The levels—entering, evidence, expected, and exemplary—are meant to indicate degrees of development or growth exhibited by a student. A student that continues at an entering level has shown no progress. Numbers could be assigned to the levels as indicators that are not meant to be averaged as a score, merely descriptions of student progress at some point in time.

Figure 12.3—Behavior description guide				
BEHAVIOR	**LEVELS OF DEVELOPMENT**			
	Entering	Evidence	Expected	Exemplary
Value art, self	disinterested, self-degrading	subject interest, insecure	story interest, secure	meaning interest, self-confident
Interact/ Cooperate	disruptive, inconsiderate	complys, accommodating	contributes, respectful	self-disciplined empathetic
Inquire	conforming, impulsive, no questions reluctant	curious, considers, illogical search	experimental, reasons, relates ideas	innovative, reflective, divergent quests moderate risks

The entering level indicates need for remedial help. The evidence level indicates some observation of growth, but at a level below what is expected at the point of observation. The expected level indicates acceptable performance that warrants continued shaping and encouragement. The exemplary level suggests excellent development and suggests continuing challenges appropriate for the individual's intellectual growth pattern. Figures 5.2, 5.3, and 5.4 (in Chapter 5) provide additional help in defining levels of behaviors.

Performance: Rating Scales

Common Errors in Ratings

A logical error occurs in rating performance when a rater incorrectly perceives a relationship between two criteria. Another common error is the halo effect, where the influence of a general impression colors a rater's response. Rating scales that define levels in terms of general rankings (poor, average, good, excellent) do not help raters to achieve interrater reliability because they are open to interpretation.

Recommendations

In order to overcome common errors in rating (i.e., generosity, severity, central tendency), prepare a bank of item examples, such as diagrams of ratings, photos of products, a computer bank of images to represent the range of achievement relative to each criterion or verbal descriptions of behaviors that merit each point on the rating scale. Teachers can also improve consistency by rating all evidence on one criterion at a time, literally or figuratively sorting all responses into groups of like ratings on that criterion. Shuffle the evidence and do the same for the next criterion, and so on. If each grouping (rating or score) is analyzed, the descriptors of each level of achievement for the criterion would emerge. In addition, teachers can:

- Express criteria as educationally meaningful, observable outcomes (avoid *understand, appreciate, feel*, and other nonspecific verbs).

- Allow raters to give no rating if they feel unqualified to do so.

- Have three raters rate 10 examples of a performance parallel to the observation or performance sample to be rated. Train, rate, compare, and retrain if necessary to remove misunderstandings.

- Re-rate and check reliability. If it is high, any one of the raters can rate comparable performances with assurance. One can also pool ratings of multiple raters.

Defining Ratings for Criterion-Referenced Art Criticism Scoring

Lockwood (1991) is among those who suggest analyzing paragraphs that are models for different ratings to come up with varying degrees of evidence related to each criterion. Wiggins (1992) recommended considering what would not be acceptable in defining each rating. Based on the art criticism rating scale format shown in Figure 11.13, the following questions are asked about each student, and the quality of the responses could be scored accordingly.

1. How well did the student observe objects important to the meaning?

 4 = elaborated on relevant objects and details beyond other students

 3 = pointed out relevant objects and details

 2 = identified the obvious objects

 1 = omitted obvious objects

 0 = no response

2. How well did the student recognize decisions the artist made in composing the work to help create its meaning?

 4 = recognized even subtle arrangements that contributed

 3 = recognized major decisions that organize the composition alone

 2 = recognized major compositional decisions with help

 1 = made observation but recognized no compositional decisions

 0 = no response

3. How well did the student interpret the meaning of the art work?

 4 = supported an overall interpretation with multiple relationships observable in the work

 3 = reasons for interpretation based on some object or arrangement

 2 = told an unrelated story using the subject matter

 1 = named obvious subject matter

 0 = related no meaning of the art work

Among those professionals developing ways to rate students' art criticism are Stewart and Katter (1993) who provide examples of four ratings for the criterion Interpreting What's There (see Figure 12.4).

For such a scale, each teacher would have to determine what is appropriate for the age level being assessed. An extended answer for an eight-year-old would be less than what is expected from an eighteen-year-old. It is probably realistic to add a no response category for all ages.

Johnson and Cooper (1993) explained a system for measuring the proportion of quality responses to frequency of responses in written art criticism essays. Evidence of three criteria—descriptive, interpretive, and evaluative items—was assessed. References to sensory, literal, physical, technical, historical or stylistic, and expressive qualities were underlined in red by the

Figure 12.4—**Statements that exemplify ratings for "Interpreting What's There"**

Rating	Statement
Extended	Stopping by the woods on a summer evening, the cows graze contentedly before fading light signals milking time. We are reminded that life has many tranquil moments, if only fleeting.
Comprehensive	Here is an idealized vision of rural life. The use of light and color makes everything seem so bright and clear, so quiet and tranquil. No smells, no mud, the ideal farm.
Limited	It looks quiet and peaceful. Probably a good place to live.
No meaning	Just an outdoors picture.

Note: From *Building a foundation for the future* by M. Stewart and E. Katter, April 1993. Paper presented at the 33rd National Art Education Association Convention, Chicago. Copyright 1993 by authors. Reprinted by permission.

raters. Qualifying adjectives increased the qualitative value and were circled in red. Interpretive ideas were color coded as blue, and evaluative responses, as green to indicate incidence. The words that added a qualitative aspect (i.e., insightful interpretations and supported evaluative ideas) were circled in their appropriate colors. A student's score on each criterion was recorded as a proportion, hypothetically shown in Figure 12.5.

Figure 12.5—**Proportion of quality responses to frequency of responses**

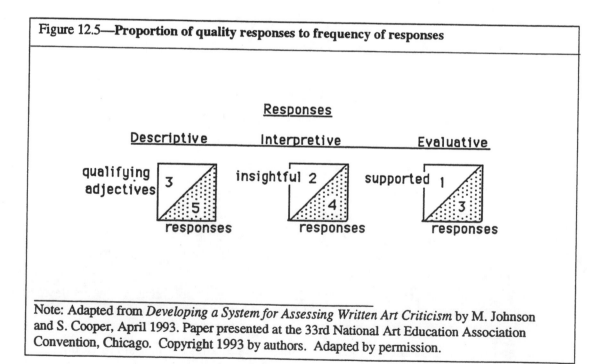

Note: Adapted from *Developing a System for Assessing Written Art Criticism* by M. Johnson and S. Cooper, April 1993. Paper presented at the 33rd National Art Education Association Convention, Chicago. Copyright 1993 by authors. Adapted by permission.

Defining Ratings for Criterion-Referenced Aesthetics Dialogues

The quality of a student's participation in an aesthetics dialogue can be indicated symbolically as shown in Figure 8.2, or better, by rating definitions specific to each criterion. For example, in Figure 11.13 ratings could be given for quality of responses as defined below for each of the four criteria.

1. Thoughtfully considered reasons for judging something to be "art"

 4 = thoughtfully considered observable or logical reasons for judging something to be art

 3 = gave plausible, associative reasons for judging

 2 = gave personal affective reasons for judging

 1 = gave irrelevant reasons for judging

 0 = made no judgment;

2. Expressed relevant, big ideas based on art learning in the encounter

 4 = expressed relevant, life-oriented big ideas based on art learning

 3 = expressed relevant big ideas about the art experience

 2 = expressed ideas about a personal product or art experience

 1 = expressed agreement or disagreement with an idea

 0 = no ideas

3. Synthesized contributions of others

 4 = synthesized and qualified contributions of others with reasons

 3 = added to contributions made by other students

 2 = listened attentively enough to agree or disagree

 1 = inattentive, daydreaming

 0 = distracted attention from others' contributions

4. Used information from diverse sources, periods of art, or cultures

 4 = used information from diverse sources in discussing art

 3 = used information from another subject area in discussing art

 2 = made reference to familiar objects or events in discussing art

 1 = made no connections between an art work and other objects, events

 0 = did not discuss art work

Essay Scoring

Restricted essays are scored according to the same principle as the problem-solving example, namely, that there are expected qualities or characteristics that should appear in the response. However, these qualities can be couched in the student's unique response. The essay task might specify meeting such criteria as factual and conceptual accuracy, completeness, relate data for interpretation, cohesiveness, analysis, inference, synthesis, and/or personal relevance. On each criterion, students can receive a rating of the quality of their essay in terms of that criterion.

Recent work in assessment varies in advocating holistic scoring or analytic scoring. Analysis of the examples of paragraphs used to guide holistic assessment ratings, can usually reveal

certain common attributes or criteria that vary in quality, but consistently appear as a consideration in the examples for each rating. Figure 12.6 shows a format and scoring guide for assessing an essay that requires a synthesis of art historical research, reflection on the role of

Figure 12.6—Analysis of criteria for scoring essays

Content/ Behaviors/ Level / Grade / Goal

AH,AC,AES/ K,O, I,V / H / H /

Criteria

Students	Factual(K)	Relate data(O/I)	Infer/generalize(O/I)	Relevance(V)
1 Angel	_____	_____	_____	_____
2 Arnold	_____	_____	_____	_____
etc.	_____	_____	_____	_____

contextual influences on art of different periods, and possible implications for the student's own art work.

Ratings for restricted essays could be determined by the following criterion achievement levels where each criterion is also associated with a basic art behavior.

1. Factual attribution and influences (Knowing behavior):

 4 = comprehensive, accurate *attributions* and *influences*

 3 = predominately complete and accurate *attributions* and *influences*

 2 = incomplete and inaccurate *attributions* and/or *influences*

 1 = committed errors or omitted critical *attributions* and main *influences*

 0 = no factual *attributions* and *influences*

2. Relate data to interpret art works (Organize and Inquire behaviors):

 4 = perceptive and logical *interpretations relating* comprehensive *data*

 3 = *interpretation related* obvious facts and influences

 2 = inadequate *interpretation* or *relatedness* between facts and influences

 1 = claimed illogical *interpretation* based on nonexistent *relationships*

 0 = did not *interpret* art works nor *relate* data

3. *Infer and generalize* (Organize and inquire behaviors):

 4 = supports speculative and/or *inferential statements* about contextual influences on *art in general*

 3 = supports *inferences* from specific data to *general ideas* about art

146

2 = makes unsupported *inferences* about art in *general*

1 = makes illogical, unsupportable *inferences* or *generalizations* about art

0 = no attempt at *inferences* or *general statements* about art

4. Personal relevance (Value behavior):

4 = principles are hypothetically *valued* for use in someone's personal art

3 = specific aspect *valued* for own art

2 = prescriptive suggestion about the *value* of art

1 = personal *preferences* noted

0 = no indication of *value*

In essence, rating essays is an analytic process for the rater, and examples of quality represented by a rating serve as a guide to greater equity and reliability in scoring.

Individual criterion scores can remain as individual subscores or be averaged into a summative score. An advantage of the multiple, criterion-referenced scores is that they serve as immediate individual conferences with students on aspects of their work that can be improved. In addition, scores on the same criterion, gathered from similar assignments, can be clustered for comparisons across time or averaged for an indication of achievement in terms of that behavior.

Defining Ratings for Criterion-Referenced Art Production Scoring

Assessment of student art products indicates how well students evidence achievement along certain dimensions (i.e., the criteria derived from the purpose of the problem). Each criterion can be achieved to different degrees and guide sheets with those degrees defined help the rater's consistency. Guide sheets may provide verbal or graphic definitions of achievement levels. Using the paper sculpture fantasy garden task from Figure 11.23 as an example, the criteria used to assess achievement are based on whether the students (a) created actual depth, (b) varied their sculptures in qualitative and quantitative ways, (c) presented with value and technical quality, and (d) organized a consistent, meaningful effect. These criteria can be rated in the following ways:

1. Created actual depth. (Organize and manipulate behaviors)

4 = all paper sculpture forms with some extending far above the base

3 = at least 75% of the paper shapes are 3-d

2 = folded shapes, simple 3-d projections

1 = predominately two dimensional, edges curled

0 = no attempt at creating depth

2. Varied in qualitative and quantitative ways. (Inquire behavior)

4 = imaginative variation of many shapes with inventive form combinations

3 = some unique variations of shapes, some combined forms

2 = shapes cut into, proportions and edges varied in common ways

1 = shapes changed in proportion, edges

0 = no variation of shapes provided

3. Presented with value, technical quality. (Value and manipulate behaviors)

4 = identified neatly, base covered around the edges, pieces adhered well

3 = identified, attempted to cover base, most pieces glued well

2 = not identified, about half of the forms coming apart

1 = not identified, many pieces becoming unglued and detached from base

0 = not identified, all unattached pieces

4. Organized a consistent, meaningful effect. (Organize behavior)

4 = consistent, meaningful impact of color-form-position considerations

3 = dominant effect, but some inconsistencies

2 = some individual parts have a mood

1 = contradictory effects created by shapes and forms

0 = no effect

Holistic Assessment Variations

Holistic assessment applies to any situation where contributions from art and other disciplines are meaningfully integrated as relevant to the art experience. Encounters, discipline-based or other, can be authentic tasks, and authentic tasks and encounters can be part or all of a portfolio or exhibit.

Authentic Tasks or Discipline-Based Encounters

Authentic tasks are complex and demand different capabilities; therefore, different instruments are appropriate for observing those specific achievements. The process by which a student explores, experiments, and searches for information to conceptualize a problem and its solution involves many inquiry behaviors and organizational skills. Perceptual awareness enables specificity in depicting ideas and recognizing qualities that contribute to the meaning created by artists. Historical knowledge informs that meaning extrinsically by contextual influences on the depiction of images and structure. Reflection can be focused personally on one's work or on big ideas about art in general. These are some of the behaviors that can characterize the art experience and contribute to a student's record of achievement in a discipline-based art encounter, authentic experience, or portfolio assessment.

Many assessment examples and scoring methods are likely to be useful in assessing holistic, authentic art experiences. Because authentic experiences are inherently ambiguous and open-ended, Wiggins (1992, 1989) suggests possible criteria of authentic assessment might include student judgment in posing, clarifying and tackling problems; student progress toward mastery; student strengths; depth rather than breadth; and student recognition of positive and negative aspects of multiple solutions.

Portfolios

Portfolios are judged on criteria appropriate to the assignment and structure required by the teacher or agreed upon by students and the teacher. Waanders (1986) recommends carefully setting parameters for students with specification of criteria to make the portfolios comparable. Criteria can center around skills (e.g., production, approach, reflection, perception) and attitudes (e.g., commitment, challenge, search behaviors, care, presentation). A portfolio grade is sometimes based on thoroughness of the process that the student reports (i.e., number of entries, number of sources used, detail of the research, reworking of solutions, and systematic collection and organization of ideas). Each of these specific criteria provide evidence of a student's inquiry process and, therefore, could be assessed separately, then averaged as one

grade. This grade does not reflect the quality of the art product nor positive effects of reworking solutions.

Assessment of different behaviors with different art experiences related to the art disciplines should be differentiated. Global grades for an art product lack meaning (Rouse, 1971). Elbow (1991) writes, "...the use of portfolios exerts a subtle pressure against holistic grading and in favor of analytic grading, against single measures of intelligence or skill and in favor of the idea that humans have multiple intelligences and skills." "...the richness of the portfolio helps us notice the perversity of that [ranking holistically one through six] procedure"(p. xiv). (Holistic grading, using one grade to cover complexes of art learning, should not be confused with holistic assessment defined at the start of this section.) Different kinds of behavior call for different observation methods and multiple indicators of achievement. At the same time, a criterion, such as organize behaviors, could be observed by how a student showed the process as well as how he/she created a world of art or organized verbal components in oral or written verbal performances. Dramatic content-specific differences on the same behavior category would signify need for instructional attention.

Content Analysis and Trend Studies

Content Analysis

Content analysis describes and categorizes content coverage and/or quality of restricted or unrestricted essays, short answers, unstructured interviews, teacher logs, anecdotal records, journal entries, and so forth. As in ethnographic research, teachers must create order out of many notes about natural events that do not occur in an organized manner. Content analysis helps to create an order by looking for recurrence of observations, relationships, or insights, and for the total synthesis. In an educational context, it seeks to determine the degree to which the frequency, accuracy, and/or creativity exhibited by those recurrences is evidence of learning that is supportive of the art goals. A teacher can design a code system to categorize comments or characteristics that constitute noteworthy evidence. The coding can emerge out of students' expressions or particular qualities desired and encouraged through instruction.

When analyzing the content of anecdotal records, it is helpful if teachers

• Make immediate notes as complete as needed for meaning.

• Focus on one incident within one anecdote for clarity.

• Write factual, thick descriptions of both positive and negative incidents without personal embellishments.

• Separate and identify their interpretations of incidents.

The literature indicates there are various approaches to organizing content analysis. Statements by students—in grades 1, 4, 7, 10, and 12—about works of art were analyzed and classified by Moore (1973). Using a modified version of C.W. Valentine's four types of statements, Moore noted comments as *Objective, Associative, Subjective, or Character expression*.

Wilson (1988) explained a comprehensive content analysis system used to assess written art criticism essays in scoring the first and second National Assessment of Educational Progress (NAEP) in Art tests. Twenty-five classifications were coded under three categories—*description and analysis, preference and judgmental, response modes*—and three items were classified in an *other* category. Each classification had a two-letter code (to identify the category and classification) by which statements were identified and descriptively scored. For example, statements under the descriptive category might be noted as DS (sensory), DC

(composition), or DX (expressive). Because such a system is designed to accommodate all possible response types, many categories may go unused for most students. In scoring:

> Each sentence is to be used as a unit of analysis. Only the first instance of each classification is to be scored in each sentence. But several different classifications may be scored within a single sentence. The first instance of a modifier (an adjective used to qualify or specify something about a major classification) is also to be scored. In some cases whether a general or specific use of a classification has been made will be noted. Some classifications are evidenced by the use of a single word, others by a phrase or sentence. (Wilson, 1988, p.39)

In more structured essays, content analysis looks for incidence of crucial elements of the ideal answer. The greater proportion of correctly used crucial elements, the higher the student's score. Structured essays appear to have similarities to and possible overlap with criterion-referenced rating scales. Either content analysis or rating scales can credit such qualities as relationships perceived, organization of ideas, clarity of expression, and integration of the answer.

Tracking Growth or Trend Study

Nonstatistical trend study is similar to content analysis except the point is to become alert to emerging directions. The emerging directions may be observed from student notes in a journal or portfolio, teacher log books, repeated interviews over time, or other sources. The completeness, variety, and relatedness of the material accumulated can be observed by the teacher. In addition, the insights or trends that the student recognizes by reflecting on the journal contents can be the focus of meaningful teacher-student discussion and reasons for curricular or instructional modifications.

Possible Nonscored Feedback

Evidence of some learning may not lend itself to scoring or grading procedures. Some aspects of the same performance (as in essays) may be scored and some not. For example, if an essay was assigned to focus on certain criteria (e.g., the ability to cite historical influences, provide reasons to support positions), only those criteria can be scored. Personal narratives or comments would not be scored.

Gronlund (1981) suggests that self-reports, interviews, course attitude scales, sociometric questionnaires, subject/art form preference inventories are adjunct to teacher observations and should not be graded or scored in any way that interferes with honest responses. However, if only group results are needed, and this kind of evidence is anonymously submitted, summarizing group scores is acceptable.

Sociometric Questionnaires

Sociometric techniques seek to identify workable social situations in a classroom or individuals who can benefit from being involved. In one example, a *Guess Who* game, a list of positively stated characteristics has a line next to each characteristic for students to write the name of a classmate who fits that description. In other techniques, students can nominate classmates with whom they want to work; negative nominations are subtracted from positive nominations for a score.

Journals

Based on teacher choices, student journals can range from being totally voluntary (e.g., diaries or cryptic notes in a sketchbook) to teacher-assigned topics on which to comment. Anderson

(1993) designed a structured journal format by which a teacher can review over time trends in a student's reflections (see Figure 12.7).

On her sample of a 9-week self-evaluation form, Anderson (1993) did have students rate themselves on a scale of one to five for worth of the artistic pursuit, growth on the artistic pursuit, amount of work, and individual class participation.

Figure 12.7—Topic-Trends reflection						
Name _____ My intended direction or goal _____						
	Media	Imaging	Expression	Process/ Techniques	Cultural/ Historical	Aesthetics
Describe first project						
Progress and change at 9 weeks.						
Progress and change at 18 weeks						
First semester conclusion						
Future thoughts						

Note: Adapted from "Portfolio Assessment as a Record of Artistic Learning" by D. Anderson, April 1993. Paper presented at the 33rd National Art Education Association Convention, Chicago. Copyright 1993 by author. Adapted with permission.

At the secondary level sketchbook/journal instructions could require students to keep class notes; complete a specified range (5-10) of pages of preliminary, detailed, and project sketches; include reflections; and complete one self-evaluation page (or frequent paragraphs where relevant) for the journal component. It might be necessary to include minimum working time limits expected.

Less specifically journals could be scored on participation, breadth, relevance, insight/connections, redirection from false starts, and goal setting with scores for rating goal setting defined as:

4 = reasonable, and challenging goal

3 = challenging, but some lack of feasibility, or contradictions

2 = unchallenging, but appropriate goal; or not feasible

1 = goal is inappropriate to task.

Depending on goals set, one could assess each student's growth in terms of his/her level of engagement, range of engagement, social responsibility, and ability to track processes, formulate plans and goals, utilize available resources, articulate aesthetic responses, and chronicle the development of a work.

Reports from art teachers vary from attaching no score, points, or grades to journals, to basing one-third of the course grade on the journals. As indicated, journal grades may be calculated on participation, quality of reflection on specific criteria, time-on-task, or even, the number of sentences. Clearly there is little consensus about the purpose and assessment of journals at the application level. The consequences on students is reason enough to carefully connect the purpose served by journals in any particular situation with logical assessment and grading practices.

Self-Report Scoring

Student self-reports include, but are not limited to criterion-referenced self-evaluation, reflective course evaluations, self-evaluation of the learning process, attitude questionnaires, and personal reaction journal entries. If student goal or outcome statements expect to observe a value or attitude dimension, then these kinds of feedback are appropriate. Questions on the NAEP in Art assessment included self-report items about time spent enjoying art or items asking students to judge the acceptability of specific works of art (Wilson, 1970). MacGregor and Gilchrist (1993) reported that a pre-report-card student self-reflective writing task included students' responses to the questions: How am I doing? What am I doing to produce these results? and What will I do to complete the year successfully?

Szekely (1985), an advocate of students' ability to judge their own work, maintains that students need to go beyond the subject of their works to answer questions such as: "Was the original intention carried out? What is the work's most meaningful aspect, and should it be pursued in future works?" adding, "If students need to discuss their works, then they need an audience, and this is the role the art teacher can play" (p.41). Indeed, good questions motivate student thinking about their involvement and thus, cycle back to instruction...a valuable end.

There are many unanswered questions remaining about appropriate administration of assessment instruments and about how and when to score instruments to provide reliable evidence that students have learned in art. Assessment is not a matter of quick wish fulfillment, but rather a carefully plotted route that will involve time and research.

Summary

All the preparation and development of purposeful assessment instruments make following the recommendations for administrating and scoring worthwhile. The concept of sampling is important whether it pertains to sampling representative content taught or ongoing sampling of student art behaviors. A distracting setting can contribute to erroneous information about what students can do; providing assessment conditions that maximize students' ability to give evidence of what they can do is a responsibility of the teacher. Consistency in rating student performance is highly dependent upon clarity of definitions of the quality ratings used. Scoring can otherwise be spurious and unfair to students. As will be seen in Chapter 13, interpretation of accumulated data depends on clearly defined criteria, criterion ratings, and the purpose of the item or instrument.

13

SUMMARIZING THE RESULTS

Summary of assessment results is addressed in Chapter 13 by attention to ways to organize, interpret, and cluster data gathered. Recommendations are made regarding ways to summarize group responses in terms of proportions of students meeting achievement levels or a mastery level. Interpretation of data is the basis for planning improvement of instruction for individuals or groups.

Cumulative Recording Methods

With some exceptions, grade books and columns of letter grades or numbers are commonplace in art. They are used for keeping track, that is, an inventory of activities; to check up or test; to find out, that is, inquire into students' responses and thinking processes; or to sum up, for accountability to parents, school boards, communities, and state boards of education (Hein, 1991). Teacher cumulative record sheets can document a profile of a student in terms of characteristics observed. Criterion-referenced cumulative record sheets can also inventory the nature of a class, answering such questions as "How much of _____ is going on and how often?" Cumulative records can track student performance on specified criteria in multiple forms—written, observed, or created. They can document how well the student exhibits desirable process behaviors.

Chittendon's (1991) comment that "One person's favorite rating sheet is another's income tax form" (p. 25)[1] is appropriate when considering the format of cumulative records. When explained, their threatening complexity is replaced by inviting practicality and efficiency. The cumulative record sheet works like a tally sheet with all students of one class on one sheet so that the teacher can see how the class progresses as a whole. Teachers mark in a criterion column to record observations of students who are demonstrating that behavior. It is not always expected that each student will be observed doing each behavior at any particular time, so this instrument constitutes a convenient place to record what happens whenever it does happen. A number instead of a tally would indicate qualitatively how well that student met the criterion.

As an alternative to externally developed and administered summative assessment, Hein (1991) wrote, "*cumulative* formative assessments that provide evidence over a longer period of time can be just as objective and comparable across classrooms or districts" (p. 126).

1. Chittenden, E., (1991). Authentic Assessment, Evaluation, and Documentation of Student Performance from *Expanding Student Assessment* (p. 25), Vito Perrone, ed. Alexandria, VA: Association for Supervision and Curriculum Development. ©1991 by ASCD. Reprinted by permission.

Systematic Sampling

The key to developing cumulative records for ongoing alternative assessments is systematic sampling. Discussed in Chapter 9 as a reliability procedure, systematic sampling requires regularly repeating performance observations. Repeated observations can verify achievement levels of students or show progress or change over time.

Art Criticism and Aesthetics Discussions

The criteria in Figures 11.13 and 11.14 focus on the nature of students' responses to general issues about art or to works of art. Because they are cognitive thinking behaviors, the art criticism criteria can apply to many art criticism experiences irregardless of the specific work of art. Likewise the aesthetics dialogue criteria can apply to numerous aesthetics discussions. Therefore an efficient way of viewing achievement of students across time is to record observations on one record sheet with columns for each experience that is coded. Figure 8.1 shows how the first observation of an art criticism experience might look. Using the definitions of ratings explained in Chapter 12, Figure 13.1 shows how a record sheet of five aesthetics dialogues might appear.

Figure 13.1—Aesthetics dialogue about the value of art from different eras

Content/ Behaviors/ Level / Grade / Goal

AES / O, I / H / J /

Criteria

	Thoughtfully considered reasons for judging something to be "art"	Expressed relevant, life-oriented big ideas based on art learning in the encounter	Synthesized contributions of others	Used information from diverse sources, periods of art or cultures
Observation:	1 2 3 4 5	1 2 3 4 5	1 2 3 4 5	1 2 3 4 5
Student				
Lisa	3 3 4 4 4	3 3 3 4 4	0 3 4 4 4	0 3 3 0 3
Jean	* 2 3 3 3	* 2 2 3 3	* 0 3 0 3	* 0 2 2 3
Henry	3 3 3 4 4	0 3 3 3 4	4 4 4 4 4	3 3 3 4 4
etc.				

Note: * = student was absent.

A method for accumulating evidence of the proportion of quality descriptors to frequency of descriptors in written samples of art criticism (Johnson & Cooper, 1993) was shown in Figure 12.5. A cumulative record sheet of multiple written art criticisms might appear as in Figure 13.2.

Figure 13.2—Systematic sampling of quality/frequency in written art criticism								
Responses								
Descriptive			Interpretive			Evaluative		
Student / Observation: 1	2	3	1	2	3	1	2	3
Rachel 2:4	3:4	3:4	2:4	3:5	3:3	1:2	2:3	3:3
Rob 2:6	3:5	4:5	2:4	2:5	4:5	0:2	1:3	2:3
Renie 3:6	4:7	6:8	2:4	3:4	4:4	1:2	2:2	3:3
Ralph 3:4	4:6	5:6	4:5	6:6	7:7	2:4	3:4	5:5

Note: Adapted from *Developing a System for Assessing Written Art Criticism* by M. Johnson and S. Cooper, April 1993. Paper presented at the 33rd National Art Education Association Convention, Chicago. Copyright 1993 by authors. Adapted by permission.

In this cumulative record, Rachel's proportion of quality adjectives within her descriptive statements about works of art increased from 1/2 to 3/4 quality responses from the first written sample to the third.

Cumulative Laser Disc and Portfolio Summaries

Laser discs provide a record of a student's achievement by videotaping performance and scanning art and written work. They can include interviews and participation in class discussions. Campbell (1992) explains that this cumulative record, with students having a disc of their work each year, can document many years of growth. Teachers could use the videotaped live discussions as practice in coding discussions in preparation for and the establishment of interrater reliability. The discs would also serve as a bank of examples of ratings given on criteria of numerous assessment instruments.

Figure 11.25 demonstrates a summative portfolio assessment for an entire class on one sheet. As recommended in Chapter 12, written definitions for each of the four ratings on each criterion would serve as a reference in applying the generic numerical ratings shown. The summative portfolio may follow earlier unit or theme portfolios with or without interviews. There is good reason to emphasize ongoing portfolio reviews accompanied by interviews: They offer solid benefits in student clarification and teacher coaching, can be readily documented on audiotape, and are conveniently kept with the portfolio. Progress evidenced by portfolio interviews with students could be the source of a running narrative account, extended by each review.

Narrative Summaries

Evidence of learning derived from content analysis of structured interviews, behavior checklists, or the like can be classified by the basic art behaviors, outcome statements, or student goals in order to compress the volume of information into a manageable organization for narrative summary.

How can a teacher summarize nonnumerical symbols used for coding? One way is to convert the observation tool from a teacher log to a checklist with regular checks for the behavior; this can produce a proportional sample of the class time in which a behavior is evident. It may help to consider the record of behaviors on checklists, logs, or think sheets in terms of opportunities to evidence that behavior. Did all students confront the same situations? Did Emily show leadership because the teacher, knowing a smooth running group would be the

result, asked Emily more often than others to head up a group? Did she learn to lead because all students were encouraged in that behavior in art class or did that interaction capability develop prior to it? Teachers might consider the proportion of evidence of behaviors to the opportunity to practice those behaviors when summarizing nonscorable evidence of learning. Having achieved assurance of fairness, frequency of evidence of a behavior can be viewed for a group, criterion by criterion.

When content analysis of logs or journals is complete, the prevalence, absence, or contradiction of any notations can provide documentation for a teacher narrative summary. A count, plus sensitivity to holistic relationships within the classroom context, may suggest prevalence and associations. When anecdotal records are based on chance observations, it is hazardous to draw conclusions unless there emerges a characteristic pattern. This means observing whether what preceded the behavior in question or what followed it was consistent. Observing the context from which the behavior emerged may contribute to insight.

Content analysis soon takes on some characteristics of trend analysis, looking for regularities in sequences of observations. Then, is such a sequence true for an individual or for a group of students? For certain activities? For certain media? While analyzing the situation sounds like a research project, it may be worth the effort to observe and report the evidence carefully, if it could significantly improve instruction for a student or a group of students. Teachers may find the time to ponder such questions while driving to school in the morning.

Traditional Tests Summaries

What is easy to score (low inference) is more difficult when summarizing data. Typical tests involve a variety of items designed to assess different behaviors. Chapter 10 encouraged identification of each item for the behavior that it indirectly represents. A cumulative score, on items that represent different behaviors, is uninterpretable for informing improvement of instruction. Therefore, to decrease the high inference or increase the meaning of tests, test items that tap the same behavior could be clustered as subscores. Low level thinking or recall of knowledge behaviors can be considered together, but separate from items that call for higher order thinking skills such as relating multiple variables or synthesizing behaviors. This is another recommendation for recording student learning by behaviors addressed by goals or outcomes.

Summarizing and Interpreting Data

Converting Tallies and Ratings to Group Percentages

School districts may ask teachers to estimate and later report on the percentage of students in a group that meets a specified achievement level relative to a goal, outcome statement, or standard. How could a teacher get from a videotaped oral discussion or anecdotal record to such a summary? The mandated summary is one concern, but assessment for feedback to the student, improvement of instruction, or curriculum reform must rest on specific bases for interpretation. A hypothetical extension of Figure 8.1, a record sheet of five art criticism observations, could look like Figure 13.3.

Using the rating scale definitions for each criterion to code art criticism responses, the quality of each response can be recorded numerically in one step. Figure 13.3 adds a fourth criterion to those shown in Figure 11.14, supported judgment of worth with relevant reasons. From Figure 13.3, a teacher could conclude about students' interpretation that:

• In regard to supporting an interpretation of the meaning of a work of art with reasons, less than half of the students present responded initially.

Figure 13.3—Art criticism cumulative rating sheet

Students:	Identified objects in the reproduction					Recognized the way the artist composed the elements					Gave reasons for interpretation					Supported judgment of worth with relevant reasons				
Observations:	1	2	3	4	5	1	2	3	4	5	1	2	3	4	5	1	2	3	4	5
Aly	2	3	3	4	4	2	2	3	3	4	2	3	3	3	4			3	3	3
Amy		*	2	2	3	*		2	2	3		*	1	2	2		*	1	1	
Ann	*		2	2	2	*			3	3	*			2	2		*		1	
Barb		*	*	2	3		*	*	2	2		*	*	1			*	*		
Becky	4	4	4	4	4	3	4	4	4	4	3	3	4	4	4			3	4	4
Cam	3	3	3	*		2	2	3	*		2	2	3	*		2	2	2	*	
Candy		3	3	3	4		3	3	3	4		3	3	4				3	3	4
Carol		3	4	4	4		3	3	3	4		3	2	3			2	2	2	3
Dee			3	3	4			3	3	4			3	3				3	3	
Ellie	4	4	4	4	4	4	4	4	4	4	4	4	4	4	4	3	4	4	4	4
Eve	*			3	3	*			2	3	*			2	3	*			2	
Fanny	4	4	4	4	4	4	4	4	4	4	4	4	4	4	4	3	4	4	4	4
Greta	2	2	2	3	3	2	2	2	2	3	1	2	2	2	1	1			2	2
Hal		2	3	4	4		2	3	3	3	2	2	2	3	3					
Ivan	4	4	4	4	4	4	4	4	4	4	4	4	4	4	4	3	4	4	4	4
Jon		3	3	4	*		2	2	3	*		2	2	3	*		1		2	*
Karl	4	4	4	4	4	4	4	4	4	4	4	4	4	4	4	4	4	4	4	4
Luke		3	*	3	4			*	2	3		2	*		3		2	*	3	3
Mart			3	3	3				2	3				2	3				2	3
Norm		1	3	3	3		1	3	3	3		1	3	3	3		1	2	2	
Oscar	3	3	4	4	*	3	3	4	4	*	3	3	4	4	*	3	3	4	4	
Paul		3	3	3	*		2	3	3	*			3	3	*		2	3	3	*
Rich	2	3	*	3	4	2	3	*	3	4		2	*	3	4		2	*	3	3
Stan	3	4	4	4	4	3	3	3	4	4	3	3	4	3	4			3	3	4
Tom	3	4	4	4	4	3	3	3	3	4		3	3	3	4				3	4

Note: * = student absent

Generic Code: (A blank box represents no response.)
 4 = Exemplary level of appropriate response
 3 = Expected level of appropriate response
 2 = Acceptable evidence of obvious appropriate response
 1 = Entry level of response or inappropriate/response.

• Of those, four initially supported overall interpretations with multiple relationships observed in the work (A 4 in observation 1, interpretation).

- Four students named obvious subject matter or told an unrelated story cued by some subject matter in the work of art (1 or 2 rating in interpretation in observation 1).

By the fifth observed art criticism experience:

- Almost 73% of students present responded and, of these, 41% supported their interpretation with multiple relationships observed as reasons (4 rating).

- 23% of students present gave reasons for their interpretation based on some object or arrangement (3 rating), and only one student told an unrelated story (1 rating). Across the group, students increased their participation and evidenced critical thinking in their responses with 68% of students present scoring at or above an acceptable level (2, 3, or 4 ratings) in interpretation of works of art. More interpretation is possible with this data.

Student absences are a fact of life. Recording the quality of student participation can take this into account by indicating an asterisk for absences (for each criterion, if applicable, on any one day) and a zero for no response. A different system could be devised if teachers choose to rotate the portion of the class coded in any one art criticism experience. Individual or group summaries could be calculated on the proportion of responses given over the number of opportunities to respond. The proportion of students scoring at the four level can be calculated on the same criterion for each observation in order to summarize any change over time, or, averaged over all observations.

Clearly expressed criteria contribute to less inference on the teacher's part when summarizing. And, parents or guardians can be given a meaningful description of the student's progress on more behaviors than are assessed in numerical form (which needs to be verbally enhanced for meaning any way).Objectively described evidence, together with teacher empathy and familiarity with the classroom, contributes to fairness in summative descriptions of relevant behaviors in art. With systematic sampling, the most dramatic and memorable incidents can be balanced by records of other opportunities a student has to provide evidence leading to greater teacher perspective.

Comparative Use of Data

Conclusions about how a group has learned are based on how individuals have learned. Assessment produces descriptive and comparative data for revealing individual student growth, and student-to-student, group, school, or district differences.

Typically, art teachers keep records of grades in order to arrive at course grades for individuals. The most viable use of assessments is to give feedback about the learning of individual students on criteria that the students understand and may have helped set.

At the same time that this cumulative data serves educational benefits for individuals, it can also provide a picture of how groups of students have learned on common expectations. Differences in students who have received the same instruction cry for explanations (e.g., demographic data, socioeconomic variables, learning style differences) that may warrant student-specific instructional approaches. Group-wide responses short of expectations may suggest instructional or curricular changes.

Group scores of students within the same course allow comparisons between groups. Scores grouped by courses enable comparisons between schools. Differences may have implications for reinforcement or revision of the art program and curriculum.

Mandated state-wide assessments can provide comparative data for determining equity in educational outcomes across communities with different demographics and economical bases.

Instead of use for individual assessment, group averages on clusters of similar outcomes can be reported in reference to the art education standards or goals. Of course, "averages" pertain to

observations that can be converted to numerical values and mathematically averaged. Some reports of group learning related to certain outcomes may need to be interpreted verbally and possibly prioritized to assert their value. Evidence of some outcomes may be indicated by the proportions of students who participated in an activity or gave some evidence of nonquantifiable learning.

Attention has been called to the multiplicity of behaviors in complex learning situations in art. That multiplicity can be summarized so that teachers can detect the kinds of behaviors which students are achieving or not achieving. For example, in Figure 11.25, the portfolio assessment instrument contains criteria that independently pertain predominately to one or another basic art behavior. Criterion 2 focuses on students' abilities to manipulate media, tools, and the like. Criterion numbers 1, 4, 5, 6 and 10 expect students to exhibit organizational abilities learned with a variety of content, (i.e., organization of visual images, abstract ideas about art, forms, or reading the organization of works of art). Criterion 7 focuses on the perceive behavior, Criterion 3 on the intellectual inquiry behavior, and Criterion 9 on the value behavior. The interact/cooperate behavior is not addressed in the criteria of Figure 11.25, but it could emerge as part of the criterion that expects an authentic problem or in an interview. Students' journal accounts of interaction with people during their authentic problem-solving process could reveal evidence of this behavior. It is not mandatory, but is likely, that all of the basic art behaviors described in this book would be employed in developing the contents of a portfolio or authentic tasks especially if they incorporate the principles of integrated discipline-based art encounters. These portfolio criteria do not provide definition of ratings used to indicate quality of the learning observed.

Homogeneous Grouping of Scores

Herman, Aschbacher, and Winters (1992) suggest that rating can be more efficient across different kinds of evidence (journals, essays, etc.) if criterion excellence is conceptualized consistently across that evidence. They write:

> When we give students a hands-on science assessment involving silk worms, we probably don't care as much whether students are able to do that specific silk worm experiment as we do about their skills in using the scientific method (p. 103).

In this book, Chapter 4 provided the rationale for considering seven basic art behaviors that operate across the content areas of art. Subsequent recommendations refer to these basic art behaviors. Student outcomes of learning focus on what students are able to do, that is, the behaviors learned. The basic art behaviors, validly derived from behaviors of role models in the disciplines of art history, aesthetics, art criticism and artists, can rightfully serve as the subsumers of groupings of criteria for assessing learning in art. The question is: If reflective thinking is a cognitive strategy that is subsumed by an inquiry behavior category, is reflective thinking in regard to aesthetics dialogues the same as reflective thinking as one reorders a work of art?

If the answer is "yes" consolidating the evidence of learning by homogeneous grouping under the subsumers of common behaviors would simplify the multiplicity and complexity of assessable learning in art. However, some research has shown a degree of variability in problem solving in math and science across content or topics so caution is warranted, and more research directly related to the visual arts would certainly help.

If consolidation across content areas is decided upon, the quality definitions on a criterion that are given the same score or rating must be comparable (see Chapter 12). A four on conceptualization (an organize behavior) in an art history essay would be as good as a four in conceptualization in a painting. If deemed comparable, all conceptualization scores across content

areas for the grading period could be averaged as one subscore, as evidence of the ability to organize as a behavioral outcome.

Interpreting

Because the behaviors learned in art enable students to carry their education into life applications, evaluating these behaviors is an appropriate way to report learning. If the criteria by which student performance is judged are behaviorally defined, there is little interpretation to be made. Direct observation, as it is accurately defined and observed, involves inference at the point of coding the performance being observed, not when summarizing cumulative records. However, too inclusive clusters of criteria can lead to meaningless claims. Art history facts are important to know, but *knowing* is a different intellectual behavior than *organizing* many contextual facts, seeing relationships, and synthesizing facts and principles into abstract generalizations about art and life. What kind of fruit comes from merging apples and oranges? That is the interpretive problem when lumping items that assess different behaviors. If objective tests made up of multiple levels of thinking and behaviors are accumulated, there is little inference in scoring (right or wrong answers), but high levels of inference, if even possible, as cumulative data. As mentioned, items on tests which assess like behaviors, and are comparably weighted, can legitimately be averaged for meaningful interpretation relative to each behavior category. Scores given to a student on interpretation of works of art can be clustered with other interpretative (organize) responses. As a major outcome desired from the art education experience, the average of "scores" of this cluster may be one of seven grades (if based on the art behaviors) given a student.

Assigning Weight to Test Items, Criteria or Course Components

Is everything *tested* of equal importance? Should showing grasp of the concept of related lines and shapes on a quiz be as important as creating a particular mood in a poster to effectively communicate (in which use of related lines and shapes contributes importantly)? This question was addressed in Chapter 12 but is worth reconsidering in this context. Even on a test made up of a variety of items which address different content or ask for different behaviors, a teacher can assign weights to items according to the importance given that item, and score accordingly. Low level thinking items (e.g., selection from given choices) may receive one point each while items that require students to generate the answer (e.g., perceiving and describing relationships or making inferences) might receive five points each. It is important that the units of measurement mean the same thing across tests if items requiring like thinking behaviors are to be clustered and averaged.

The argument for interpretability of assessments supports the idea of multiple scores or grades, each with its own continuum and definitions which match the common, acceptable level of achievement. Multiple outcomes entails problems of value of each goal or outcome statement. Unfortunately, in actual practice, single course grades seem to predominate.

Should there be equity or inequity of student goals in art? Are some outcomes valued more highly and therefore deserve more weight in assigning grades than others? Many art teachers have already answered these questions where they must give a single course grade by giving certain components of a final grade more weight. A method by which to arrive at a final grade is to multiply the average of each criterion cluster or behavioral domain by the weight assigned to it. Then add all mathematical products subsumed by a behavioral domain and divide each sum by the total of the weights.

To relate grades to basic art behavior domains, (i.e.. know, perceive, organize, inquire, manipulate, value, and interact), the question could be: Should *know* or *perceive* be considered as important as *value, organize* or *inquire* since know and perceive are behaviors which enable others, or, should each behavior be given equal value? Is manipulation of tools and media as

important as thinking (e.g., organize, inquire) or valuing behaviors? Figure 13.4 sugges
answer with a sample weighting of the seven basic art behavior domains.

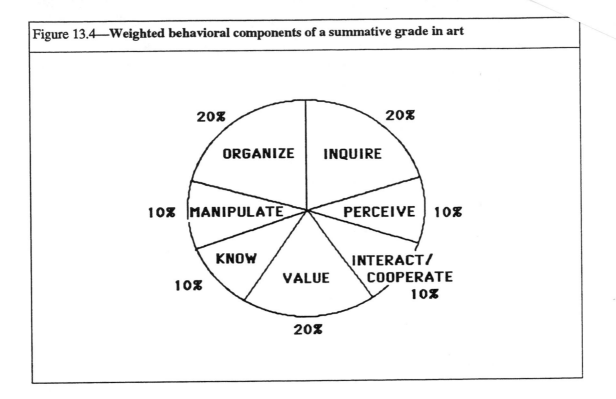

Figure 13.4—Weighted behavioral components of a summative grade in art

According to Figure 13.4, if assessment is used for assigning individual grades, components
of an individual grade could be:

20% = organize: interpretation of art works, art product synthesis, meaning

10% = know: evidenced by conceptual accuracy, art history worksheets,

20% = inquire: reasoning skills demonstrated in aesthetics dialogues and art criticism
 experiences, experimentation, exploration, flexibility, innovation

10% = perceive: evidenced in visual specificity in sketches and art work

20% = value: evidence in oral comments and journal entries,

10% = interact/cooperate: evidenced by classroom process behaviors, and

10% = manipulate: evidenced in skillful handling of media, tools.

With this weighting, a holistic grade could represent relative value of each behavioral domain
by multiplying each organize, value and inquire subscore by two and the remaining behavior
subscores by one. Sum and divide by ten for a weighted holistic grade.

Estimating Student Achievement at Levels of Acceptability

Teachers may be asked to estimate levels of achievement for each objective, outcome, or
behavioral domain inferred by the art goals. The conceptual level of the students, the
homogeneity or heterogeneity of groups to be assessed, and the context of the assessment (e.g.,
place, time, resources) are among the variables to consider in estimating the level of
achievement expected.

Conceptual Level

Initially, estimates can be determined by a teacher's experience or by generalizations about children's stages of cognitive, motor, and values development derived from child development sources and recent work in development in art (Clark & Zimmerman, 1978; Gardner, 1990; Parsons, 1989). Some higher order thinking can be expected of young children if students, encouraged by appropriate teacher facilitation and using concrete objects or images, relate and synthesize multiple direct experiences into big ideas or meanings (Armstrong & Armstrong, 1977).

Local Contextual Differences

Because of community differences in resources and student backgrounds in art, art teachers must reserve the right to determine reasonable levels of acceptability for students in their school or district. There is no point in setting unreasonably high nor unchallenging expectations for student achievement. Students can fall embarrassingly short of unreasonably high expectations, and low acceptability levels may reflect lack of teacher confidence and its attendant inference, lack of challenge.

One way to estimate achievement levels is by comparison across grade levels. Stewart and Katter (1993) suggest expected success on *Interpreting What's There*, a criterion used to assess the outcome, *Arriving at Meaning*, in art criticism experiences. They predict student performance at grades 3, 6, 9, and 12 according to the rating scale definitions in Figure 13.5.

Figure 13.5—Grade level performance expectations on an art criticism criterion: Interpreting What's There

	Grade level checkpoints			
Rating scale definitions	3	6	9	12
no meaning	very few	none	none	none
limited meaning	many	some	very few	none
comprehensive meaning	few	some	many	many
extended/poetic meaning	none	very few	few	some

Note: From *Building a foundation for the future* by M. Stewart and E. Katter, April 1993. Paper presented at the 33rd National Art Education Association Convention, Chicago. Copyright 1993 by authors. Reprinted by permission.

School districts may elect the mastery level concept guided by national standards or school notions about passing cut-off percentages. Translation of percentage points to alternative assessment approaches may seem difficult, but the parallel would be decisions made by definitions of ratings on criterion-referenced assessments. On a four-point rating scale with a 0 to indicate no evidence, where is the passing point? Is alternative assessment used by other subject areas? If a weighted average of 1 means a student falls seriously short of evidencing the anticipated behaviors, is that a poor but passing grade or not a passing grade? Is "Well, he/she tried" a passing judgment? We face these tough decisions every day. *Passing* levels should be discussed and agreed upon so that they are employed consistently within a school or in whatever context comparisons between groups are anticipated.

Estimating percentages of students who might achieve at different passing levels can accommodate very hetergeneous groups. This is consistent with rating scales that describe different qualities of responses—evidence of achievement at several levels. Rather than a pass/no pass judgment, achievement levels suggest a stage on the way to mastery of a criterion. In any group, there are students operating at a variety of levels and needing specific kinds of coaching by the teacher. Using assessment for diagnostic purposes would let the student who is at a less than acceptable mastery stage in some area(s) be conditionally passed with remedial recommendations or deficiencies assigned to be addressed before attempting learning dependent on the foundation of deficient areas. It would be a disservice to pass students who remain at an entry level on most criteria. Figure 13.6 hypothetically shows percentages of students expected to achieve at several levels in a fourth-grade group.

Figure 13.6—Criterion levels of acceptability

	Percent projected to achieve at or above each level			
Grade 4	1	2	3	4
1.1 Thinks before answering	5	20	65	10
1.2 Displays experimental, open attitude	5	15	60	20
1.3 Chooses logical method to find out how	5	20	65	10
1.4 Accepts a challenge	5	15	70	10
1.5 Supports opinion with observable reasons	5	20	65	10

Teacher Notes:

Key: entry (1); evidence (2); expected (acceptable) (3); exemplary (4)

If one level of mastery were expected for each outcome (goal, behavior category), criteria related to each would be clustered. In Figure 13.6, all items are related to the way students inquire. For each criterion, acceptable or better (3 and 4) ratings estimate student achievement at 70% to 80%, so an estimate of achievement on students' ability to *Inquire* as an outcome is 70%. It is noteworthy that there are no caps on how many students are expected to achieve achieve at any level. There is no ranking of students. No one need change rank because of the achievement of others. This does not ask teachers to project a relative situation, but rather an absolute achievement (Herman et al., 1992).

Wiggins (1989) recommends equating local standards of scoring to some credible wider-world standards. A standard is a level for which to work, that is, a possible, worthwhile, and challenging level for all students. If national standards in art suggest a mastery level of achievement for all students by a certain grade level, some school districts can anticipate lower achievement results at first. The whole curricular-instructional-assessment-standards process may be new. Initial results become base lines from which to improve toward the consensus of what students can know and do in art, that is, standards.

Improvement Plan

The major purpose of assessment is to help students learn. The initial curriculum planning, carried out through instruction, is planned to be assessed by how well students learned what was planned. Figure 13.7 portrays that basic relationship which is expanded in subsequent sections.

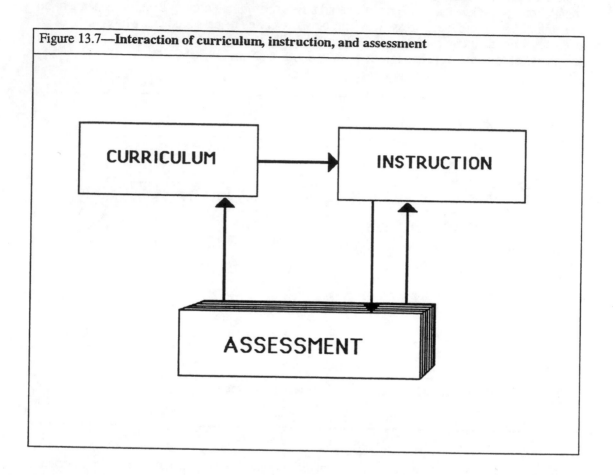

Figure 13.7—**Interaction of curriculum, instruction, and assessment**

The planned curriculum shapes instruction which facilitates learning which is assessed and provides feedback regarding the effectiveness of instruction and/or the curriculum planned. Accuracy of that feedback depends on its specificity. A deficiency somewhere must be identifiable.

Analytic assessment helps teachers to diagnose problem situations. Explanations depend on the interpretability of analytic, not holistic assessment. If assessment is to be used for diagnostic purposes, Herman et al. (1992) point out its necessity to meet two tests: (a) the criteria of an instrument should describe the component and process aspects of performance, and (b) theory should support the relationship between task components or processes and the outcome being assessed. These points have been encouraged throughout this book, especially in Chapters 4-6 and 9-12.

In Chapter 5, each art behavior was shown to have levels of sophistication at which students could achieve. In the sample items in Chapters 10 and 11, each sample was coded for the content, behavior, and level of behavior addressed in that item. The level refers to sophistication of the behavior (i.e., a point of achievement on the continuum toward total adult mastery of that criterion). Especially in the case of organize behaviors, teachers may want to cluster and

score items separately that are similar in level of organization, that is, low level organizing behaviors (e.g., forming a concept) as opposed to higher order organizing behaviors (e.g., relating and synthesizing complex information or images). If students differ on their ability to organize, improvement of instruction is difficult unless the teacher can interpret what proportion of students or which individuals need coaching on handling complex information, and which need help in organizing attributes that characterize a particular concept. The search for causes of student responses, observation of patterns, points of misconceptions, difficulty or errors depends on interpretable instruments and scoring procedures. More effort based on what is not clear from unspecific assessment offers little promise of effective change.

Assessment for the purpose of improving curriculum and instruction in art can be considered as a gradual process occurring at three levels (not years) of assessment results. Each level should use results from several years of assessment at each grade level to verify the consistency of the apparent observation. A suggested guide for considering assessment results for forming an improvement plan is:

First Level—Baseline Data
Assessment provides initial feedback about what students are learning in art.

Results:

- Focused curriculum planning and tentative changes in instructional methods, content, emphasis.
- Several classes at same grade level assessed to establish an average baseline for school or district.

Second Level—Comparison Data
Assessment results are compared to assessments from initial years.

Results:

- Revisions and/or introduction of new content.
- Confirmation of progress in intended directions.

Third Level—Verification Data
Assessment provides strong evidence of successfully achieving goals or outcomes.

Results:

- Modeling for other districts.
- Continued revisions in assessment, curriculum, and instruction.

Summary

Systematically sampled evidence of learning can result in accumulated data that is meaningful, but basic rules of fairness must be considered. Summarizing the evidence of learning involves accumulation of like kinds of behaviors or outcomes in order to interpret accurately from that data. Its purpose is to provide feedback to the student or inform decisions on instructional/curricular changes.

The process of improving curriculum and instruction with the aid of assessment should not be approached with the all too common gusto that vanishes as quickly as it comes on the scene. If instructional practice and curricular structures need to be changed, time must be allotted to do so responsibly and ethically. This is a serious venture that can fulfill its promise, but it must be pursued with sensitivity to the nature of art and the needs of students, with the full commitment of the teachers of art, and with tenacity that will overcome inevitable disappointments of slow progress and setbacks. The task becomes easier as methods improve from effort and as insightful teachers and others concerned reflect on and shape the entire process.

14

ETHICS AND ASSESSMENT

Ethics are an important consideration in making many assessment decisions. The well-being of the student is of primary concern. Validity and reliability are revisited from the particular viewpoint of what is ethically valid and reliable. The support of ethical assessment by parents and the community eases the burden of responsibility on the teacher who is most constantly concerned with ethical practices of ongoing as well as summative assessment.

Teaching, then assessing the effects of that teaching (even in the most carefully considered program), certainly differs from assessing a precisely engineered manufactured product. Human beings are fragile and tough, complex and unique, to suggest just a few dimensions of variability that complicate any neat assessment of what they learn. Flawless perfection evades the most dedicated efforts. This acknowledgment cherishes the human diversity and is not meant to dissuade; rather, it is meant to encourage reflection, sensitivity and caution as we learn together to improve assessment procedures for the assessed as well as for improvement of the art curriculum and instruction.

Well-being of the Student

Heterogeneity of Groups

The diversity of our nation is reflected in the demographics of students assessed in our schools. In 1992, the National Council on Education Standards and Testing (NCEST) reported that "about one third of all American students are poor, disabled, or do not speak English as a first language" (p. G-13)[1]. They maintain that the **result** of opportunity must improve and that equity in outcomes is a moral and economic imperative.

Normal accommodation of the needs of special students applies to assessment also, if they are to be included in the art assessment. Students who are partially sighted need materials with high black and white contrast (e.g., tests, work sheets, and photocopied reproductions). Written materials can be planned far enough in advance to allow district translators, if they are provided, to translate the materials for non-English reading students. Special needs students

[1] The views expressed in the Task Force report are not necessarily those of NCEST.

167

should build toward mastery in as many areas as possible, have their achievement assessed, and be helped to recognize their progress. If students are not assessed, they cannot benefit from the desirable effects of improvement of instruction (NCEST, 1992).

Ideally, assessment concerned with the well-being of the student would consider needs of not only those with identified disabilities and language handicaps, but also those who vary in their verbal development, life experiences, gender expectations, achievement motivation, test-taking skills, attitudes toward assessment and art, anxiety, self-confidence, and innumerable other factors that may disallow students' performance to their potential level. Variations in cognitive strategies (Gagne & Briggs, 1974), developed in formative years, may require unlearning some approaches to thinking (impulsivity, conformity) that are unproductive for success in art. The following basic suggestions may offer teachers ideas for their specific situations:

- Seek evidence that supports or contradicts the outcome behavior being assessed by assessing that behavior with different content or form of communication. If cultural characteristics could allow students to give evidence of achievement of outcomes in a way other than that assessed originally, it would be much like constructing curb ramps to enable wheelchair "pedestrians" to get where other pedestrians can go. NCEST (1992) recommends equity in standards, but variation in area of students interests.

- Provide practice in the kind of behaviors required in the assessment task (e.g., help students learn the process behaviors and approach to solving any problem); administer under normal, nonthreatening conditions; and be alert to signs of stress during assessment and try to alleviate the problem.

- Employ aides to assist special students in knowing what question is being asked and to help the student communicate a response.

- Interpret the results of assessment to students in terms of their strengths, not just their deficiencies, without subtle bias in "leading" students to their life choices.

- Provide opportunities for students to respond to challenges beyond the expected outcomes.

- Verify the results of any assessment mode by a comparable assessment in a different mode.

Different modes of assessment are not a panacea. Lockwood (1991) calls attention to the initial threat of a different mode of assessment when authentic assessment was introduced. However, it became accepted and successful in changing the way students discussed their learning experience. Maeroff (1991) reported on the other side that:

> Students who score poorly on the much-maligned norm-referenced tests with their multiple-choice responses are not necessarily going to perform better on the alternatives. In fact, there is reason to suspect that the weakest students could look even worse—though they may avoid the embarrassment of being ranked and compared on a numerical scale (p. 281).

Different attitudes exist also about how to assess in multicultural/multiethnic groups. Conversion of tests to culture-fair versions may lower the validity of the test to assess certain behaviors for which they were designed. This may result in giving misleading information to the assessed individuals about their ability to perform in society. This position would seem to support a "prepare for the mainstream for success" argument. Eventually that may be considerate of the well-being of the student. The hazard of insisting that students be assessed as in the mainstream culture is that discouragement, without remediation and coaching, may work against students ever realizing their potential. Perhaps legal educational opportunity carries with it the responsibility for society to provide actual educational opportunity which facilitates access into the mainstream culture.

Student Involvement in Assessment

Considering the teacher-dominated, traditional approach to assessment of the past, it will take some reorienting of thinking to value greater student involvement in assessment. Being able to self-assess is a realistic behavior for life, but it generally takes the opportunity to practice plus coaching to learn anything. That is true as well for the preparation for self-assessment. Students should be clearly aware of the criteria by which their outcomes are to be assessed and then their input solicited as to what the experience meant to them. Figure 14.1 emphasizes the role of the student, not just as recipient of feedback, but also as a provider of input as to the nature, content, and qualitative criteria of the assessment. It suggests an interactive process between teacher-planning and students as participants in the learning and its assessment.

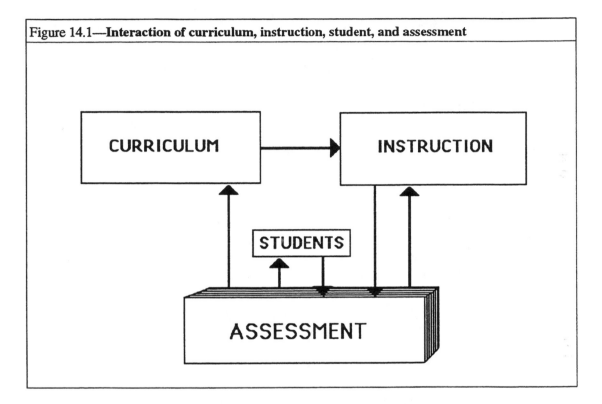

Figure 14.1—**Interaction of curriculum, instruction, student, and assessment**

Students should know what they are supposed to learn and the criteria by which their achievement will be judged. Age, conceptual development of the student, and contextual variables such as scheduling and number of students served by an art teacher are considerations in deciding details about students' setting their own evaluative criteria. Is a student working independently? How much experience do students have to enable setting challenging art goals? How do such goals relate to curriculum planning and goals or outcome statements that were set and submitted for approval to the school district or state board of education before the student's entry into the art program? As most reform issues, change in procedures for establishing assessment criteria can take time to consider the contextual variables and anticipate the consequences.

Students' attitudes about grades and assessment develop early in life and are tenacious. Even though college students can read in a syllabus that quizzes and exams are 10% or 20% of a grade, they tend to judge their course achievement by that small portion. With the realistic use of a final grade for determining so many opportunities for students, change in attitudes about assessment will take patience and persistence. It will take a sympathetic attitude on the part of teachers and their guidance in helping students share in the ownership of assessment. This

process may not only reveal important modifications to present practices, but it may be the most effective inroad to viewing assessment as an important and welcome part of learning.

Validity and Reliability Revisited

Chapter 4 emphasized the importance of content and construct validity of assessment instruments. Assessment should provide evidence that corresponds with the curricular goals or outcomes that have shaped instruction and student art experiences. Furthermore the observations credited as criterion evidence should correspond to the theory and research definitions of the construct inherent in the criterion. In other words, assess what is claimed for the assessment.

The concern for the well-being of the assessed and repeated concerns that assessment not run rough-shod over humans seem to align themselves with another kind of validity—integrated validity—identified by McCollister (1993). McCollister searched for support of the idea that assessments could foster self-esteem and enthusiasm within the learner by emphasis on self- or group-generated criteria. She considers consequences for the learner that have aesthetic wholeness, adherence to a code of values (integrity), equity, completeness, and avoidance of disintegration and fragmentation. McCollister writes, "Integrated validity supports the learner's voice in assessment design, values continuing enthusiasm for learning, and promotes recognition and reinforcement of one's own intellectual aesthetic" (p. 160).

Another validity issue beckons. It seems appropriate for a state to mandate that school districts meet visual arts goals or exceed them with district-appropriate goals. One assumes that these goals are not trivial and that instructional experiences are designed to help students meet them. However, if such a school district would consider assessment obligations fulfilled by a state test, the state test would not be comprehensive enough to validly assess the added district goals. Valid local assessment would need to supplement the state test. Assessment based on national standards (which are voluntary) must similarly be considered within the local district context. Darling-Hammond (1991) writes:

> We need high standards, but those standards must be adapted to local needs...flexible, situational, and multicultural, rather than national, mandated, and standardized...[and] tied to instructional decisions that teachers have helped make and for which they can be held accountable. (p. 220)

Role of Parents and Communities

Parents have every reason to care about assessment and they are a valuable source of out-of-school evidence of how their children are learning. They also deserve to be informed about the nature of art education and appropriateness of new approaches to assessment so that they can positively contribute to ethical assessment. Persons operate on the basis of their cognitive maps—the organization of knowledge and comprehension of life experiences. Cognitive maps enable structures or systems by which people appreciate—their evaluative maps. Persons are not likely to appreciate what is not part of their experience. Informing parents about ethical assessment practices that the school is using can help them to be supportive of assessment practices that were not part of their experience. Thus, parents need to be helped to value practices such as alternative assessment, multiple assessment approaches and multiple course grades.

Sometimes a blind faith in assessment leads to questionable rewards. Is it ethical to reward or put sanctions on a school based on assessment scores which disregard the demographics of the student population? This confuses the *opportunity* for meeting curricular challenges with *achievement*. If resources for challenging curricula are rationed to a small proportion of students from schools that are already able to provide better resources, a vicious cycle exists.

Greater student needs must be supported proportionately to enable them to achieve competitively. Without that move toward equity, schools tend to resort to unethical practices—to hide or not admit students who might be low scorers—practices Darling-Hammond (1991) referred to as "engineering of student populations" (p. 223). Equal resources are necessary to meet equal standards, and that may mean initial unequal distribution to bring the opportunity for learning to the same level.

Ethics and the Role of the Teacher

Teachers, because of extensive contact time with students, have the most opportunity to be sensitive to the ethics of assessment. Perhaps awareness of that fact accounts for some teacher reservations about assessment. Bracey (1991) listed effects of standardized multiple-choice achievement testing on teachers. A different outlook can be proposed for each.

- Embarrassment by public disclosure of scores might be turned around by emphasis on the test's purpose of accumulating baseline data, the point of which is to establish direction for improving of education. Baseline data informs schools (not just individual teachers) how to work toward improvement which can be observable in subsequent assessments, dependent, of course, on allocation of resources necessary to make improvements and on the passage of enough time for change to occur.

- Beliefs about the invalidity of tests and the pressure to raise scores might be countered by good arguments for more valid local assessment procedures which meet district art goals.

- Beliefs about the emotional impact on children can induce teacher expressions (e.g., verbal, facial) and body language that convey worry to students. A supportive stance and ongoing, varied assessments could make assessment a normal and accepted part of instruction.

- Resentment of loss of teaching time for assessment could be considered in light of whether teaching more and more without checking for results is wise. Could teachers selectively teach less, but better? Lockwood (1991) writes about the effects of authentic assessment practices on two schools,

 > instruction ... had to be shifted from curricular practices that emphasized coverage of large amounts of material within a prescribed time frame, to in-depth situations in which students are encouraged to develop problem-solving and higher order thinking abilities. (p. 13)

- Uneasiness about curricular and instructional shifts motivated by emphasis of a test is understandable. Acceptance of either—the old or the shift—can be based on (a) analysis of the importance of existing goals and instruction, (b) study of the rationale for the structure of the test in question, and (c) supported decisions to supplement the test with locally developed assessment instruments or to change the curriculum and instruction if the change is warranted.

Stiggins (1991) asks teachers to be literate about assessment (i.e., notice and modify assessment items or instruments that are problematic or unclear, recognize and adjust extraneous factors that influence evidence of learning and use caution in drawing conclusions from inadequate samples and meaningless results). However, teachers do not have to have known all there is to know about assessment. University courses in evaluation or assessment in art are infrequently offered. Some recent art education texts (Chapman,1987; Day & Hurwitz, 1991; Hobbs & Salome, 1991) do offer excellent chapters but are necessarily limited in space as methods courses have limited time to devote to assessment. For those who can attend conferences, there are many sessions in which efforts are being shared. Teachers can also keep aware of equity in resources, curricular expectations, and standards with options for variation based on student interest.

Gronlund (1981) identified charges, brought by critics of testing, that pupils experience negative effects. Teachers can try to alleviate these effects and answer questions about the ethics of assessment in their classrooms. Purported negative effects and ways to alleviate them include:

- Anxiety: Assure students that the assessment emphasis is not speed, but rather quality and thoughtfulness and that tests measure only part of what is learned. Delay tests until students have other feedback.

- Labeling: Adjust learning groups to avoid categorization.

- Self-concepts: Help students to interpret results of their assessment in terms of strengths and weaknesses to work on. Discourage comparisons with others. Use criterion-referenced assessments and discuss the results in terms of criteria.

- Self-fulfilling prophesy: Concentrate on using multiple means of assessing.

- Minority unfairness: Examine and remove bias from assessment instruments, instructions, and visuals. Be consciously fair. Use multiple means of assessment.

- Sex bias: Correct any bias traced to the assessment instrument. If a gender difference is apparent in assessment results that are not influenced by the assessment instrument, study possible sociological origins, help students to recognize the cultural reasons for such results, and encourage well-rounded development and expectations for success.

- Invasion of privacy: Treat student journals or other incidents of personal disclosure with strict confidence. An exception would be journal notes of a student who wishes to exhibit a portfolio which includes them. A legal exception to privacy may exist where a student discloses suicidal tendencies or abuse.

Ethical Teacher-constructed Assessment Instruments

Teachers may construct their own assessments based on the curriculum taught with no hidden criteria. As Brouch (1973) wrote:

> In behaviorally designed programs, these tests are drawn directly from the concepts and competencies we have listed as critical properties. Nothing else. Nothing sneaky to see if anyone has been reading ahead in some book; nothing for 'extra credit" or to 'separate the sheep from the goats.' (p. 161)

After an assessment, teachers are responsible for knowing that students have fully explored and understood, because the teacher can consistently observe the student and follow-up on "confusing, glib, or ambiguous answers." (Wiggins, 1989, p. 709)

Every school district has its own policy on grading students with disabilities. If assessment is for describing what groups of students know and are able to do, the approach may be different than when giving grades to individuals who exert an amazing effort but whose outcomes are still markedly deficient. Keep in mind, however, that "good-hearted" grade inflation develops ultimate problems. Generosity invalidates descriptive baseline information and the comparability which would allow claims of the effects of art education.

One art teacher struck a compromise by gathering baseline data on first-grade groups using a drawing task. Students were coded in the grade book according to several levels of sophistication. All the art production tasks were sorted on each criterion and given a comparative, defined rating. Ratings for individuals were averaged at the end of a semester. If a student had been coded at "entry" as a low-ability student and had averaged only a two but consistently tried hard, the grade assigned could be raised to a 3. In this scenario, the assessment data remains unaltered by effort considerations.

A slightly different compromise derives from the "slanty rope" approach. The slanty (jump) rope allows younger or less able students to have easier success by lowering the rope (standards) on one end. With this practice, however, the database is contaminated and is a deceptive source of information for making curriculum and instruction modifications. Ultimately it is deceptive to the student also in not kindly addressing specific strengths and weaknesses.

Absenteeism creates another ethical assessment dilemma, especially for scheduled state tests. The task of keeping track of what students have not been taught, but on which they are being assessed, is overwhelming when an elementary art teacher may see a thousand students a week. This ethical problem is not the teacher's alone; it should be shared by parents and the school.

Cultural considerations raise questions about the ethical use of the normal curve in grading. Expecting the normal curve distribution of scores is hard to justify when assessing a single group of students. The normal distribution can be expected only for very large groups who are not affected by an intervention like instruction. And carefully planned art instruction is certainly expected to have more than a chance effect. In fact, even if test scores of a group do seem to fit a normal curve one year, another year they could vary considerably.

Use of the Results

With good intentions and some research to support it, assessment has been used to track students into homogeneous groups for instruction. Criticisms of this practice dealt with lower teacher expectations similar to labeling which in turn affected motivation and self-expectations of students. The current position of the NCEST (1992) is that:

> Studies show that children do not do well when their teachers have low expectations for them. All children have the right to aspire to the same set of goals, to be held to equally high expectations. National standards can thus be an instrument of equity by requiring all of us to do what it takes to educate all youngsters. (p. K-2)[2]

A positive connotation of tracking based on assessments is tracking individual growth or development. That use of tracking, a kind of trend analysis, can be rewarding and informative, and call attention to needed changes in instruction or approach. The section on comparative use of data dealt with tracking groups.

Finally, the NCEST report cautions about (a) using weak evidence as the sole basis for making decisions that may have unfair consequences, (b) teaching the test in order to reap accountability rewards, and (c) using tests not aligned with the local standards or goals, and not inclusive of the experiences that enable students to meet those standards.

Summary

Ethics enters into assessment practices in some obvious and subtle ways. Educators are in a caring profession where comprehensive, wholesome growth of students is the primary concern. Ethical assessment practices and responses must fit compatibly into that concern whether made by administrators, parents, school board members, community members, or teachers. Students can be involved in the entire process of assessment, sharing the ethical responsibilities inherent in assessment decision-making. Standards, adapted to local demographics, need to be understood and supported by parents and the community at large. Conducted and used intelligently and with sensitivity, assessment is critical to the improvement of education for all students.

[2] The views expressed in the Task Force report are not necessarily those of NCEST.

15

REPORTING THE RESULTS

Reports of assessment results serve to provide (a) interactive feedback to students, (b) data for curriculum and instruction articulation, (c) descriptions of status or accountability data, (d) data for professional research , and (e) information for the public leading to good community-school relationships and cooperative ventures. General comments about the audience, presentation and format, and recommendations of reports will precede ideas specific to purposes of assessment reports.

Reporting student progress toward curricular goals both culminates and initiates the ongoing and cyclical curriculum-instruction-assessment process of education. Assessment reports can verify the degree to which instructional experiences are having a significant impact on desirable student outcomes. It also gives art teachers the opportunity to share with others what occurs and why, what could be changed, and how others can assist in positive change efforts.

Presentation

The Audience

Reporting on assessment results can enable making sound judgments about student learning as well as simultaneously educating adults about art education. Assessment reports are created by persons who are *practically* literate about assessment for persons who may use that information—the *functionally* literate (Stiggins, 1991). The practically literate are school teachers, teacher educators, administrators, counselors or school psychologists who both generate and use data. They must understand the basic principles of development and construction of assessment instruments, their limitations, strengths, and interpretation. (A third level of assessment literates is that of professional wide-scale assessment developers.) Stiggins (1991) wonders how parents, school board members, and community members can become functionally literate about assessment (i.e., understand, value, and responsibly use assessment results). The most promising avenue may be well-explained reports presented by the teachers who created, conducted, interpreted and summarized the assessments.

It is important that an assessment report is easily understood, has credibility, and assists the audience in appreciating the nature and goals of the art program. It may be the only contact art teachers have with a particular audience. In presenting the report, art teachers may want to use language and style compatible with the values of the audience. By changing the emphasis, or

slightly altering the shape of the presentation, the same information can appeal to community concerns or the interests of a particular audience.

Expectations of results can have a bearing on how a report of an assessment is received and used. People who assume that success or failure is beyond their control tend to attribute positive feedback to their own competencies, but negative feedback to external forces (e.g., the assessment instrument, bias, bad luck) and therefore do not act on that information. People may need to be encouraged to withhold attribution, but use information to seek ways to improve art education. Reporters of assessment results can help an audience to anticipate using information from assessments to make improved decisions and solve problems. Mokros (1982) makes four recommendations for doing so: (a) stress to the audience that the assessment results will provide new information for art education modifications, (b) emphasize the ongoing, goal-correcting role of assessment, (c) frame positive and negative assessment results as problem-solving feedback not as a "grade," and (d) refocus audience tendencies away from blame and toward the problem to solve. The assumption is, of course, that the assessment plan, procedures, and instruments reflect sound recommendations for valid and reliable assessment. The role of expectations about assessment results also applies to the first audience of those results, the teachers.

Misconceptions about the value of art and art education may need to be clarified. If adults experienced art in their schooling, very different motivations may have guided that experience. An audience may need some brief background information in terms of educational reform and emphasis of the four content areas—aesthetics, art criticism, art history, and art production—and their role in art education goals. Today's adults may not have been encouraged to think and talk about the nature and value of art (a lack of experience that may lead to uninformed opinions of art and the value of art education). To put one's self in their position, ask what they might not know as background to understanding assessment in art education.

- What are the art goals and standards that schools help students meet?

- Why are these goals valid for the general education of students?

- Where is the art program in terms of moving toward the goals?

- How is art assessment similar to, and different from, other subjects?

- How do assessment results indicate effectiveness of district efforts?

Style and Format

Organization

Regardless of the audience and the presentation format, oral, written, or graphic, organization is important. The goals addressed in the art program are the critical part of the presentation's structure. In addition,

- All parts should fit the structure.

- Evidence gathered by instruments should be linked clearly to the goals.

- Descriptive language should succinctly create a persuasive image that supports the data presented.

- Evidence should be knit in such a way that inspires a cohesive synthesis that is convincing or inclines the audience to participate in seeking solutions.

Figure 15.1 shows a goal-referenced structure used to organize reporting on the appropriate employment of different assessment methods. In Figure 15.1, assessment instruments used are

clearly related to five hypothetical goals and the basic art behaviors that were identified in Figure 9.3.

Figure 15.1—Model of Goals as the Structure for Organizing Assessment Reports

Goals

(vertically, above each goal, add
 codes for art-related behaviors encouraged
 by each goal)

Assessment Instrument:	1	2	3	4	5
unit: traditional, machine-scored tests		x		x	
art criticism, aesthetics discussion, peer critique rating scale	x		(x)		x
criterion-referenced art product rating scale			x		
student journal or comment sheets, teacher log book	(x)	(x)	(x)	(x)	(x)

Note: (x) means that evidence of goal achievement *may* be observed through these sources

A particular assessment instrument may include items that address more than one goal. Items that address Goal 1 and Goal 3, for example, would be summarized separately and clustered with items from similar instruments that provide evidence of student learning related to the same goal. If several ways of checking on students' approaches to creative problem solving (inquire) have been employed, the results can be reinforcing and so noted.

Goals may or may not be tied to the content areas of art—art criticism, art history, art production, and aesthetics. If a teacher perceives that the audience would value focus on the disciplines of art, the report could do so also. In this case, the four content areas would be placed across the top of the figure and the instruments again along the left side. An objective pencil-and-paper test might be noted as a means of gathering both art history and art production data, whereas coded discussions might be the means of gathering evidence of student learning in art criticism experiences and aesthetics dialogues.

Goals may address a mix of content areas and art-related behaviors. Charting the objectives and instruments to be used helps visualize how to organize data summaries. For example, a "citizenship" grade might include teacher records of the students' art-related behaviors, Interact/ Cooperate and Attitude evidenced in classroom interaction, testimonies from the students' journals, or parent responses to a questionnaire.

A basic outline for an assessment report might include the following:

Abstract—This could become an administrative or executive report. It collapses the details and highlights the results relative to major categories of the report.

Preface—This message to the reader sets the stage for expectations: It describes the rationale for art education and assessment approaches.

Overview—A brief assessment plan history looks at past and present, notes progress and gives projections.

Context description—This fills in the demographic data, personnel, scheduling, grade-appropriate instructional and student research resources, and the grading system.

Goal 1, 2, etc—For each goal, the learning experiences, evidence of learning, assessment instrument(s) to record evidence, interpretation of data, and summary of group results assessed on that goal can be included.

Summary—The overall summary could include commendations, areas in which to improve, and recommendations for accomplishing this improvement in subsequent phases of development.

Formats

Response to a report is influenced by its presentation of information or procedures. Readability, conceptual clarity, and attractiveness contribute to perceived usefulness, credibility, and relevance of the report. Different formats of publication can be used to fit the needs of diverse audiences.

An attractive, informal handout, brochure, or booklet can reinforce whatever information is presented at a meeting. This printed material could be available in district offices for persons unable to attend a formal presentation. A simple, well organized description of the intent of assessment, techniques used, the kind of data collected, could be followed by an explanation of why these fit with the way art uniquely contributes to the district general education goals for students. The piece could conclude with a summary of major results.

Setting important facts or quotes within a box or printing them in bold gives them added emphasis and could be used to highlight memorable results, such as:

Across all grade levels, 85% of students in art could

answer three out of four questions about the "roots" of art.

A postcard or clip form could be included on a flyer or in a booklet to invite inquiries for more information.

Presentations to school boards or similar size groups, can utilize transparencies. Organizing the transparencies enables an oral presentation without reference to notes. A complex diagram is better shown in stages, or transparency overlays starting from the general structure then adding parts, such as in Figures 13.7, 14.1 and 15.2. Major points presented clearly on a one-page handout help the audience to follow the report. Profound statements of students can be quoted and written on large size banners and displayed with student works of art around a room in which a meeting is held.

Photographs or slides (depending on the situation) of students creating art, discussing art works, or searching for information about art are helpful in creating visual images for the words describing these changes in art education, especially for news media interviews or reports. Student *then-to-now* portfolios can portray certain aspects of art learning and growth over time. Videotapes of classroom art experiences, such as aesthetics dialogues, could be effective evidence for TV interviews as well as meetings of parent or other community organizations. Art teachers have used the Getty (1991) videotape when given a 15-minute time slot at a school board meeting to "tell everything there is to know about art education and how it is taught, too." The videotape professionally presents a reconceptualization of art education for anyone holding dated ideas about art education, (e.g., busy work, time filler, entertainment, or relaxation).

Written reports requested by an external body, such as a state board of education, would naturally follow particular content and format suggestions from that body. A cover letter could describe briefly what is being submitted.

Purposes Served by Assessment Reports

Feedback purposes of assessment have already been introduced in Chapter 13, (i.e., for improvement of curriculum and instruction), and in Chapter 14, (i.e., for interactive feedback to the student). Figure 15.2 expands on these purposes of assessment by including mandated reporting and informing the community. In this section, each of these groups is explained as being inclusive of more than the category name. The ultimate purpose of art assessment reports may be to createaudiences more literate about assessment and, as a result, more literate about art education. Until audiences responsible for the support of general art education universally value it, there is a never-ending struggle for that educational opportunity for students.

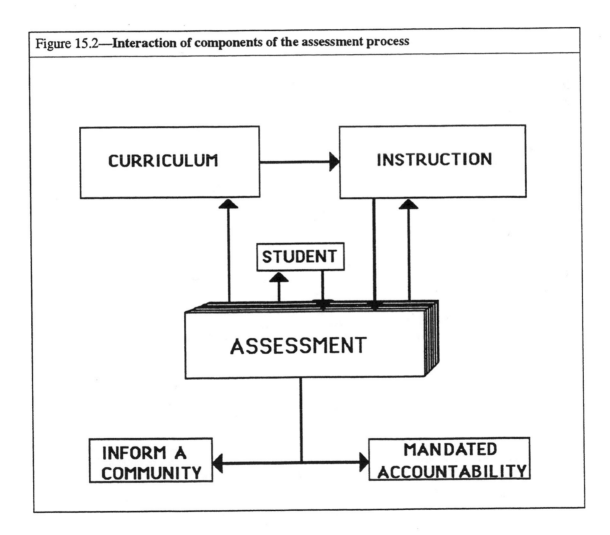

Figure 15.2—**Interaction of components of the assessment process**

Feedback to the Student and Parents

Students can thoughtfully reflect about their art performance and about the comments of their teachers, regarding their achievements. Parents and guardians can become critical consumers and appreciators of students' experiences in art.

Interactive Student-teacher Dialogue

A missing component of most teacher-oriented assessments is clarification of a student's intent. Although during informal ongoing feedback as teachers converse with students, a student's intent may become known, many blocks to this knowledge can and do occur—students' reluctance to disclose it, progress or insight that occurred effecting closure while working away from the classroom, inability for a teacher to get around at appropriate times to each student, or students being at an incomplete, in-process searching stage when a teacher is available.

An alternative is to schedule interactive portfolio reviews with students instructed to prepare for the reviews by reflecting on their performances. Because it's an interactive situation, the teacher is not in the dangerous position of possibly incorrectly reading an intent or missing an intent. With greater awareness of student intent frequently comes greater opportunities to praise and to help students know how to be more successful in doing what they were attempting to do. This makes assessment a true learning experience and is a world apart from judging competitions by a turn of the card that indicates "in" or "out." Interactive assessment does not take all educated guess-work out of assessment (Wolf, LeMahieu & Eresh, 1992), but it does invite more information for making decisions than the teacher might otherwise have available. On the downside, Maeroff (1991) points out that putting less emphasis on comparisons by ungraded portfolio reviews is fine, but at some point parents have a right to know whether their child's progress is reasonable for his/her age and experience.

Traditional Report Cards and Variations

Report cards may always be with us, but they need not be the same single grade per subject. There are changes away from that direction already and numerous educators including Gronlund (1981), Peeno (1987), and Wiggins (1992) deplore the use of a single grade. The groundwork laid in Chapter 13 on defining rating scales offers a format for a multiple grading system as shown in Figure 15.3.

This schema for communicating to students and/or parents is a compromise to allow comparative estimates (as in letter grades) as well as a descriptive statement in reference to each major goal or behavior for which instructional experiences were provided. Each behavior could be achieved at any of four levels or not observed. The value weight assigned to a behavior is indicated. The anecdotal statements (definitions of the rating scale) could be computer-selected and printed out on a report sheet as appropriate for each student as shown in Figure 15.4. This allows students to see what is needed for improvement.

Figure 15.4 is an example of an individual multiple-grade card using the statements from Figure 15.3. Another method would be to reproduce the schema as the grade card and circle the appropriate statement relative to each behavior for a student for that grading period.

Giannangelo & Lee (1974) reported on Computer Assisted Reporting to Parents (CARP) which created anecdotal reports of a child's progress. A CARP form had a series of statements suggesting progress; need for practice, individual work, or more careful work; or praise warranted for general capabilities related to curricular goals. Teachers circle numbered anecdotal statements from a list provided that appropriately indicated the performance achievement level of a student for each objective to be evaluated in that reporting period.

Figure 15.3—Statement Selection Schema for Individual Subscores Report Card

Behavior	Subscore Weight	No Evidence	Entry	Evidence	Expected	Exemplary
KNOW	1	Does not demonstrate art knowledge	Shows little retention of art information	Needs prompts to recall art information	Retains 70-85% of art information assessed	Recalls over 85% of information assessed
PERCEIVE	1	Apparently unaware of a visual world	Makes only obvious visual discriminations	Uses visual qualities appropriately in making art. Notices some specific qualities of works of art.	Visually differentiates accurately in viewing and creating. Notices particular qualities of works.	Makes fine visual differentiations that contribute to effectiveness in interpretation and creation of works of art.
ORGANIZE	2	No attempt to put concrete objects together as groups.	Arranges concrete items into groups.	Shows some organization of images and ideas. Plans.	Relates ideas, images, or forms to communicate effectively	Logical organization of ideas, images and form into meaningful syntheses.
INQUIRE	2	No inclination to search	Conforming, impulsive. Does not question.	Curious, considers illogical search procedures.	Experimental, flexible. Uses reasonable search procedures.	Innovate, reflective, divergent guests. Moderate risks in searches.
VALUE ART, SELF, OWN ART WORK	2	No awareness of art. Self-value not	Disinterest and/or self-degrading about art.	Subject interest in works of art. Insecure, non-committal about own art.	Story interest in art works. Associates art with experience. Secure.	Unprompted appreciation. Interest in meanings. Self-confident.
MANIPULATE	1	No use of tools. No evidence.	Gross motor control with tools and media.	Control with simple tools and media for age level.	Constructs, models, draws at age-appropriate level.	Refined motor control with tools and in media contributes to intended meaning.
INTERACT/ COOPERATE	1	No interaction with others.	Somewhat disruptive. Some inconsiderate acts.	Complies, trys, is accommodating Cooperates.	Contributes. Helpful to others. Respectful.	Self-disciplined, Empathetic. Peacemaker. Leadership

Parents generally approved of the CARP system, but students missed the comparisons to their peers. Teachers kept more specific accounts of what was taught and learned, leading to more meaningful analysis of student learning. In turn, this enabled teachers to give parents more precise information which indirectly educated them more about the school program and encouraged home and school communication. It should also have enabled parents to respond more knowledgeably and appreciatively to their children's home assignments and discussion of school experiences.

Parent-teacher Conferences

Parent-teacher conferences offer a direct opportunity for parents and teachers to converse on a one-on-one basis. However, because of parent work schedules and the like, this reporting system is too unsystematic to be used without the support of formal report cards. Likewise,

Figure 15.4—Model for Individual Subscores Grading Card			

Name_____Elda_____

Behavior	Weight	Sub-Score	Comment
KNOW	1	Exemplary	Recalls over 85% of information taught.
PERCEIVE	1	Expected	Visually differentiates with accuracy.
			In viewing and creating, notices particular visual qualities.
ORGANIZE	2	Exemplary	Logical organization of thoughts, forms and images into a meaningful synthesis.
INQUIRE	2	Evidence	Curious. Considers illogical search procedures.
VALUE	2	Evidence	Subject interest in works of art. Insecure about own work.
MANIPULATE	1	Expected	Constructs, draws, models at age-appropriate level.
INTERACT/ COOPERATE	1	Exemplary	Self-disciplined. Peacemaker. Empathetic.

informal letters, although a personable report, are time consuming and unlikely to consistently address the same goals or behaviors for each student.

Gronlund (1981) offers a long list of do's and don'ts regarding the teacher's conduct in parent-teacher conferences that deal with preparation, establishing and maintaining rapport, sharing information with parents during the conference, and planning a course of action with the parent. Being prepared means having focus and examples of student work, presenting information in an organized way, giving thought to questions to be asked and anticipating parent questions, and creating a comfortable, uninterrupted setting. Using language understandable to the parent together with a positive, friendly, sincere and listening approach is helpful. It is also advisable to use tact, start with a child's good points, and encourage contributions from the parents in describing areas that can improve and in planning how to proceed.

If teachers take notes during the conference, it is best to end the conference positively by reviewing the notes with the parent in summarizing the discussion. Negative or comparative remarks about other teachers, children, administration, or district are not appropriate; the parent conference is not the time to hang out the dirty laundry about facilities and supplies. The parent is there to know about the child's progress, and school issues that may impede progress of all students can better be dealt with at other times. Avoid interrupting parents, overloading them from a soap box, or asking embarrassing questions. Confidentialities revealed must stop with the teacher.

Teachers may want to have a special place to note ideas about grading procedures and parents' feelings about what can effectively inform them about their children's needs. Scheduled small group meetings could invite parents' and students' input in cooperatively creating meaningful ways to communicate how students are meeting goals, to identify goals that need to be added, and to discuss adequate assessment procedures for diagnostic purposes that are compact enough for practicality.

Parent-teacher-student Conferences

Some variations of the sit-down conference involving parents, teachers, and students include:

- A Students-Teach-Parents Night where students in small groups lead art criticism experiences with parents, help parents participate in art production experiences, and the like.

- Then-Now Portfolio Exhibits where early art tasks or products are compared to later ones to show change over time.

- Notes are sent home attached to art tasks that help the child explain the purpose of the learning experience whether it is an art history worksheet, an art product, or a big question about art to be answered.

- Visit Art Class Week, where parents are sent an invitation to join their child's art class sometime over a two-week period (depending on scheduling and how frequently the art teacher sees all students). One art teacher sent a schedule to each parent or guardian showing the day, room and grade level, and school of all art classes.

Colleagueship: Counselors, Cross-Department Faculty

Art teachers can take the initiative to share assessment results with their colleagues in whatever form is appropriate to a situation. For example, an information pamphlet on art education especially created for rising eighth graders could be created and placed in the counselor's office for visitation day at the high school or Fall orientation. An informal discussion in the teachers lounge on the nature of what is assessed in art could be a conversational gambit to help broaden conceptions of what students do in art. Or the conversation could be steered to what a teacher hopes to promote, such as the need for a school-wide, multiple-grade reporting system. Formally or informally communicating the results of art assessment can be shared in various places—faculty meetings, bulletins, conference rooms, hallways, lounge areas, cafeterias, and administrative offices displays.

Similarities and differences between subject areas may influence variations in the marking systems used for these subjects. Chapman (1978) claimed that in art very little lends itself to absolute standards that may be assumed indisputable by teachers of other subjects. Some consistency, such as letter grades for achievement in a subject, but other kinds of marks for attitude, cooperation, or effort, might be agreed upon as well with a little extra effort and communication. The scale—four-point, five-point, or whatever—needs to be used with consistency for meaningful communication to parents and students. The meaning of the scale points also needs to be consistent. Discussions about the grading scale may reveal opportunities for greater assessment efficiency by including some cross-subject cooperation, such as writing across the curriculum. The very discussion becomes informative to the art teacher and other teachers about what each discipline is attempting to teach, and reinforcement of behaviors common to different subjects can occur.

Curriculum and Instruction Change: Analyzing for Improvement

Modified Technical Report

The technical report is the basis for the most thorough analysis of assessment data. Its educational purpose is to create a record of baseline data and make comparisons in consideration of demographic differences. The modified technical report is a report *for* teachers *by* teachers and may involve guidance from an external consultant during the process or as a check on tentative decisions. Art teachers, the most sensitive to art situations, may want to join with a broader based assessment analysis committee to analyze raw data and interpret it. Explanations can lead to planning changes anticipated to improve meaningful student learning. It may become clear that the development of a system for tracking growth is needed. In seeking explanations, teachers may decide to consciously research effects of certain demographic variables. In priori-

tizing needs for change teachers may consider what is feasible for short-term changes and what is worth working toward over a period of time. A needs list may lead to expansion and prioritization. The committee can assign tasks to persons and agree upon dates that drafts of possible changes will be due for the group's consideration. With this kind of analysis, the focus of subsequent phases of the assessment program emerges. An improvement plan time line and schedule of phases may be created or modified as part of the analysis process.

District or School Goals-Instruction-Assessment Compatibility

Internal analysis and summarizing of data may entail reexamination of content validity and construct validity of instruments and interrater reliability. Refinement of procedures, creation of new approaches to assessment, or new instruments may be deemed necessary to validly assess learning that is assumed to occur in art in order to gather evidence to demonstrate it. More imaginative ways to "catch the butterfly" without damaging it may be need to be created.

Articulation Between Elementary and Secondary Schools

Analysis of assessment data may be portrayed in bar graphs for depicting differences on goals or basic art behaviors by grade levels assessed. Comparisons may reveal where steady or irregular growth occurs. Evidence precedes analysis, interpretation, explanations, and decisions as to whether the profiles are acceptable or warrant intervention by curricular or instructional changes. A more clear vertical sequence or definitions of ratings on criteria appropriate for grade levels are likely to result from this internal analysis.

Ethical Considerations: Resources, Individual Needs

Results of assessment can also be analyzed in terms of the demographics of a group or school. Individual art teachers' analysis of assessment data may reveal a need to consider individual exceptions in ability to learn from procedures that are generally successful, and explore accommodation possibilities and alternate ways of instruction or assessment.

District-wide art assessment analysis teams could uncover and deal with inconsistencies in opportunity attributable to unequal resources. Lack of resources may contribute to inequity in outcomes of learning. If a parent group from one school finances the purchase of reproductions of art or art museum study trips, but parents of children at another school are not capable of doing the same, the learning experiences are not equal and inequity in outcomes cannot be attributable to the students' inability to learn. Such a situation cannot be ignored.

Mandated Accountability or Description of Status

Administrative or Executive Summary

Imagine a hearing where persons are given three minutes to save their home from destruction. Whatever is said must be clear, critical, and convincing. An administrative assessment summary is similar. What do administrators—immediate or district—want to hear about assessment in art for their purposes and what else would be of benefit for them to know? Inevitably, they want a concise description and facts.

Administrators, who are not trained in art, cannot be expected to read the available literature in art education and appreciate the basis for changes in the field of art education. Trained art teachers can be concise, clear and organized in presenting the rationale for these changes and the relationship of assessment methods to the unique contribution of art education to the general education goals and arts goals of the district. Summarized results in relation to each

goal should be sharply presented. Overall, visual presentation, which separates key ideas by space, bulleted points, and bold or highlighted key words, will help to quickly get across the main ideas. Length may vary with the project but, whether one or four pages, the abstracted format is expected.

School Board Limited Report

Is the audience a school board deciding whether or not to continue a program? Do they need to see that the art program is uniquely meeting the district goals for student learning? Perhaps they need a formal report with specific percentages of achievement clearly matched to each goal, a concise summary, and an action plan for improvement. It may be wise to request time each year to update the board on the status of art education even if it is not a formally rotated practice. A well-edited videotape of the assessment process—planning committee to assessment procedures and scoring—could help school boards visualize the unfamiliar world of assessment in art education. Events, examples, results of assessment, and a brief, feasible plan for improvement can show alertness to the goals of the school and competence as a subject-matter specialist.

Contextual Assessment: Sociometric Data and School Report Card Demographics

Gronlund (1981) and NCEST (1992) suggest that a school-wide assessment program should be reported in conjunction with the total accreditation evaluation program of the school (See next paragraph). Combining socioeconomic and other demographic data from school report cards and insights from faculty self-study of their programs and community, with the results of learning assessment would enrich the possibility of meaningful connections surfacing—a *contextual assessment*. The information provided by this combination should be part of the technical report which is the basis for curricular and instructional modifications or dramatic change.

Accreditation: Self-Study Components

Assessment results can figure into the self-study of a high school art department. The results can support responses of faculty to general questions asked and prepare teachers for responding to questions during the external evaluation team's on-site visit. Having prepared a mandated assessment report, teachers can easily add well-presented items to the self-study as addendum items.

One high school, preparing for an external school-recognition visitation by state board of education evaluators, produced a 16-item checklist of assessment procedures on which department chairs would elaborate. The list included objectives-state goal relationships, grade levels at which objectives would be measured, and standards (number of objectives each student must accomplish to satisfy meeting the goal). The report included the percentage of students expected to meet each objective, the assessment tool used for each objective, validity and reliability of each tool, and demonstration that the tool is bias-free. After using the tools and collecting and recording the data, reports are to be made on the number of goals met by each student, percentage of students meeting each objective, and after analysis, a general plan for improvement and individual remediation plans for each student who did not meet one of the state goals. A public report of these actions was also an item on the checklist.

Phase I, II, III Comparison Reports

At some point it may be necessary to demonstrate progress in assessment results over time. The tracking of progress that resulted from analyzing assessment results and planning for improvement, can document the assessment-curriculum-instruction feedback loop. A check-off list of priorities and tasks assigned and met through the phases can show responsible assessment practices. The actual assessment data can be plotted and will speak for itself.

Professional Contribution

Cooperative Research

It takes time to follow recommendations for good educational practice. To teach less (but) **better** makes practical sense, but verification is needed. Providing verification calls for collaboration between art teachers and persons with expertise in gathering data. Reports of the findings of such research need to be shared at professional conferences and through professional journals.

Sharing Experiences

On a less formal level, in local and national meetings, teachers can share their pilot studies in developing and testing instruments and their ways of recording evidence of student learning. These reports may not meet stringent research standards, but they are a critical step in the right direction. Art assessment should pass through a growing and refining process and be given time and resources to proceed responsibly.

Inform Communities, Public Relations and Community Cooperation

Inform

In addition to reporting to parents on the progress of individual students, reports about activities that broaden common conceptions of art education have merit also. The speaker who presents assessment information should be chosen with the nature of the audience in mind—their purpose in hearing the presentation and the style to which they would respond favorably. Consider how effectively the speaker will present assessment results and recommendations.

At guest nights or open house nights, selected students can explain their portfolios and the variety of educative experiences that comprise them. Exhibits in the community and other time-honored ways of making the art education program visible could incorporate student statements and banner announcements of the results of assessment, such as:

85% OF THIRD GRADERS CAN GIVE REASONS WHY THIS SCULPTURE IS ART

Written reports can be made available at meetings of school boards, parent-teacher organizations, civic organizations, and local art support groups, and to building or district teachers. When art teachers make presentations to community groups or art students participate in community events, the message can include the proof of the pudding—data that reinforces what seems to be evident by the art experience (art works, videotaped discussions, or written papers) portrayed. Reporting can be effectively accompanied by slides or videotapes of

students creating art, talking about art, and displaying behaviors that are fostered in art education.

Student work can be displayed at the meeting place accompanied with brief written explanations of how the work demonstrates meeting an art goal. Teachers can describe the related activities from art history or criticism experiences that built the foundation for the final product, and the application for this type of art learning to everyday living, to an informed-about-art adult status, or to careers in art. Posters, enlarged photographs, or diagrams of key goals and assessment results related to them help focus attention on the major points and give impact to facts and figures. It may be expecting too much for the average citizen to draw the conclusions that seem obvious to the art teacher, so make the point clear. Because these events only repeat what has been part of the art program, the preparation required is modest, yet they make the art program visible and assessment results convincing.

News Media

Assessment results can be made public through local news media. Art teachers have the choice of writing an article so that it presents the results as intended, or telephone the local newspaper feature editor and alert that person to the possibility of a newsworthy story. A written article will likely be edited or used just to spark interest of the editor who may, in turn, assign a writer and photographer to the story. Weekly newspapers may be quite receptive to news releases from schools. Local television or radio interviews are other possible ways to share successes of community students through assessment results.

Newspapers prefer to highlight the novel, unique or unexpected event. They usually look for what **they** consider human interest stories about art, (e.g., a former local art student whose career is successful in art, art students who visit a local art-related business as an art learning experience, or use of the computer in art education). Their ideas of art education are also based on what they know about art. They do not see themselves as an arm of education for the public, but rather as bringing sensational news to their readers, that is, entertainment. Therefore, a teacher needs to use good judgment in approaching the media and be aware of what **type** of items will pique their interest. It may also be necessary to broaden their idea of human interest related to art education. If a teacher's intent is to educate the community to understand the nature of art education, he or she can start with what is a new development. Juxtaposing today's students analyzing and interpreting art—and the students' excitement about formulating their well-reasoned positions—with the outmoded concept of art education as relaxation time could be made intriguing.

Even percentages (generally understood by the public) of change that assessment reveals can be highlighted. Here the focus should be on the percentage scored at the highest level (rather than the percent at any other level) and on how these results show that local objectives related to behaviors needed for life-long learning are met by new approaches in art education. Do members of your community even know that art has not stayed the same since they were in school?

Assessment reports can be turned into proposals for future directions. A community organization may be impressed that art teachers can focus on a worthwhile direction, pursue it, and produce evidence that there was a pay-off to that effort. The responsibility that is demonstrated lends confidence to support subsequent endeavors. Successful results speak for procedural competence and increase the likelihood that an organization would view financial help as a good investment in the community's future. Assessment experience and good results are more convincing than mere assertions.

Summary

This final chapter brings the topic of assessment in art education back to the beginning: its rationale and purposes. It considers the nature of the people that education is designed to serve and to whom it is accountable—formally and informally—in reporting progress, and shaping the presentation and approach.

Feedback to the students, parents, and art teachers of ongoing and summative assessment results acknowledges that all concerned have a voice in the educational process. A cooperative stance shapes recommendations for improvement of curriculum and instruction through parent-teacher-student interaction and with art department analysis of data.

Formal, mandated assessment reports or descriptive reports vary with their function for the audience, and in some cases gigantic amounts of data may need to be consolidated into a very concise summary.

Reports to one's community can be approached in ways that fit the media charge to bring human interest stories to the public. The assessment of art also has possibilities for leading to future community support and cooperative projects.

GLOSSARY

The definitions of terms used in the context of this book are simplified, but are based on recommendations by art education and evaluation experts.

Achievement. Ability to demonstrate accomplishment of some outcome for which learning experiences were designed.

Achievement levels. Behaviors along a continuum that represent degrees of attainment of a criterion (D. J. Davis, 1971). Achievement levels may vary according to the conceptual development of the student, life experiences, formal educational experiences, physical capabilities, and attitudes or interests.

Adversary evaluation. An evaluation resulting from judgments based on observations by a person who is inclined to disagree with the principles of the program being evaluated or who is known to prefer another approach. The evaluation is performed to provide a critical examination and/or discover weak spots.

Advocacy evaluation. An evaluation resulting from judgments based on observations by a person who is inclined to agree with the principles of the program being evaluated.

Alternative assessment. Nontraditional means of recording evidence of learning, such as coding live art criticism discussions, portfolio reviews, rating art products on criteria established by teachers and students, journals, authentic task assessment. Entails direct observation of student performance.

Alternative-response test items. True-False, Yes-No types of questions where a choice is forced between given response alternatives.

Art content areas or disciplines. In keeping with recent emphases, the content areas from which art education is drawn are art history, art criticism, aesthetics, and art production. Each content area, or discipline, contributes information, concepts, and exemplary models of approaches (i.e., behaviors) to creative and critical thinking in that discipline.

Art-related behaviors. Common art education behaviors are mental and/or physical responses such as thinking capabilities; attitudinal systems; technical or manipulative physical skills; cooperative interpersonal and group skills; working independently and investigatively; and personal management skills in reference to one's own art creation and responding to art of others—past and present. In this book, behavior does not refer to misbehavior such as being disruptive.

Assessment. The process of judging student behavior or product in terms of some criteria (Clark, 1975). Assessment may include, but is not limited to, what is normally considered testing. Evidence may also be assessed from discussions of works of art, museum visit worksheets, essays, group art production work, writing samples, and so forth. Assessment may use a variety of means to record evidence of student learning, such as rating

scales, observation checklists, content analysis, or interviews. Interpretable assessment results in multiple scores. Individuals are assessed, but responses are summarized to ascertain achievement of groups or subgroups of students.

Authentic assessment. Assessment that fits meaningful, real-life learning experiences. It includes recording evidence of the learning process, applications in products, perception of visual relationships, integration of new knowledge, reflecting profitably on one's own progress, and interpreting meaning in consideration of contextual facts.

Bench mark. Exemplary samples of performance or production.

Concept. An idea. More specifically, an art concept is the knowledge taught that should show up as a competency in the art product or statements about art (e.g., varied shapes, balance of colors). Woodruff (1968) identifies four types of concepts that vary from simple to complex. With examples in parenthesis, they are item or event concepts (my mother, a fettling knife, 12"x18" white newsprint paper, Armistice Day); process concepts (wedging clay, cutting a mat, crosshatching); structure concepts (composition, advertising careers, National Endowment for the Arts, art criticism); and act-consequence statements. (Artists portray situations that arouse viewers to action; varying pressure on a loaded pen of ink creates undulating lines; visual examination of actual objects increases data for creating visual imagery.)

Conceptual development. Building an increasing awareness and use of more complex ideas and structures of ideas over time.

Connoisseurship. The art of appreciation, the ability to define the quality of an object or environment (e.g., insight into what is transpiring in a classroom and description of that experience so that the reader participates in and can interpret that observation). Eisner (1976,1991) likens educational evaluation to the act of art criticism where the evaluator, because of understanding and empathy, is able to portray the special qualities of a situation. A teacher's familiarity with what is involved in teaching art enables greater perceptivity and interpretation. In the context of assessment of art learning, decisions about what to assess and what will best serve as evidence of that learning should be made by the teacher of art who understands and cares.

Criterion. A behavior, characteristic, or quality of a product or performance about which some judgment is made (Clark, 1975). It represents what a teacher intended to teach and what is checked to see if students did indeed learn what the teacher thought was taught.

Criterion-referenced assessment. Includes criterion-referenced testing but also all those other means of assessment included under the definition of assessment. Criterion-referenced means that achievement is being assessed in reference to some student outcome that can be expected as a

result of an educational experience (i.e., a degree of mastery of identified criteria) (Davis, 1972; Ebel, 1975). Criteria are qualities that can provide evidence of achievement of goals or outcomes, such as comprehension of concepts introduced or reinforced, a kind of inquiry behavior encouraged, or a manipulative technique practiced for its potential contribution to the meaning of the work of art. It makes sense to assess in terms of what a teacher believes was taught. When the criteria of several assessments may contribute to a more general objective for student learning, another term, objective-referenced assessment may be used in place of criterion-referenced assessment.

Figure G.1—The Relationship between Evaluation and Assessment of Student Learning in Art

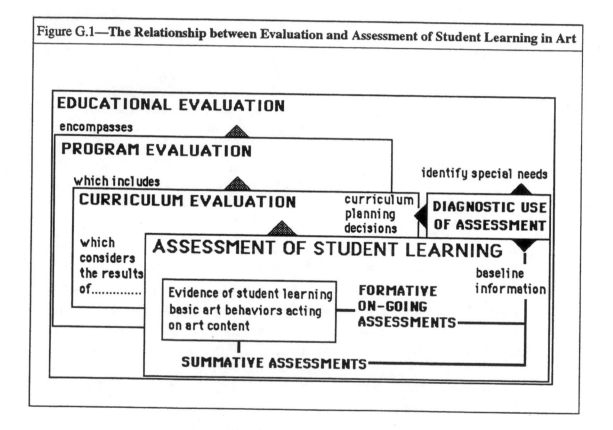

Cued Assessment. In contrast to types of assessment where the learner synthesizes information and generates responses, a cued assessment provides the selections from which the learner chooses a response (multiple choice).

Direct assessment. Direct assessment is observation of the student performing (e.g., defending a judgment about art, creating a sculptural art work, discussing the process that led to a direction shown in a portfolio, etc.). It is assessment without inferring outcomes from test items or self-reports.

Discipline. An area of knowledge in which individuals can be instructed (Aesthetics, Geometry, History, Zoology, etc.) and which has a structure of hierarchical concepts. In the context of contemporary art education and assessment of student learning, "art disciplines" refer to art history, art

criticism, aesthetics, and art production. In this book, discipline does not refer to misbehavior or unruly classroom problems and their correction.

Encounter. An extended lesson composed of a cluster of meaningfully integrated activities deriving content from the art disciplines—art history, aesthetics, art criticism, and the products of artists (Efland, 1977).

Evaluation. A judgment of merit based on various measurements, notable events, and subjective impressions. A total art **program evaluation** assesses the quality of components such as facilities, resources, teacher preparation, extracurricular art activities, or safety in the art room and includes **curriculum evaluation** and the program for **assessment of student learning**. Assessment of student learning in art can lead to refining or reinforcing curriculum (what is taught, when) and instruction (how). Figure G.1 shows the relationship between curriculum, instruction, and assessment of student learning.

As can be seen in Figure G.1, art programs operate within the context of a community and a state. This context has an impact on all aspects of an art program including curriculum goals. Art education goals must be compatible with district curriculum goals and show how art experiences contribute to those general education goals in unique ways. Assessment of student learning or outcomes is the procedure for ascertaining whether the criteria (content knowledge and behaviors) related to goal achievement have been met. Levels of achievement of art content and behaviors can be determined.

Formative and Summative evaluation. Formative evaluation is the process of judging an ongoing, changing process or product for diagnosis, revision, description, information, or comparison. **Summative** evaluation, a final-end judgment serving purposes of persuasion, verification, prediction or validity, is also referred to as outcome evaluation.

Goals. Statements of expectations of general capabilities or student outcomes resulting from planned educational experiences. General educational goals refer to state or district goals for all students. Art goals can refer to state, district, teacher-planned, or teacher/student-planned expectations for student learning (i.e., student outcomes that will result from the planned experiences in art). Instructional goals refer to what the teacher will do in order to facilitate that student outcome. An objective, in terms of student behavior, delineates a more focused outcome than a goal (i.e., a breakdown of a general goal statement) but does not refer to the over specification of minute enabling behaviors (i.e. each manipulative skill).

High stakes assessment. When assessment results are tied to funding for schools from states or other agencies, the stakes or consequences are highly influential. When states base their judgment prematurely on a statewide test, what is testable on that one-shot instrument tends to drive the instruction if results are to be published and schools compared.

Higher order thinking. A complex level of thinking that entails analyzing and classifying or organizing perceived qualities or relationships, meaningfully combining concepts and principles verbally or in the production of art works, and then synthesizing ideas into supportable, encompassing thoughts or generalizations that hold true for many situations.

Holistic. Holistic, whether describing learning or assessment, refers to the conscious awareness of the way parts interact and influence, looking globally rather than analytically.

Inquiry approaches, cognitive strategies, or art process behaviors. The behaviors, predominately cognitive in nature, that contribute to learning in art. They include: experimenting, being analytical and reflective in thinking, persisting in trying, varying ideas, observing closely, thinking divergently and imaginatively, analyzing and making well-reasoned judgments. It is these behaviors, "strategies," or "approaches" to learning that contribute to the innovative thinking needed for creative problem solving. An inquiry approach is not what one thinks about nor at what level of complexity one thinks: It is how one thinks. It involves a **disposition** along with a **capacity** to inquire.

The inquiry behaviors that characterize philosophers include listening, selecting words carefully, offering reasons for statements, discriminating and analyzing, reflecting, clarifying, challenging, checking, and considering factors that could affect an opinion or decision. When artists write about their inquiry behaviors (not in those terms), it is evident that they keep themselves from coming to premature closure on ideas—a philosophic-minded behavior—and frequently change and reorder their ideas and work (Armstrong, 1986).

Instrument or assessment tool. A method of gathering data about student performance in art could be a questionnaire, a test, a checklist of stages in solving a problem, or a criterion-referenced rating scale for an art product.

Measurement. May be a frequency count of kinds of responses, a rating indicating the level of attainment of a desired quality, or the percentage of correct answers on a multiple choice test and so forth.

In criterion-referenced assessment, assessment is specified as degrees of attainment (a score or a rating) based on what is possible. The degrees may be stated in terms of percentages of attainment along a continuum or section of a continuum (what can be expected for a particular grade level), where the continuum represents ultimate mastery of the criterion.

Norm-referenced testing. Indicates how that student's performance compares with other students' performances in an appropriate reference group on the same test.

Ongoing assessment. Tracks student learning by performance on tasks that are part of the natural instructional process. Ongoing assessment, producing

samples of work clustered by the outcome demonstrated, provides accumulated data for summative analysis.

Outcome. A successful culmination of a cluster of integrated learning experiences. It involves correct application and synthesis beyond direct instruction.

Outcomes of learning. Goals or objectives written in terms of what students should know and be able to do or value. Outcomes of learning in art are kinds of observable, life-oriented capabilities that students acquire as a result of art experiences. Open-ended goals or outcomes clearly evidence intended learning but allow students to exercise choice, empowering them to make meaningful decisions. Gagne and Briggs (1974) identified three cognitive categories (information, Intellectual skills, and cognitive strategies), an attitudes category, and a motor skills category as potential outcomes of learning. Behaviors or outcomes in each of these categories can be more specifically delineated.

Performance. Directly observable, student-generated evidence of learning (e.g., creating a woven basket, planning advertisement for a multifaceted student art fair, providing good reasons why a work of art has merit, interpreting a conceptual work of art).

Portfolio. A collection of forms of evidence of learning. Examples might include a videotape of participation in an art criticism experience, a painting, sketches that record the preliminary thinking process for an environmental artwork, a journal of ideas and experiences that provide insight about the learning, essays, tests, teacher notations from a log book, and classroom interaction checklist results.

Reliability. A test or measure is reliable when it is consistent (i.e. repeated measurements would show the same achievement or several observers of a classroom situation would closely agree with ratings recorded for individuals on the same criterion).

Responsive program evaluation. Evaluation that is oriented to program activities rather than intents, that responds to audience requirements for information gathering and considers expressions of worth from individuals whose viewpoints may differ. In Stake's (1975) aptly named Responsive Evaluation approach, the evaluator is a helper in the sense that the evaluator provides an outside view about how well a program is resulting in what the teachers are striving to do. By contrast, preordinate evaluators approach the evaluation with predetermined expectations and criteria. Teachers who ask students for comments on worksheets, or questionnaires or to assist in identifying meaningful criteria by which they would weigh their achievement, are operating in the spirit of responsive evaluation.

Social responsibility. A general education outcome to which art education contributes. For example, students are expected to maintain good working conditions in art classrooms, treat classmates and their work or ideas with

respect, and give expression to their concern for the improvement of public conditions, the environment, and world situations.

Standards in art. Challenging, but attainable visions of art student outcomes (i.e. what students should know and be able to do and appreciate, resulting from their art education experience). Art standards for excellence can motivate change in art education programs, curriculum, instruction and assessment. National standards in art education can guide educational decisions about art programs and fill a gap in the large picture of art in education.

Systematic sampling. Observation of students at regular intervals to avoid bias in timing of observing evidence of learning (e.g., every fifth of twenty-five art criticism experiences that students were involved in).

Traditional assessment. Traditional assessment instruments refer to forced-choice, machine-scorable, pencil-and-paper tests (e.g., matching, true-false, multiple choice) and restricted-completion, short-answer, or essay questions.

Validity. Validity occurs when the assessment procedure measures the performance described in the objective, that is, what it claims to measure.

APPENDIX A

Figure 5.3

Worksheet: Relationship of goals to behaviors
and levels of attainment inferred by the goal

ART GOALS	ART-RELATED BEHAVIORS AND ATTAINMENT LEVELS						
	KNOW	PERCEIVE	ORGANIZE	INQUIRE	VALUE	INTERACT, COOPERATE	MANIPULATE
HIERARCHICAL LEVELS OF BEHAVIORS The student will:	bodies of knowledge facts labels	analyze differen-tiate discriminate	evaluate relate generalize conceptualize	innovate reflect elaborate	consistent concern choose prefer	interpersonal skill be responsible comply	complex of skills routines part skills
1							
2							
3							
4							
5							
6							
7							
8							
9							
10							

Figure 6.2—Worksheet: Interaction of Art Behaviors and Content Implied by Goals

ART CONTENT	Know	Perceive	Organize	Inquire	Value	Manipulate	Interact/Cooperate	Community Concern
Aesthetics								
Contextual value: Art world/social world								
Theory/Issues categories								
Characteristics: Aesthetician								
Art Criticism								
Criticisms written by critics								
Types of criticism								
Stages of the critical process								
Art History								
Research methods								
Contextual influence: attitudes/institutions								
Facts, attribution: time, location								
Assoc. w/style, artist, period, culture								
Art Production								
Synthesis: Creative problem solution								
Strategy, technique								
Tools, materials, equipment								
Processes, areas								
General: Visual arts disciplines								
Elements of visual art								
Principles of organization								
Community concern for content								

ART–RELATED BEHAVIORS

Key to Goals:

Figure 9.2—Worksheet: Instruments by which to assess the interaction of art behaviors and content

ART CONTENT	Know	Perceive	Organize	Inquire	Value	Manipulate	Interact/Cooperate	Community Concern
Aesthetics								
Contextual value: Art world/social world								
Characteristics: Aesthetician's approach, aesthetic experience								
Theory/Issues categories: What is art?								
Art Criticism								
Criticisms written by critics								
Types of criticism								
Stages of the critical process								
Art History								
Research methods								
Contextual influence: attitudes/institutions								
Facts, attribution: time, location								
Assoc. w/style, artist, period, culture								
Art Production								
Synthesis: Creative problem solution								
Strategy, technique								
Tools, materials, equipment								
Processes, areas								
General: Visual arts disciplines								
Elements of visual art								
Principles of organization								
Community concern for content								

ART–RELATED BEHAVIORS

KEY: Assessment tools or instruments:
C = checklist CA = content analysis TS = trend study R = rating scale
T = traditional test or quiz (multiple choice, unlimited multiple choice, true-false, completion matching)
W = Worksheets, educational games

APPENDIX B

Figure 8.1—Art criticism behaviors cumulative rating scale

		Identified objects in the reproduction	Criteria Recognized the way the artist composed the work	Gave reasons for interpreting "natural"
Students	Observation:	1 2 3 4 5	1 2 3 4 5	1 2 3 4 5
1				
2				
3				
4				
5				
6				
7				
8				
9				
10				
11				
12				
13				
14				
15				
16				
17				
18				
19				
20				

Figure 8.3—**RATING SCALE WORKSHEET**

Student _____

UNIT NAME:

EXPERIENCES:════════════════════**criteria averages** ▼

1 _____

2 _____

3 _____

4 _____

5 _____

CRITERIA:═══════════════

product averages

GENERIC KEY TO GRADING SCALE:

4= GOOD TO TOP EXPECTATION

3=AVERAGE TO GOOD FOR LEVEL

2=BELOW AVERAGE FOR LEVEL

1=COMPLETION ONLY

0=NO CREDIT, INCOMPLETE

Comments:

Figure 11.13—**Aesthetics dialogue about the value of art from different eras**

Content/Behaviors/Level/Grade /Goal

AES / O,I / H / J /

CRITERIA

Student	Thoughtfully considered reasons for judging something to be "art"	Expressed relevant, life-oriented big ideas based on art learn-ing in the encounter	Synthesized contribu--tions of others	Used informa--tion from diverse sources, periods of art or cultures
1. _____				
2. _____				
3. _____				
4. _____				
5. _____				
6. _____				
7. _____				
8. _____				
9. _____				
10. _____				
11. _____				
12. _____				
13. _____				
14. _____				

Figure 11.25—**Portfolio assessment rating scale**

Variety of art forms explored are consistent with problems addressed.

Use of processes, techniques, media at grade level of competence. Presentation.

Functional redirection, exploration, integration of influences.

Growth in complexity of ideas: depth with issue, form or concept.

Shows synthesis of art history or criticism experience.

Authenticity of problem(s) addressed.

Utilization of visual awareness for achieving goals.

Criteria of the problem are met.

Challenge, effort, quantity of work.

Aesthetic quality beyond criteria.

Individuality, originality.

Student

+ v −

+ v −

Generic coding:

4=commendable
3=expected
2=below expected
1= remedial
0 = no evidence
＊ = exemplary initiative
+= beyond experiences provided by the art curriculum
✓=as provided by the minimum recommendations for art curricula
—=below experiences provided by the art curriculum
o = no evidence

Total ＊/4 +/3 ✓/2 —/1 o/0

APPENDIX C

RECOMMENDATIONS FOR BIAS FREE LANGUAGE

RECOMMENDATIONS FOR BIAS FREE LANGUAGE

Use:	Instead of:
men and women	men and girls
husband and wife	man and wife
homemaker	housewife
chair	chairman or chairwoman
the artists...they	the artist...he
when painting, an artist...	when an artist paints, he...
Picasso...he, and O'Keeffe...she	
artist families	artists, their wives and children
drafter	draftsman
artist	lady painter
O'Keeffe achieved	O'Keeffe, whose husband was...
ancient, early	primitive
unreal issue	strawmen
human	man
Asian	Oriental
person with a disability	handicapped person
hearing impaired	the deaf, deaf and dumb
visually impaired	the blind
Chinese	Asian
Inuit	Eskimo
U.S.-born Mexican-American, Hispanic	Chicano
Native American or	
native-born American	Amerindian or Indian
technical quality	craftsmanship
you, class, students, people	you guys

Terms in the "instead of" column should be replaced by those in the "use" column or by more currently accepted terms. The list is not comprehensive.

List of Figures

REFERENCES

Adler, M. (1982). *The Paideia proposal*. New York: Macmillan.

Anderson, D. (1993, April). *Portfolio assessment as a record of artistic learning*. Paper presented at the 33rd National Art Education Association Convention, Chicago, IL.

Armstrong, C. (1986). Stages of Inquiry in art: Model, rationale, and application to a teacher questioning strategy. *Studies in Art Education, 28*(1), 37-48.

Armstrong, C. (1990a). *Development of the Aesthetics Resource : An aid for integrating aesthetics into art curricula and instruction*. DeKalb, IL: School of Art, Northern Illinois University.

Armstrong, C. (1990b). Integrating aesthetics, art criticism, art history, and art production in an elementary education majors' course. Coveny, A., Ed., (1990) *Directions: Addressing art history, aesthetics, and art criticism in Illinois schools* 50-60, DeKalb, IL: Illinois Art Education Association. (EDRS No. ED 342 712)

Armstrong, C., & Armstrong, N. (1977). Art teacher questioning strategy. *Studies in Art Education , 18*(3), 533-564.

Battin, M., Fisher, J., Moore, R., & Silvers, A. (1989). *Puzzles about art: An aesthetics casebook*. New York: St. Martin's Press.

Bloom, B. (Ed.). (1956). *Taxonomy of educational objectives: Handbook I: Cognitive domain*. New York: David McKay Company.

Bracey, G. (1991). Testing: Some cautionary tales. *Phi Delta Kappan, 73*(3), 225-226.

Brallovsky, C., Bordage, G., Allen, T., & Dumont, H. (1988). Writing vs. coding diagnostic impressions in an examination: Short-answer vs. long-menu responses. *Research in Medical Education (RIME) Proceedings of the 27th Annual Conference of the Association of American Medical Colleges, 11-17 of November, 1988*, 201-206.

Brandt, R. (1978). On evaluation: An interview with Daniel L. Stufflebeam. *Educational Leadership, 35*(4), 248-254.

Brandt, R. (1992). On performance assessment: A conversation with Grant Wiggins. *Educational Leadership, 49* (8), 1-3.

Bridgeford, N., & Stiggins, R. (1986). Promoting classroom assessment in the arts. *Arts Education Policy Review (Design)* [formerly, *Design for Arts in Education*], *88*(1), 40-42.

Brophy, J., Evertson, C., Anderson, L., Baum M., & Crawford, J. (1976). *Criterion-referenced observational measurement in the classroom*. (Report No. 76-5). Austin, TX: University of Texas at Austin, Research and Development Center for Teacher Education.

Brouch, V. (1973). *Art education: A matrix system for writing behavioral objectives*. Phoenix, AZ: ARBO Publishing Company.

Bruner, J. (1960). *Process of education*. Cambridge, MA: Harvard University Press.

Campbell, J. (1992, May). Laser disk portfolios: Total child assessment *Educational Leadership, 49* (8), 69-70.

Chapman, L. (1978). *Approaches to art in education*. New York: Harcourt, Brace, Jovanovich.

Chapman, L. (1987). *Discover art*. Worcester, MA: Davis.

Chittendon, E. (1991). Authentic assessment, evaluation, and documentation of student performance. In Perrone, V. (Ed.),. *Expanding student assessment* (pp. 22-31). Alexandria, VA: Association for Supervision and Curriculum Development.

Clark, C. (1975). Evaluation in art education: Less subconscious and more intentional. In D. J. Davis (Ed.),. *Behavioral emphasis in art education* (pp. 43-50). Reston, VA: National Art Education Association.

Clark, G. & Zimmerman, E. (1978). A walk in the right direction: A model for visual arts education. *Studies in Art Education, 19* (2), 34-39.

Clark, G., Zimmerman, E., & Zurmeuhlen, M. (1987). *Understanding art testing: Past influences, Norman Meier's contributions, present concerns, and future possibilities*. Reston, VA: National Art Education Association.

Collins, G. & Sandell, R. (1984). *Women, art and education*. Reston, VA: National Art Education Association.

Darling-Hammond, L. (1991). The implications of testing policy for quality and equality. *Phi Delta Kappan, 73*(3), 220-225.

Davis, D. J. (1971). Human behavior: Its implications for curriculum development in art. *Studies in Art Education, 12*(3), 4-12.

Davis, D. J. (1993). Art education in the 1990's: Meeting the challenges of accountability. *Studies in Art Education, 34*(2), 82-90.

Davis, F. (1972). *Criterion-referenced measurement*. Bethesda, MD: ERIC Clearinghouse on Tests, Measurement & Evaluation, Educational Testing Service Princeton, NJ

Day, M. (1985). Evaluating student achievement in discipline-based art programs. *Studies in Art Education, 26*(4), 232-240.

Day, M. & Hurwitz, A. (1991). *Children and their art*. New York: Harcourt, Brace, Jovanovich.

Ebel, R. (1975). Educational tests: Valid? biased? useful? *Phi Delta Kappan, 57*(2),83-89.

Ebel, R., & Frisbie, D. (1986). *Essentials of educational measurement*. Englewood Cliffs, NJ: Prentice-Hall, Inc.

Efland, A. (1974). Evaluating goals for art education. *Art Education, 27*(2), 8-10.

Efland, A. (1977). *Planning art education in the middle/secondary schools of Ohio*. Columbus, OH: State of Ohio Department of Elementary and Secondary Education.

Eisner, E. (1974). Towards a more adequate conception of evaluation in the arts. *Art Education, 27*(7), 2-5.

Eisner, E. (1976). Educational connoisseurship and criticism: Their form and function in educational evaluation. *Journal of Aesthetic Education, 10*(3-4), 135-149.

Eisner, E. (1979). *The educational imagination: On the description and evaluation of school programs*. New York: Macmillan.

Eisner, E., (1991).*The enlightened eye: Qualitative inquiry and the enhancement of educational practice*. New York: Macmillan.

Eisner, E. (1992, May). *Educational crisis and educational desperation: A nation still at risk*. Paper presented at the 32nd National Art Education Association Convention, Phoenix, AZ.

Elbow, P. (1991). Foreword. In P. Belanoff & M. Dickson (Eds.). *Portfolios: Process and product*. Portsmouth, NH: Boynton/Cook Publishers of Heinemann.

Erickson, M. (1983). Teaching art history as an inquiry process. *Art Education, 36*(5), 28-31.

Feldman, E. (1967). *Art as image and idea*. Englewood Cliffs, NJ: Prentice-Hall.

Ferguson, G.A. (1971). *Statistical analysis in psychology and education*. New York: McGraw-Hill Book Company.

Fitzner, D. (1988, April). *Testing in the visual arts- Video format*. Paper presented at the 28th National Art Education Association Convention, Los Angeles.

Frederiksen, J., & Collins, A. (1989). A systems approach to educational testing. *Educational Researcher, 18*(9), 27-32.

Gagne, R., & Briggs, L. (1974). *Principles of instructional design*. New York: Holt, Rinehart and Winston, Inc.

Gagne, R., & Driscoll, M. (1988). *Essentials of learning for instruction*. Englewood Cliffs, NJ: Prentice Hall.

Gardner, H. (1989). Zero-based arts education: An introduction to ARTS PROPEL. *Studies in Art Education, 30*(2), 71-83.

Gardner, H. (1990). *Art education and human development*. Los Angeles: Getty Center for Education in the Arts.

Getty Center for Education in the Arts. (1985). *Beyond creating*. Los Angeles, CA: Author.

Getty Center for Education in the Arts. (1991). *Arts for Life* [Videotape]. Los Angeles, CA: Author.

Giannangelo, D., & Lee, K.Y. (1974). At last: Meaningful report cards. *Phi Delta Kappan, 55*(9), 630-631.

Gitomer, D. (1991). The angst of accountability in arts education. *Visual Arts Research, 17*(2), 1-10.

Gitomer, D., Grosh, S., & Price, K. (1992, January). Portfolio culture in arts education. *Art Education, 45*(1), 7-15.

Greer, W. D. (1987). A structure of discipline concepts for DBAE. *Studies in Art Education, 28*(4), 227-233.

Greer, W. D. and Hoepfner, R. (1986). Achievement testing in the visual arts. *Arts Education Policy Review (Design)* [formerly, *Design for Arts in Education*], *88*(1), 43-47.

Gronlund, N. (1981). *Measurement and evaluation in teaching.* New York: Macmillan.

Guba, E. (1978). *Toward a methodology of naturalistic inquiry in educational evaluation: CSE monograph series in evaluation, 8.* Los Angeles: Center for Study of Evaluation, University of California.

Hamblen, K. (1984). An art criticism questioning strategy within the framework of Bloom's taxonomy. *Studies in Art Education, 26*(1), 41-50.

Hamblen, K. (1986, February). *Constructing questions for art dialogues: Formal qualities and levels of thinking.* Paper presented at the Art/Museum Education Conference. Northern Illinois University Art Gallery, Chicago.

Hamblen, K. (1992, May). *Art education's movement toward the core curriculum.* Paper presented at the 32nd National Art Education Association Convention, Phoenix, AZ

Hebert, E. (1992). Portfolios invite reflection—from students and staff. *Educational Leadership, 49*(8), 58-61.

Hein, G. (1991). Active assessment for active service. In Perrone, V. (Ed.), *Expanding student assessment* (pp. 106-131). Alexandria, VA: Association for Supervision and Curriculum Development.

Henry, G., Dickey, K., & Areson, J. (1991). Stakeholder participation in educational performance monitoring systems. *Educational Evaluation and Policy Analysis, 13*(2), 177-178.

Herman, J. (1992). What research tells us about good assessment. *Educational Leadership, 49*(8), 74-78.

Herman, J., Aschbacher, P., & Winters, L. (1992). *A practical guide to alternative assessment.* Alexandria, VA: Association for Supervision and Curriculum Development.

Hobbs, J., & Salome, R. (1991). *The visual experience.* Worcester, MA: Davis Publications.

Hubbard, G. (1987). *Art in action.* Austin, TX: Holt, Rinehart & Winston.

Hubbard, G., & Rouse, M. (1972). *Art: Meaning, method and media.* Westchester, IL: Benefic Press.

Hyndman, R. (1993, April). *Arts education assessment consortium: Current and future activities.* Paper presented at the 33rd National Art Education Association Convention, Chicago, IL.

Johnson, M., & Cooper, S. (1993, April). *Developing a system for assessing written art criticism.* Paper presented at the 33rd National Art Education Association Convention, Chicago, IL.

Kibler, R., Barker, L., & Miles, D. (1970). *Behavioral objectives and instruction.* Boston: Allyn and Bacon, Inc.

Krathwohl, D., Bloom, B., & Masia, B. (1964). *Taxonomy of educational objectives: Handbook II: Affective domain.* New York: David McKay Co.

Lankford, L. (1992). *Aesthetics: Issues and inquiry.* Reston, VA: National Art Education Association.

Lockwood, A. T. (1991). Authentic assessment. *Focus in Change: The Quarterly of the National Center for Effective Schools, 3*(1), 3-13.

Lovano-Kerr, J., & Roucher, N. (1993, April). *Development of a comprehensive assessment model for the visual arts.* Unpublished paper. (Available from Dr. Jessie Lovano-Kerr, MCH Room 123, B-171A, Florida State University, Tallahassee, FL 32306-3014.)

MacGregor, R. & Gilchrist, D. (1993). *Coming to consensus: District-wide assessment.* Paper presented at the 33rd National Art Education Association Convention, Chicago, IL.

Maeroff, G. (1991). Assessing alternative assessment. *Phi Delta Kappan, 73*(4), 272-281.

Mokros, J. (1982). Explaining and using negative findings. *Phi Delta Kappa Center on Evaluation, Development, and Research Quarterly, 15*(1), 18-21.

McCollister, S. (1993). Theory and practice of integrated validity. In S. McCollister's, *Validity theory and the assessment of visual art learning: Introducing integrated validity.* (Chapter V). Unpublished doctoral dissertation. University of Oregon.

Meyer, C. (1992). What's the difference between authentic and performance assessment? *Educational Leadership, 49*(8), 39-40.

Moore, B. (1973). A description of children's verbal responses to works of art in selected grades one through twelve. *Studies in Art Education, 14*(3), 27-34.

National Art Education Association (NAEA). (1984, September). *NAEA Board minutes.* Reston, VA: Author.

National Art Education Association. (In process). *Standards document.* Reston, VA: Author.

National Assessment of Educational Progress in Art. (1978). *Knowledge about art.* (Contract No. OEC-O-74-0506). Washington, DC: National Center for Educational Statistics. U.S. Department of Health, Education and Welfare, Education Division.

National Assessment of Educational Progress in Art. (1978). *Attitudes toward art.* (Contract No. OEC-O-74-0506). Washington, DC: National Center for Educational Statistics. U.S. Department of Health, Education and Welfare, Education Division.

National Council on Education Standards and Testing. (1992). *Raising standards for American education.* Washington, DC: Author

National Evaluation Systems, Inc. (1990). *Bias concerns in test development.* Amherst, MA: Author.

Norris, S. (1989). Can we test validly for critical thinking? *Educational Researcher, 18*(9), 21-26

Packard, S. (1973). Creative tempo in children's art production. *Studies in Art Education, 14*(3), 18-26.

Parsons, M. (1989). *How we understand art.* New York, NY: Cambridge University Press.

Peeno, L. (1987, Fall). Reporting pupil progress to parents, school boards, and the public. *NAEA Advisory*

Popham, W. J. (1974). An approaching peril: Cloud-referenced testing. *Phi Delta Kappan, 55*(9), 614-615.

Popham, W. J. (1993). Circumventing the high costs of authentic assessment. *Phi Delta Kappan, 74*(6), 470-473.

Resnick, R. (1980). Standardized testing—Trends of the 80's. *Thresholds in Education, VI*(1),6-7.

Rouse, M. (1971). What research tells us about sequencing and structuring art instruction. *Art Education, 24*(5), 18-26.

Rubin, B. (1982). Naturalistic evaluation: Its tenets and application. *Studies in Art Education, 24*(1), 57-62.

Stake, R. (1975). *Evaluating the arts in education: A responsive approach.* Columbus, OH: Charles Merrill.

Stake, R. (1986). An evolutionary view of educational improvement. In E. House (Ed.), *New directions in educational evaluation.* 89-102. London: The Falmer Press.

Stewart, M. (1988, April). *Teaching the skills of philosophic inquiry in art.* Paper presented at the 28th National Art Education Association Annual Convention, Los Angeles, CA.

Stewart M., & Katter, E. (1993, April). *Building a foundation for the future.* Paper presented at the 33rd National Art Education Association Convention, Chicago, IL.

Stiggins, R. (1991). Assessment literacy. *Phi Delta Kappan, 72*(7), 534-539.

Stoddard, S. (1993, April). *Let's reevaluate reflective journals.* Paper presented at the 33rd National Art Education Association Convention, Chicago, IL

Szekely, G. (1985). Teaching students to understand their art work. *Art Education, 36*(5), 39-43.

Turner, R. (1990). Gender-related considerations for developing the text of art instructional materials. *Studies in Art Education, 32*(1), 55-64.

Waanders, J. (1986). The art of assessment. *Arts Education Policy Review (Design)* [formerly, *Design for Arts in Education*], *88*(1), 17-23.

Weischadle, D. (1978). Accountability without alienation. *Illinois Schools Journal , 58*(2), 3-15.

Weiss, C. (1986). The stakeholder approach to evaluation: Origins and promise. In E. House (Ed.), *New directions in educational evaluation.* 145-157. London: The Falmer Press.

Wiggins, G. (1989). Toward a more authentic and equitable assessment. *Phi Delta Kappan, 70*(9), 703-713.

Wiggins, G. (1991). A response to Cizek. *Phi Delta Kappan, 72*(9), 700-703.

Wiggins, G. (1992). Creating tests worth taking. *Educational Leadership, 49*(8), 26-33.

Wilson, B. (1970). The status of National Assessment in Art. *Art Education, 23*(9), 2-6.

Wilson, B. (1971). Evaluation of learning in art education. In B. Bloom, J. Hastings, & G. Madaus (Eds.), *Handbook on formative and summative evaluation of student learning.* New York: McGraw-Hill.

Wilson, B. (1988). An assessment strategy for the arts: Components of comprehensive state and school district-based programs. In B. Oberman (Ed.), *Education for the nineties: The arts in the curriculum,* 23-41. The Illinois Alliance for Arts Education, Chicago, IL.

Wilson, B. (1992, September). *The status of standards, curriculum and assessment: Irony, paradox, promise, and progress.* Paper presented at the American Council for the Arts: Symposium on Arts Education Assessment, Action Agenda: Student Performance and Learning Outcomes, Atlanta, GA.

Wolf, D., LeMahieu, P., & Eresh, J. (1992). Good measure: Assessment as a tool for educational reform. *Educational Leadership, 49*(8), 8-14.

Woodruff, A. (1968). *First steps in building a new school program.* Unpublished manuscript.

Young, B. (Ed.). (1990). *Art, culture and ethnicity.* Reston, VA: National Art Education Association.

Zessoules, R., & Gardner, H. (1991). Authentic assessment: Beyond the buzzword. In Perrone, V. (Ed.),. *Expanding student assessment* (pp. 47-71). Alexandria, VA: Association for Supervision and Curriculum Development.

Zimmerman, E. (1992). Assessing students' progress and achievements in art. *Art Education, 45*(6), 14-24.